Wildlife Photographer of the Year

PORTFOLIO SIX

Designer
GRANT BRADFORD

Text Editor
MIRANDA MacQUITTY

Project Co-ordinator
SHEELAGH COGHLAN

FOUNTAIN PRESS

Published by
FOUNTAIN PRESS LIMITED
Fountain House
2 Gladstone Road
Kingston-upon-Thames
Surrey KT1 3HD
England

© COPYRIGHT
FOUNTAIN PRESS 1996

Picture Editor
Design & Layout
Grant Bradford

Text Editor
Miranda MacQuitty

Project Co-ordinator
Sheelagh Coghlan

Page Planning
Rex Carr

Colour Origination
Centre Media
London

Printing & Binding
Die Keure n.v.
Belgium

ISBN 0 86343 327 8

Foreword

What do we feel when we see a breathtaking photograph of a bird in flight, a herd of elephants at sunset, zebra disappearing in a dust cloud, a leopard languidly camouflaged in the branches of an acacia tree? A mixture of emotions I would suspect.

Wonder at the beauty of the animal, admiration for the photographer who, with such patience and with such understanding, has captured a unique moment for us to share but also, perhaps, a piercing and poignant realisation that these animals, these moments, are each and every one "an endangered species".

The category "The World in Our Hands" has its own special comment to make. We perceive all too clearly what man's manipulative hands have imposed upon the earth, what havoc they have wrought. Can there be many corners of the planet which we have not diminished, or many animals we have not exploited and continue to exploit?

But all is not yet lost, and never before have nature's wonders been so accessible to us. As we turn these pages the camera's eye reveals secrets of ocean and forest, glacier and desert, fascinating animal behaviour, exquisite detail of fur, feather and skin. Cherish these inspirational pictures, the images and messages they bring us. All the world is in our hands. Would we ever be forgiven - could we forgive ourselves - if these last fragments slipped through our fingers?

Virginia McKenna

Contents

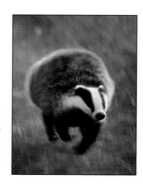
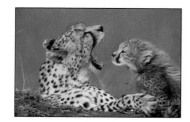
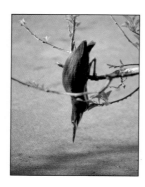
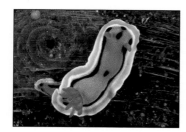
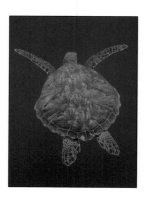

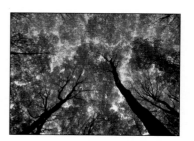

CONTENTS

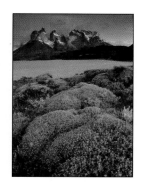

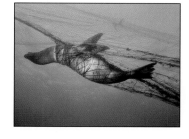
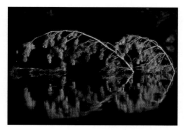
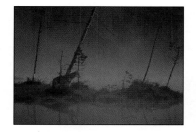
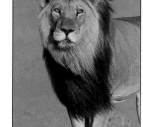
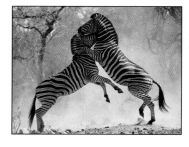

British Gas

Wildlife Photographer of the Year

1996

"British Gas is proud to have sponsored the Wildlife Photographer of the Year Competition for the last seven years. This long association is one which reflects a common interest: the commitment to our global environment, in all its richness and variety.

In our operations around the world we are weaving environmental management more closely into the fabric of our business. We are pleased with our progress, although conscious that there is much still to do, if we are to preserve the wonders of nature for future generations.

These superb wildlife photographs are beautiful and very potent reminders of this inheritance. It is a privilege for British Gas to be involved with the Competition again this year."

R V Giordano KBE
Chairman British Gas plc

WINNERS 1984-1995

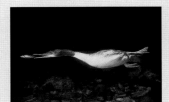

1984 Richard & Julia Kemp
United Kingdom

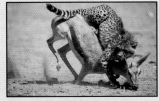

1985 Charles G Summers Jnr.
United States of America

1986 Rajesh Bedi
India

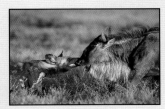

1987 Jonathan Scott
United Kingdom

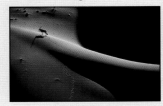

1988 Jim Brandenburg
United States of America

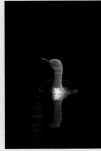

1989 Jouni Ruuskanen
Finland

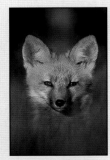

1990 Wendy Shattil
United States of America

INTRODUCTION

This book displays the winning and commended images from the 1996 Wildlife Photographer of the Year Competition, which has been organised for the thirteenth year by BBC Wildlife Magazine and The Natural History Museum, London, and sponsored for the seventh year by British Gas.

The competition aims to find the best wildlife pictures taken by photographers worldwide, and through these images to emphasise the beauty, wonder and importance of the natural world. This year the standard of entries was higher than ever with new entrants from as far afield as Argentina, Bulgaria, Costa Rica, Egypt, Mexico and Thailand.

Photographs, which had to be colour slides, were entered in 12 different categories which each carried a first prize of £500 and a runner-up prize of £250. Where competition was particularly fierce the judges awarded a specially commended, or third prize. Some of the photos that reached the final stages of the judging were highly commended. In addition, the Eric Hosking Award was given for the best portfolio of pictures by a photographer aged 26 years or under. The Gerald Durrell Award for Endangered Wildlife entered its second year commemorating Gerald Durrell's long-standing involvement with the competition and his work with endangered species. There was also a Young Wildlife Photographer of the Year Competition for photographers aged 17 years and under.

The winners gathered at The Natural History Museum in October for the presentation of the main awards and the official opening of the exhibition of winning and commended images. Three travelling sets of the exhibition tour the UK, visiting some 36 different galleries, museums and nature centres. Additional sets of the exhibition go on display in Australia, France, Germany, Holland, Japan and the USA.

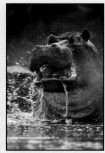

1991 Frans Lanting
The Netherlands

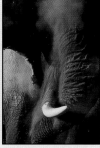

1992 André Bärtschi
Liechtenstein

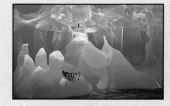

1993 Martyn Colbeck
United Kingdom

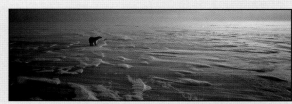

1994 Thomas D Mangelsen
United States of America

1995 Cherry Alexander
United Kingdom

7

Wildlife Photographer of the Year

The 'Wildlife Photographer of the Year' title was awarded for the single image judged to be the most striking and memorable of all the photographs entered for the competition. The 1996 winner Jason Venus, received the British Gas award - a bronze trophy of an ibis - and a cheque for £2,000.

Jason Venus

On leaving school, Jason Venus wanted to be an illustrator. He first held a camera in 1986 when he took a Youth Training Scheme course with a commercial photographer. Within a month, he had purchased his first camera and was hooked on photography. He learnt a great deal about lighting, perspective and composition. Taking wildlife photographs was a natural progression since he had always been fascinated by animals. Turning freelance in 1990 he won an award in the BBC Country File photographic competition. Since then he has worked on location, taking stills for wildlife film-makers who inspired Jason to take even more creative pictures. He continues to work both as a commercial and wildlife photographer. He specialises in back-lit subjects because he says "they always seem to have that extra bit of atmosphere".

Jason Venus
United Kingdom
WILDLIFE PHOTOGRAPHER
OF THE YEAR 1996

Badger running

"In the hot summer of 1995, the badgers in the Somerset group I watch regularly were coming above ground particularly early, from about 6.30 pm onwards. One of their paths led them across the head of a valley that has no cover. When they crossed this hundred metre stretch, they trotted to minimise the risk of being seen. The shot shows one of the younger badgers sprinting across, both to avoid being noticed and to catch up with another badger."

Nikon F90 with 70-210mm lens; 1/60 sec at f5.6; Fujichrome Provia 100

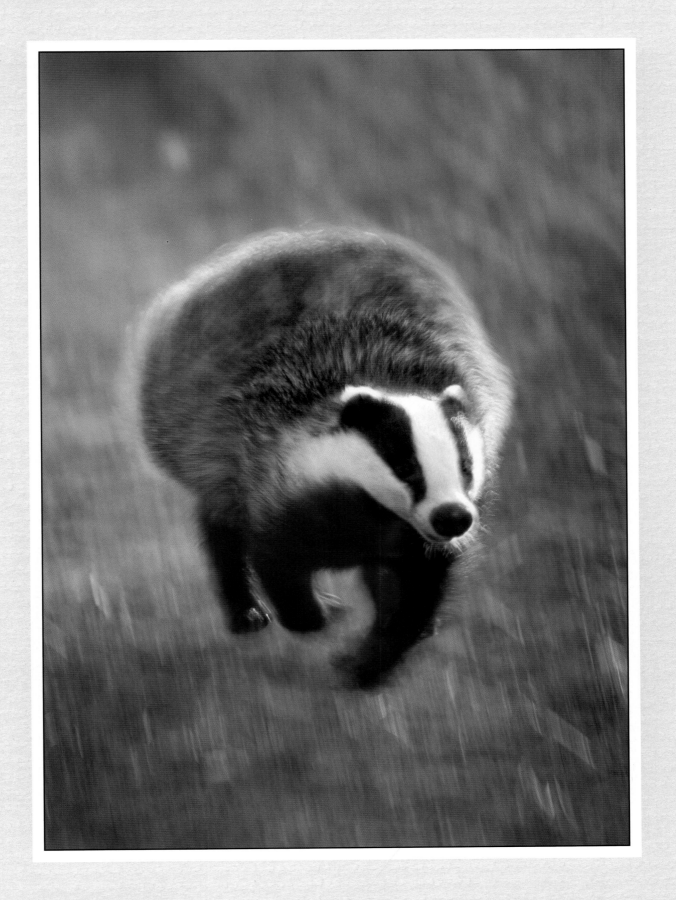

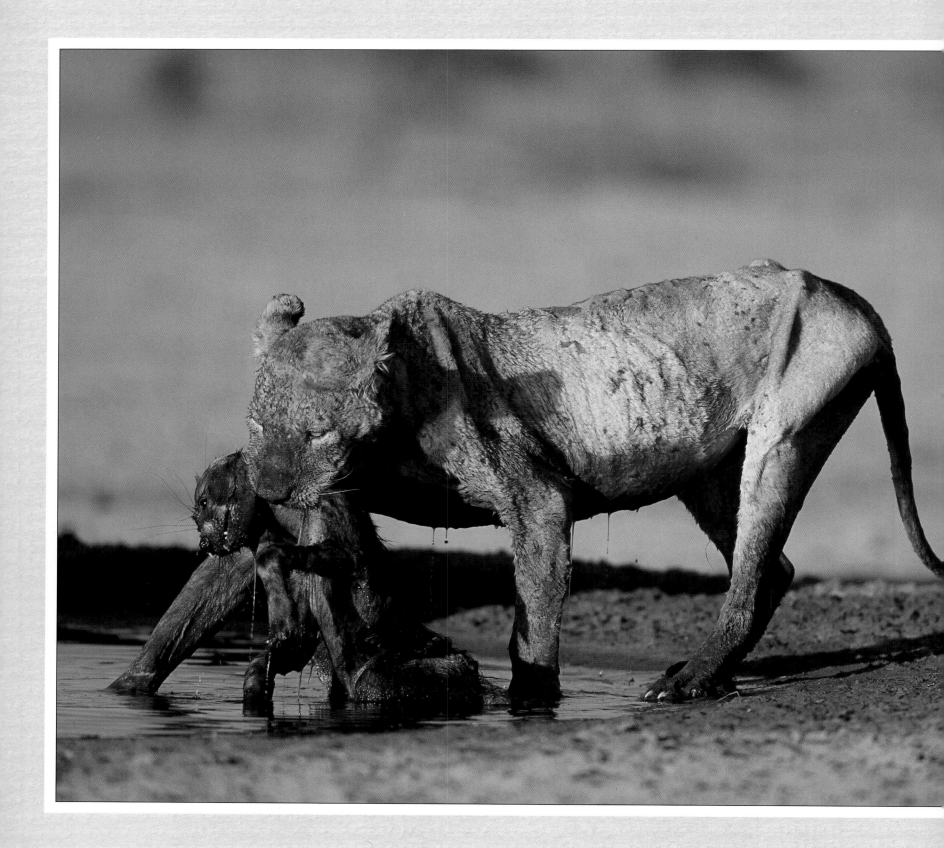

Animal Behaviour

- MAMMALS -

The photographs entered in this category should show the subject actively doing something. Pictures are judged on their interest value as well as their aesthetic appeal.

Adrian Bailey
South Africa
WINNER

Old lioness with brown hyena kill

"In the Kalahari Gemsbok National Park, we were waiting for this old lioness at a borehole, when a young brown hyena came to drink. The lioness stalked the hyena, eventually drowning it in the borehole's overflow, accompanied by a cacophony of howls and growls. When she tried to open the carcass, we noticed that her teeth were almost completely worn down. We never saw her again."

Nikon F90 with 500mm lens; beanbag; 1/400 sec at f4; Fujichrome Velvia rated at 40

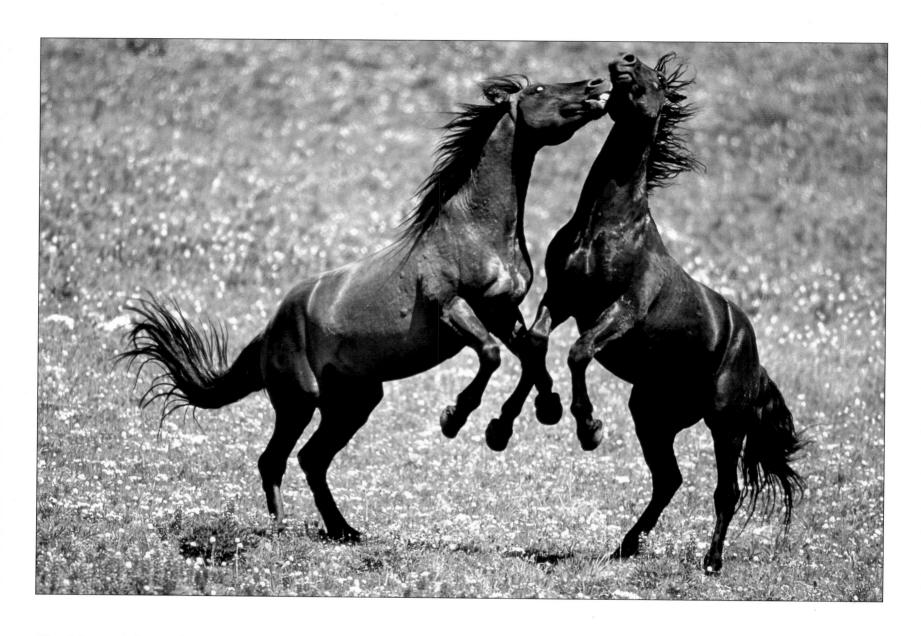

Yva Momatiuk & John Eastcott
USA / New Zealand
RUNNER-UP

Wild mustangs playing

"In the Montana Wild Horse Range, two
young stallions are play-fighting. The stallions
have been expelled from their own family
bands, having reached sexual maturity.
They are still too young and inexperienced
to have harems so live in bachelor bands,
grazing, sleeping and playing."

Canon EOS 1N with 600mm lens; Fujichrome Velvia

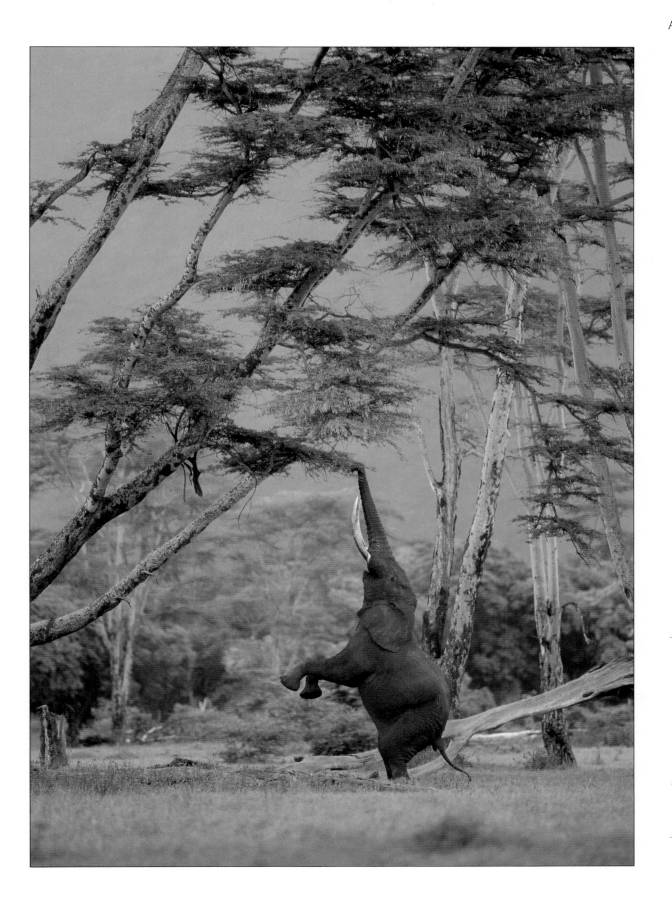

Ulrich Döring
Germany
HIGHLY COMMENDED

Elephant feeding on an acacia tree

"We spotted this elephant attempting to reach the high branches of a yellow-barked acacia in the Ngorongoro Conservation Area in Tanzania. The late afternoon light brought out the colours of the tree bark. Living in Tanzania gives me ample opportunities to explore my interest in photographing wildlife in natural light."

SLR with 300mm lens; f2.8; tripod; professional film 50 rated at 40

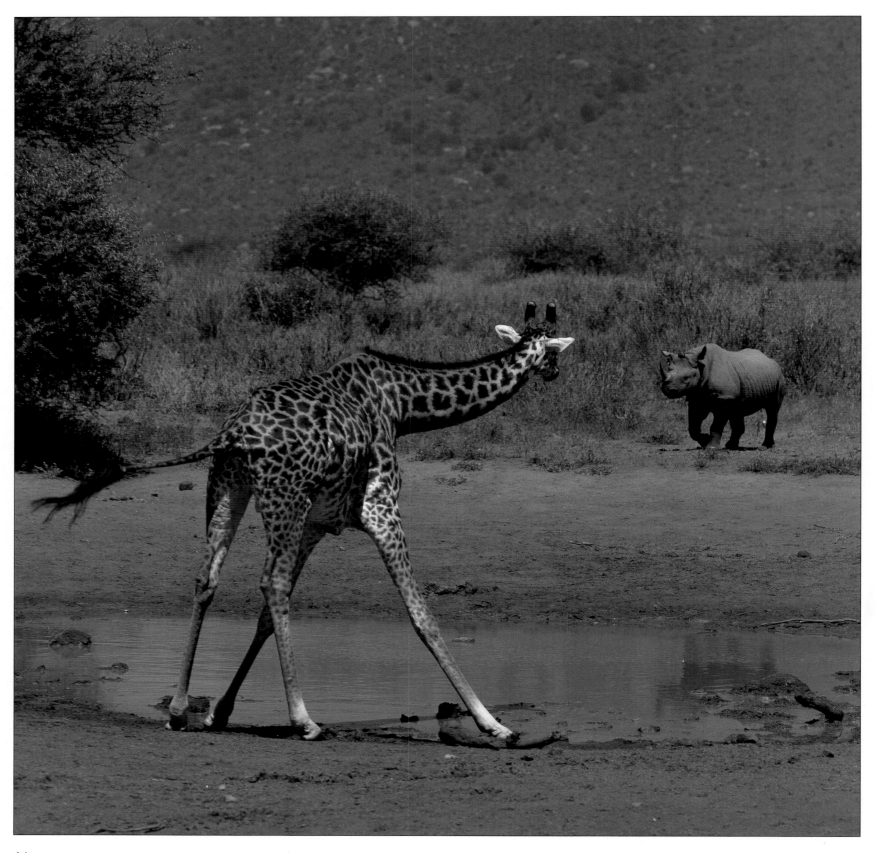

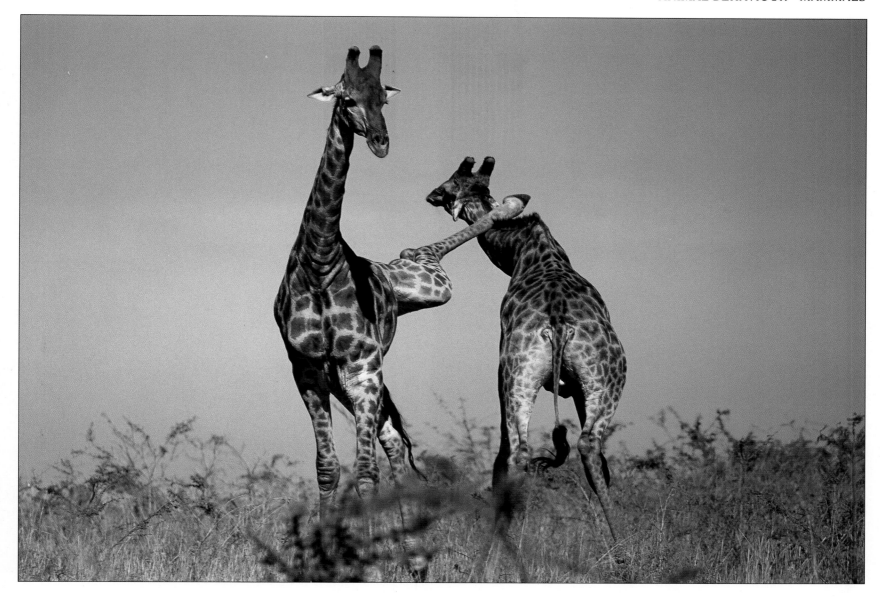

Wolfgang Schweden
Germany
HIGHLY COMMENDED

Giraffe and rhino at a waterhole
"We were watching some giraffes drinking at a waterhole in Tsavo West, Kenya when a white rhino suddenly appeared. The rhino intended to drink but a big elephant chased it away. The giraffe interrupted its drinking to watch the action."

Pentax 67 with 300mm lens; 1/500 sec at f5.6; Fujichrome Provia 100

Luiz Claudio Marigo
Brazil
HIGHLY COMMENDED

Giraffes
"A dominance hierarchy is established between male giraffes so that serious fighting is rare unless a new male enters the area. Mature males assess each other's status by standing tall while younger males often neck-wrestle."

Nikon F3HP with 500mm lens; 1/500 sec at f8; Fujichrome Velvia rated at 64

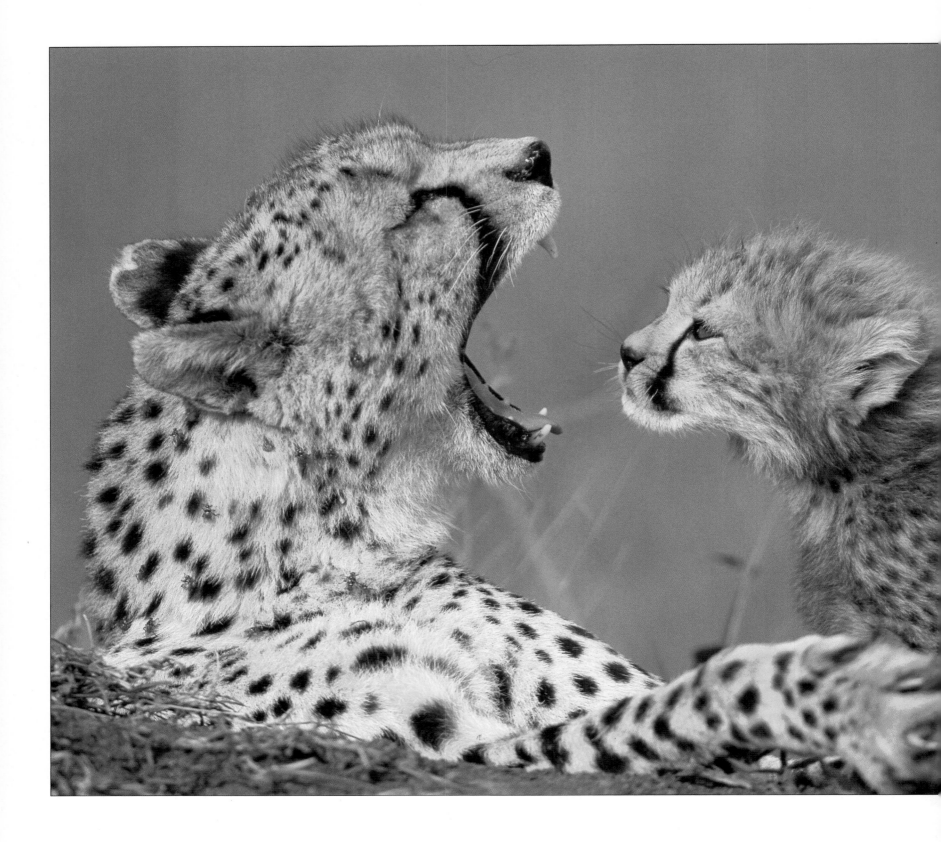

Martyn Colbeck
United Kingdom
HIGHLY COMMENDED

Anup Shah
United Kingdom
HIGHLY COMMENDED

Cheetah yawning

"In the soft evening light, I photographed this cheetah mother and one of her four cubs on a mound in the Maasai Mara. After yawning, she stretched her body before setting off to hunt."

Canon EOS 1 with 600mm lens; 1/125 sec at f5.6; Fujichrome Velvia

Bonobo resting in rainforest canopy

"During the heat of the day, Mon an adult male bonobo, rested in a small day nest he had made in the crown of a tree. He was one of the more relaxed, and to my mind the best looking bonobo in the group I'd been filming in Central Zaire. I took the picture from a tower made by local people just after a rain storm as the watery light lit Mon's face."

Canon EOS 1 with 300mm lens; Fujichrome Provia 100

17

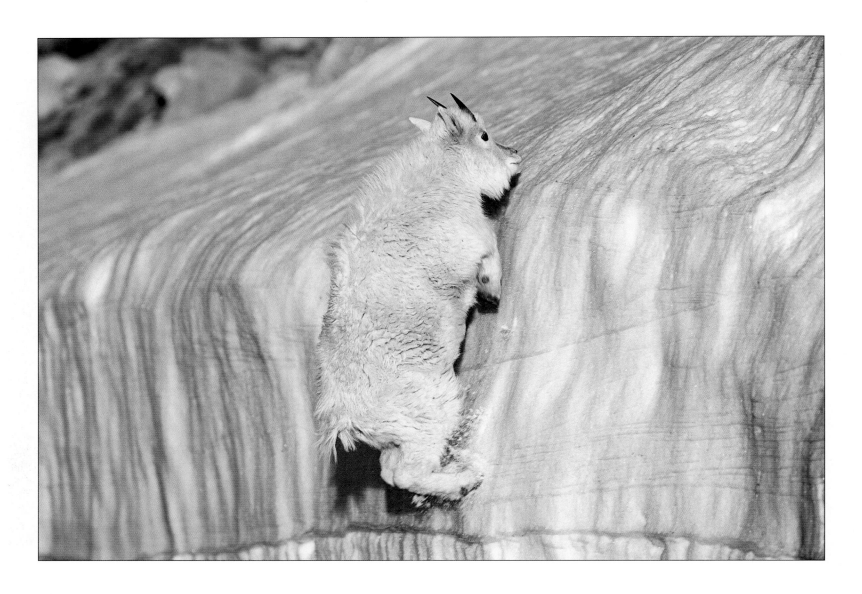

**Wendy Shattil
& Bob Rozinski**
United States of America
HIGHLY COMMENDED

Mountain goat scaling snow face

*"Normally most of the snow disappears from
Mount Evans, Colorado by July but 1995
was unusual. Large snowfields remained at
4,000 metres where this photograph was
taken. Mountain goat yearlings are adept at
scaling the snow and rock. They climb
seemingly impossible obstacles."*

Canon EOS 1N with 70-200mm lens and x1.4
teleconverter; 1/250 sec at f11; Fujichrome Velvia

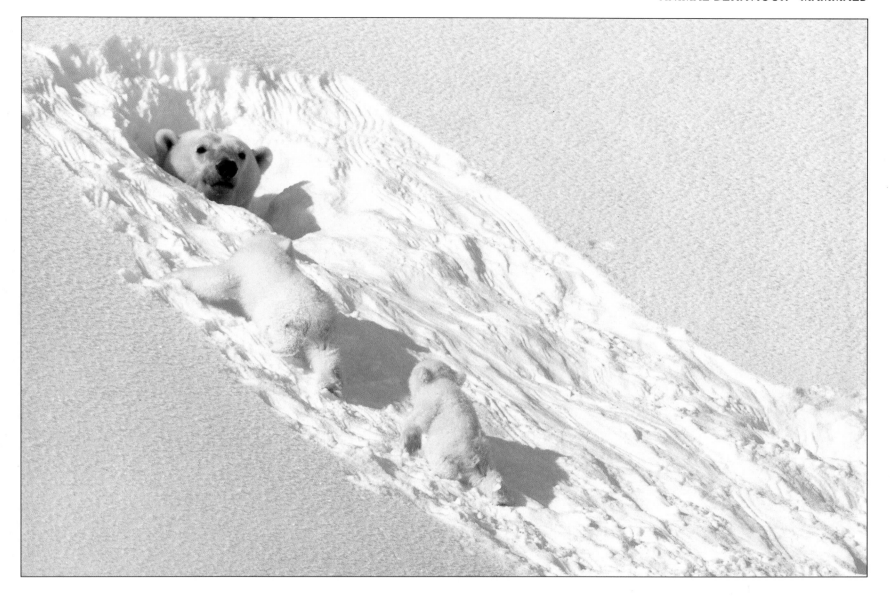

Kennan Ward
United States of America
HIGHLY COMMENDED

Polar bears at their den

"At Wrangel Island, Siberia, in March two polar bear cubs return to their den while the mother bear keeps a look-out at the den's entrance. This is their first excursion from the den since their birth in early January."

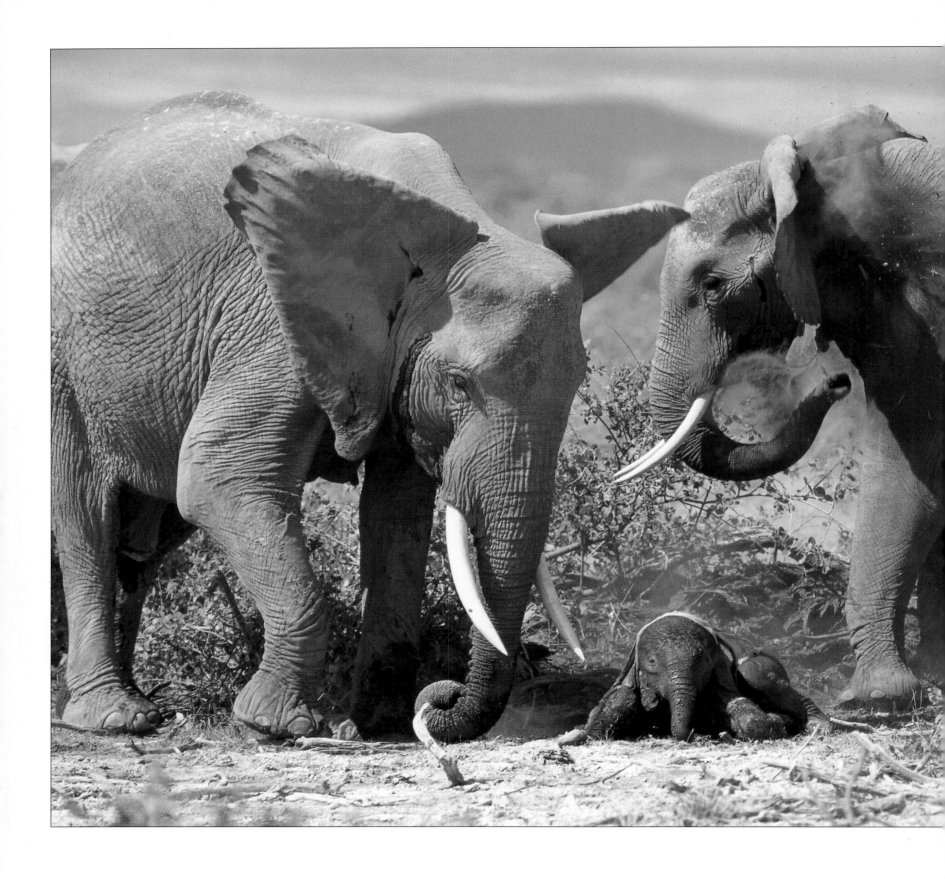

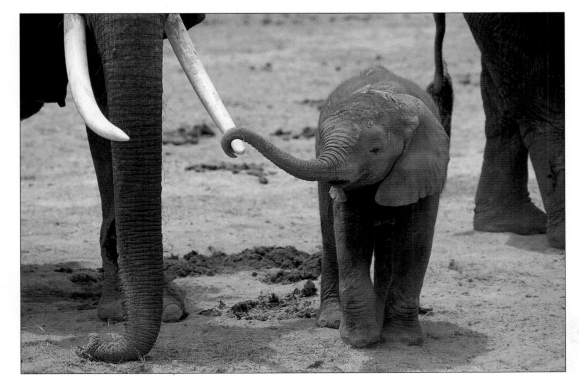

Konrad Wothe
Germany
HIGHLY COMMENDED

African elephants with newborn
"In Amboseli National Park, I was watching a group of elephants that seemed very excited. They were trumpeting and flapping their huge ears. When I got closer, I discovered the reason for the excitement, a newborn. The mother (on the left) tried to help it onto its feet by pushing gently with one foot. In less than an hour the youngster had managed to stand up."

Canon EOS 1N with 300mm lens; 1/400 sec at f4; Fujichrome Sensia 100

Daniel J Cox
United States of America
HIGHLY COMMENDED

Baby elephant holding mother's tusk
"This mother and baby were photographed in Amboseli National Park. Both of them were standing at rest in the middle of the day. Baby elephants like to get reassurance by touching their mothers."

Nikon N90s with 300mm lens; beanbag; Fujichrome Velvia

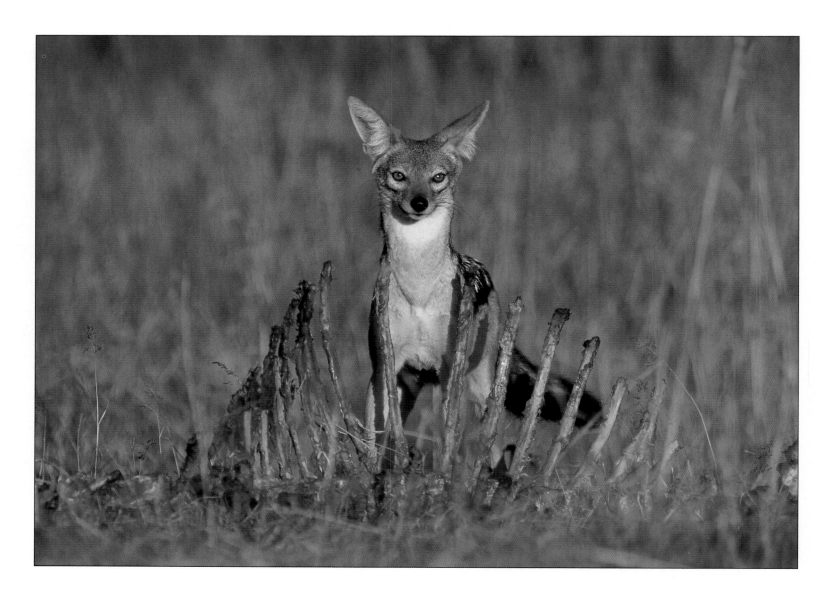

Gabriela Staebler
Germany

HIGHLY COMMENDED

Jackal defending kill

"One morning in the Maasai Mara, I waited
to see what would come to feed on the bloody
skeleton of a wildebeest. This black-backed
jackal arrived but it couldn't feed since it was
too busy guarding the food from vultures.
After half an hour, the jackal gave up and
the vultures took over the kill."

Canon EOS 1 with 300mm lens; Fujichrome 100

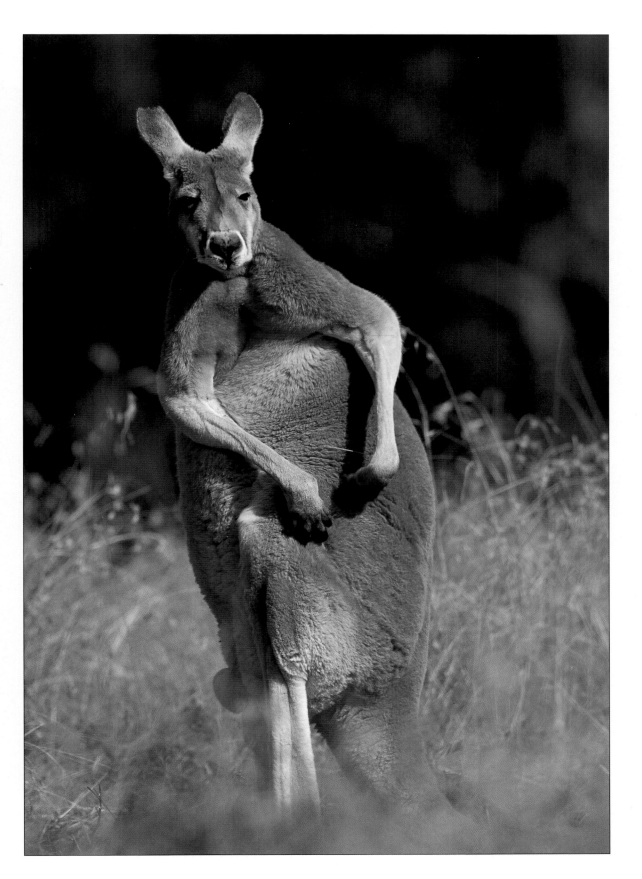

Martin Harvey
South Africa
HIGHLY COMMENDED

Red kangaroo scratching

"In the wilds of Australia, I was photographing red kangaroos while they were feeding. Every so often, an individual would stop to scratch. It looked so human and rather funny, so I spent some time trying to get pictures of this behaviour."

Canon EOS 1 with 300mm lens; tripod; Fujichrome Velvia

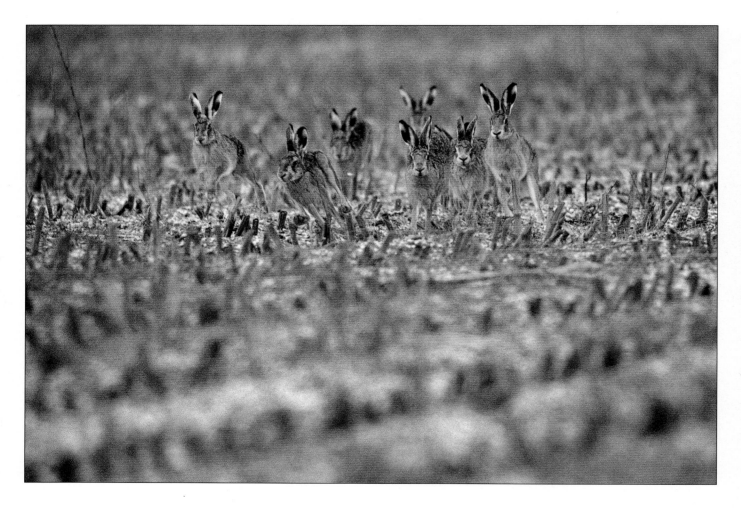

Rupert Büchele
Germany
HIGHLY COMMENDED

Wild hares in a panic

"Over a period of some weeks, I watched the behaviour of hares during the mating season. One morning several hares gathered about two hundred metres away. Suddenly, the hares began to panic because they sensed people in the distance. They ran directly towards my hiding place which is when I took the picture."

Nikon F4 with 300mm lens and x2 teleconverter; tripod; 1/125 sec at f5.6; Kodachrome 200

Richard du Toit
South Africa
HIGHLY COMMENDED

Impala ewe

"Impala often leap up to three metres into the air when fleeing from predators, but on this occasion at the Mala Mala Game Reserve, South Africa, some of the herd were simply racing around in circles and apparently enjoying themselves."

Nikon 801s with 500mm lens; 1/500 sec at f4; Fujichrome 100

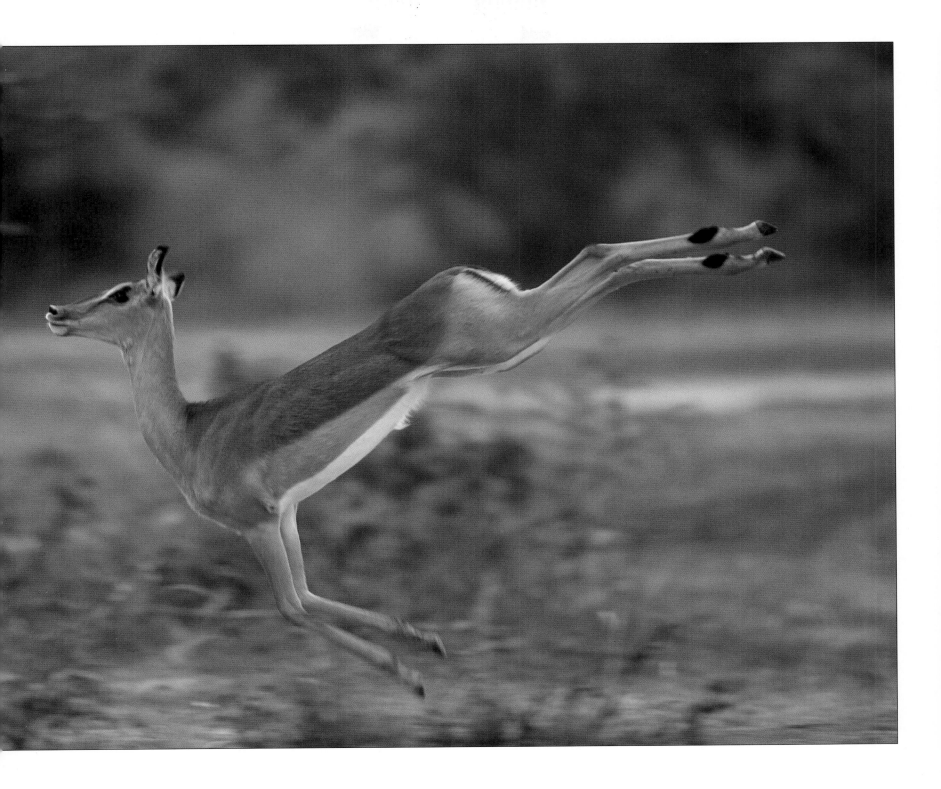

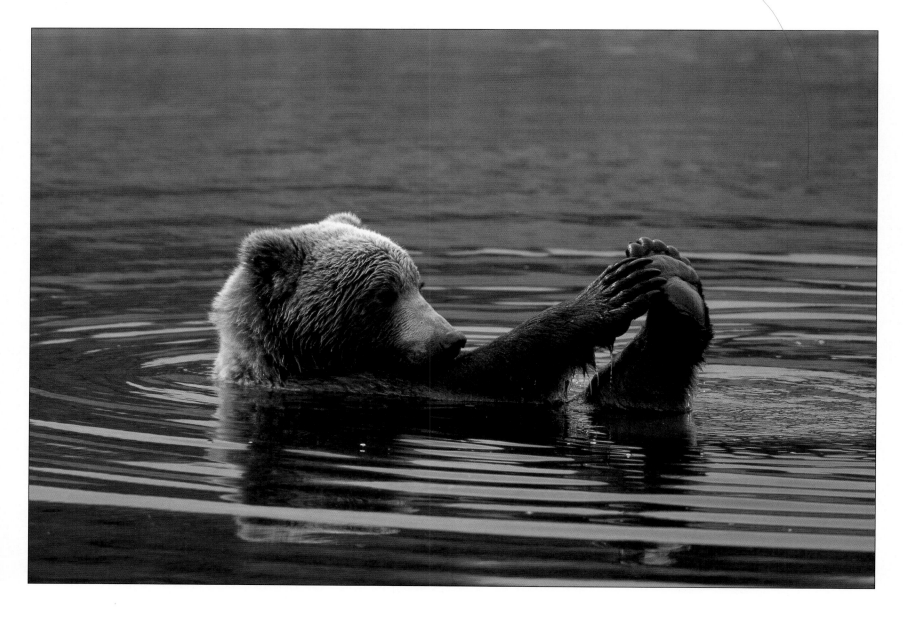

Greg Pierson
United States of America
HIGHLY COMMENDED

Brown bear playing with its foot

"The McNeil River Sanctuary in Alaska
contains the world's highest concentration of
brown bears during the annual salmon run.
Supervised access to the sanctuary provides a
unique opportunity for visitors to safely view
and photograph the bears."

Canon EOS 1 with 500mm lens; Fujichrome Provia 100

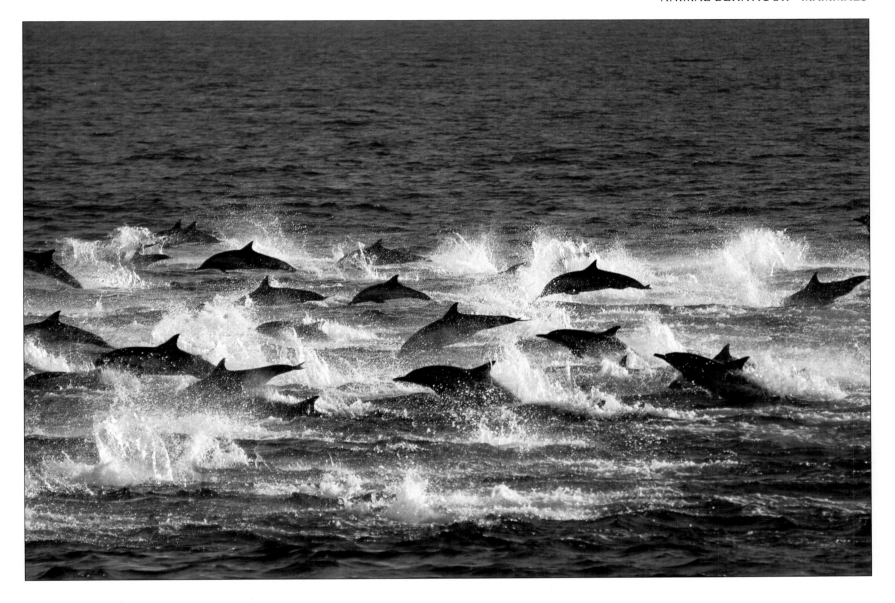

George D Lepp
United States of America
HIGHLY COMMENDED

Dolphins leaping

"This photograph was taken while leading a photography group in the Sea of Cortez, off Baja California. The large pod of common dolphins suddenly formed a tight group and increased their speed. This behaviour lasted for about ten minutes then the pod spread out and moved on again at a leisurely pace."

Canon EOS 1N with 35-300mm lens; 1/500 sec at f8

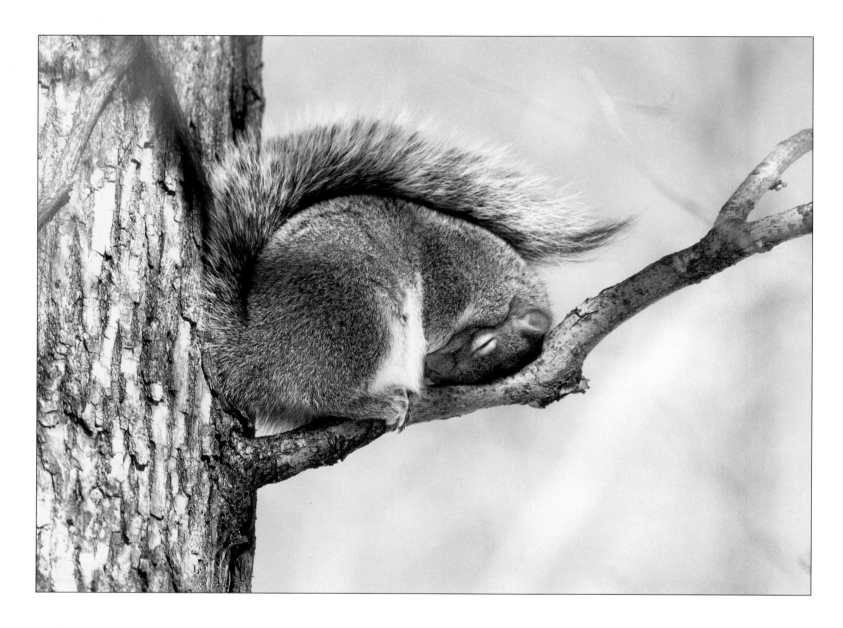

Philippe Henry
France
HIGHLY COMMENDED

Grey squirrel sleeping

"In November 1995 the first snow in Quebec, Canada, came with very cold temperatures. The Eastern grey squirrels already had their coats of thick fur. When the wind blew harshly, the squirrels used their thick tails like a blanket to keep warm."

Canon EOS 1 with 300mm lens and x1.4 converter; tripod; 1/250 sec at f8; Fujichrome Velvia

Ingrid van den Berg
South Africa
HIGHLY COMMENDED

Ground squirrels playing

"We watched these little creatures of the semi-desert for hours in the Kalahari Gemsbok National Park. On this occasion their play included rolling around, mock fighting and chasing each other. It was fun to watch but their erratic movements were tricky to capture on film."

Canon T90 with 500mm lens; Fujichrome Velvia

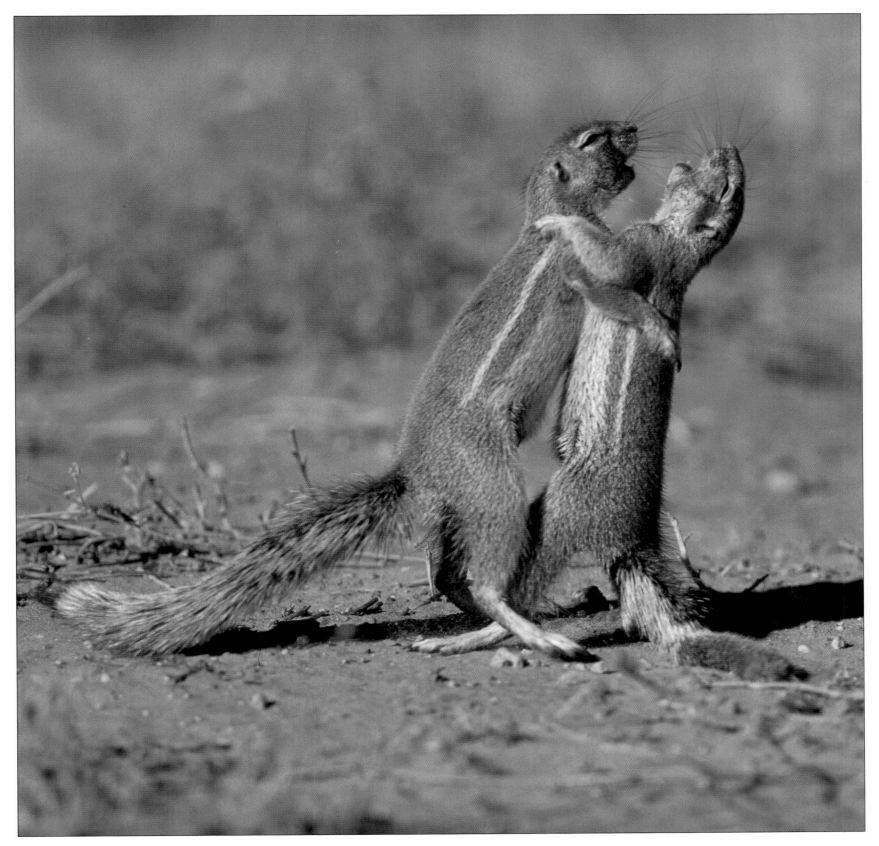

Animal Behaviour

- BIRDS -

The birds should be actively doing something. Pictures are judged on their interest value as well as their aesthetic appeal.

Derrick Hamrick
United States of America
WINNER

Young wood duck

"It took days of preparation to capture this shot of a young wood duck leaping from its nest hole. I had to calculate the distance the duckling would travel after it broke an infrared beam before firing the camera and flashes. I had experimented with the equipment for the past three seasons before finally getting the image I wanted on film this year."

Nikon F4 with 500mm lens; four flashes; tripod; 1/250 sec at f8.5; Kodak Elite 100

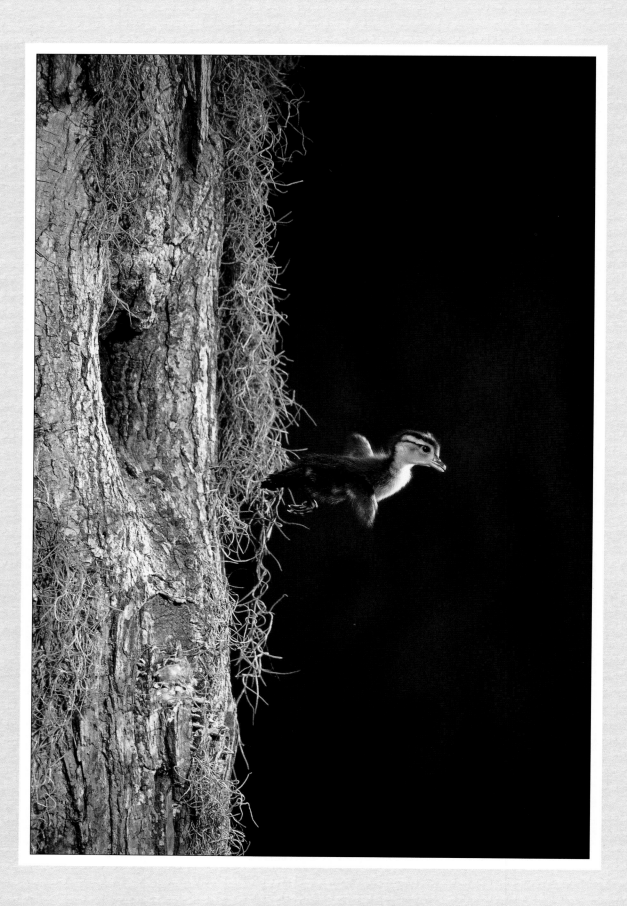

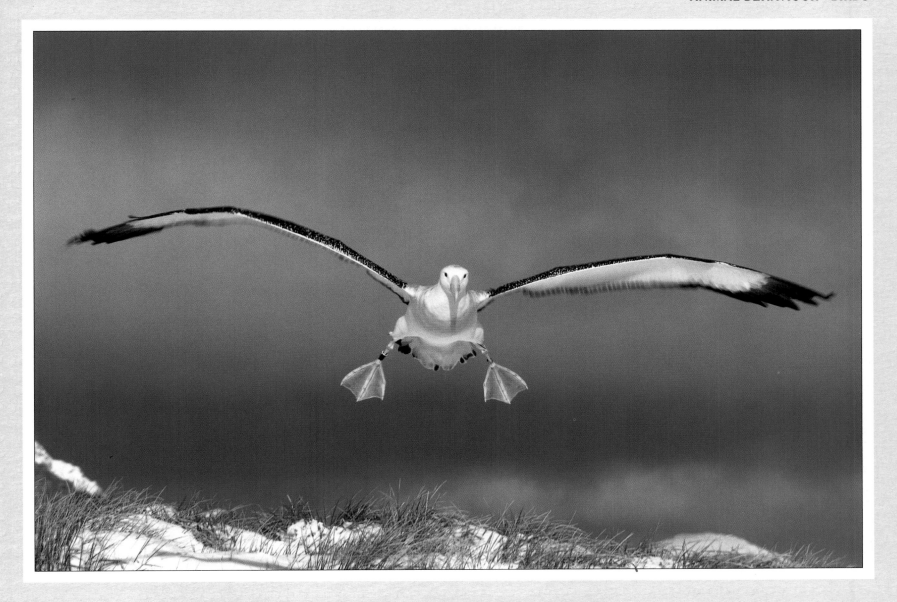

Norman Cobley
United Kingdom
RUNNER-UP

Wandering albatross landing

*"An adult male wandering albatross arrives
back at the nest to feed it's chick at Bird
Island, South Georgia. The albatross had
spent the previous two to three weeks on a
foraging trip, which may have taken it as far
as the coast of South America, a round
trip of 2000 kilometres."*

Nikon F-801 with 70-210mm lens; UV filter;
Kodachrome 64

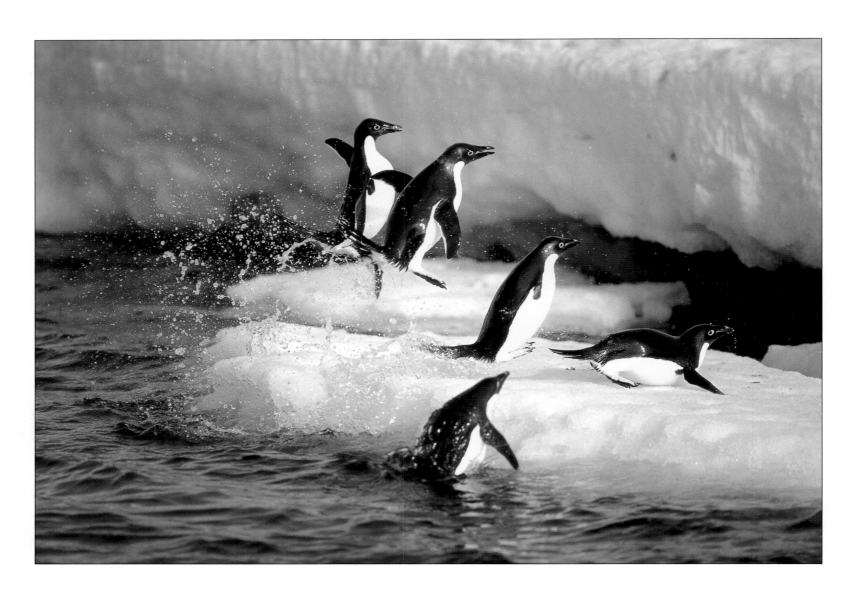

Tom Schandy
Norway
SPECIALLY COMMENDED

Adelie penguins leaping onto an ice floe

"On a visit to an Adelie penguin rookery on the Antarctic Peninsula, I noticed a group of penguins sitting on an ice floe. Suddenly, one by one, they dived into the water. They swam around at high speed, porpoising like dolphins. After a few minutes, the group leapt back onto the ice floe in great style. They repeated the whole show several times."

Nikon F90 with 300mm lens

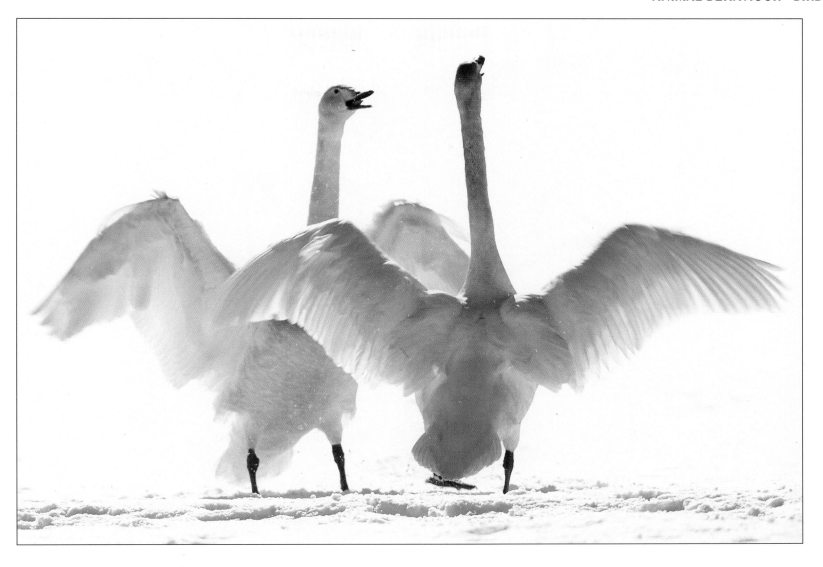

Hannu Hautala
Finland

HIGHLY COMMENDED

Swan pair

"For three years now, I have followed this pair of whooper swans when they come to breed in a swamp in north-east Finland.
I waited in a hide for more than a day to get this picture of the pair keeping guard near their nesting territory. The pair got very excited when a strange pair of whooper swans flew over."

Canon EOS 1N with 600mm lens and x1.4 teleconverter; tripod; hide; 1/750 sec at f6; Fujichrome Velvia

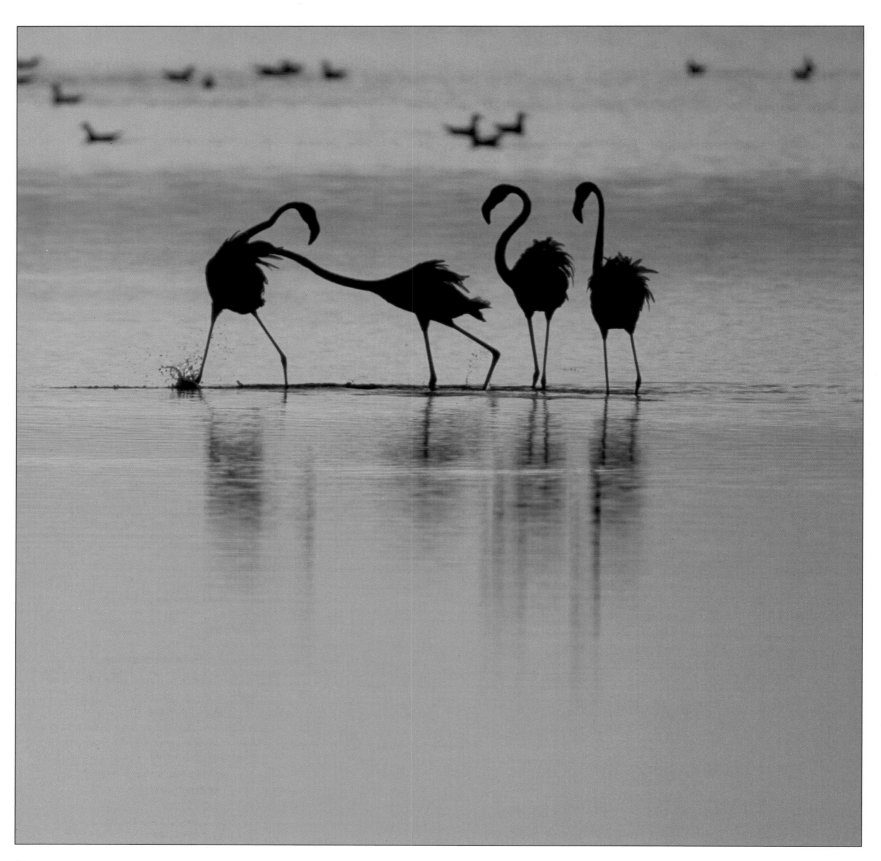

Mike Hill
United Kingdom
HIGHLY COMMENDED

Greater flamingo dispute

"These flamingos are part of a resident flock in Bahrain that live in the tidal area near an oil refinery. I often go and watch them in the late afternoon. On this occasion the water was very still. Some birds were just preening while others were still feeding. Two birds in this group began to fight."

Nikon F4 with 600mm lens and x1.4 teleconverter; car mount and ballhead; Fujichrome Sensia 100

Norbert Rosing
Germany
HIGHLY COMMENDED

Hummingbird and cactus blossom

"The cardon cacti were in flower during my visit to Isla Catalan in Baja California. By using a high shutter speed I was able to capture a picture of a Costa's hummingbird as it approached a flower to feed."

Leica R7 with 400mm lens; 1/1000 at f2.8; Fujichrome Velvia 50

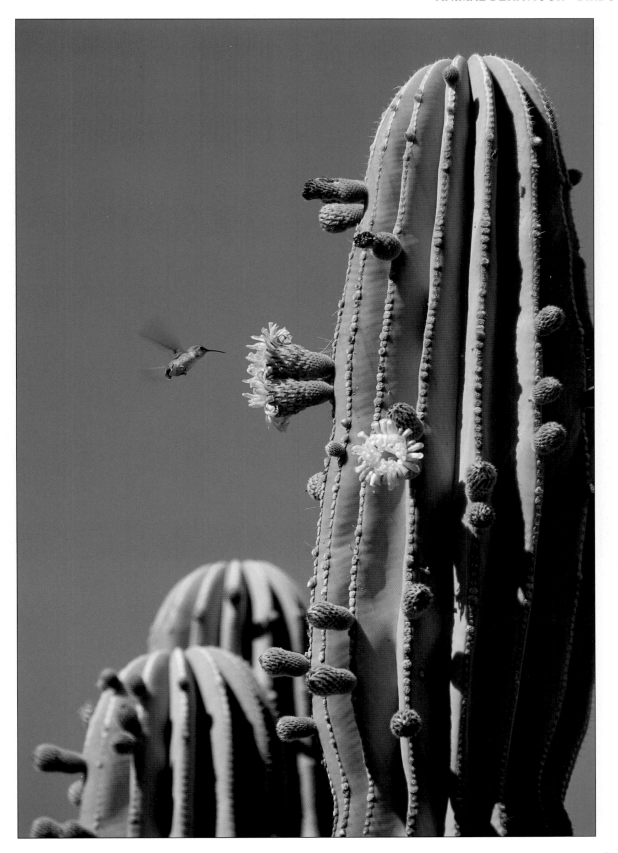

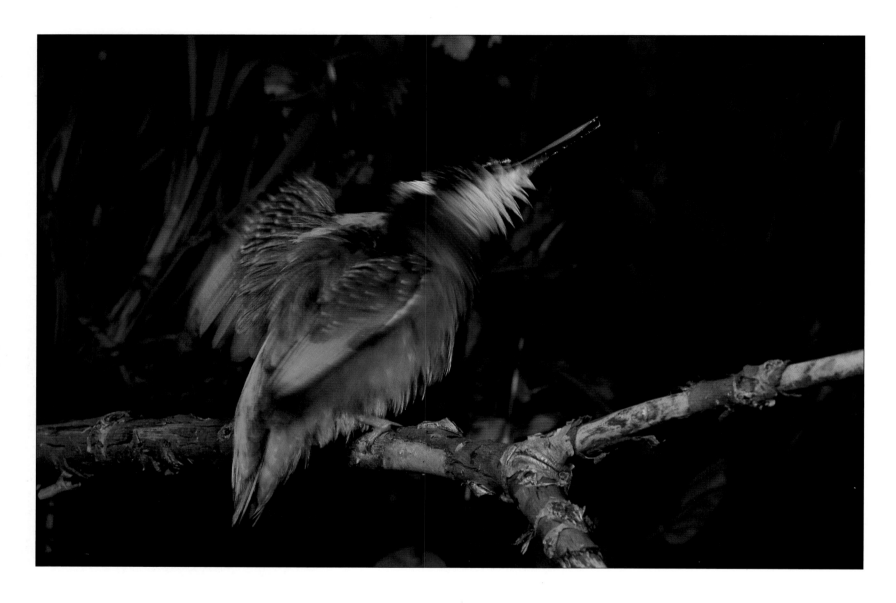

Dave White
United Kingdom
HIGHLY COMMENDED

Kingfisher shaking off water

"As a keen angler, I have often seen
kingfishers and one has even perched on my
rod. Over the past three years, I have taken
many photographs of kingfishers but
I remember this occasion well because a mink
moved upstream and passed right under the
bird's burrow in the river bank."

Nikon F-801s with 75-300mm lens; hide; tripod; twin
flash; 1/250 sec at f22;
Fujichrome Velvia rated at 40

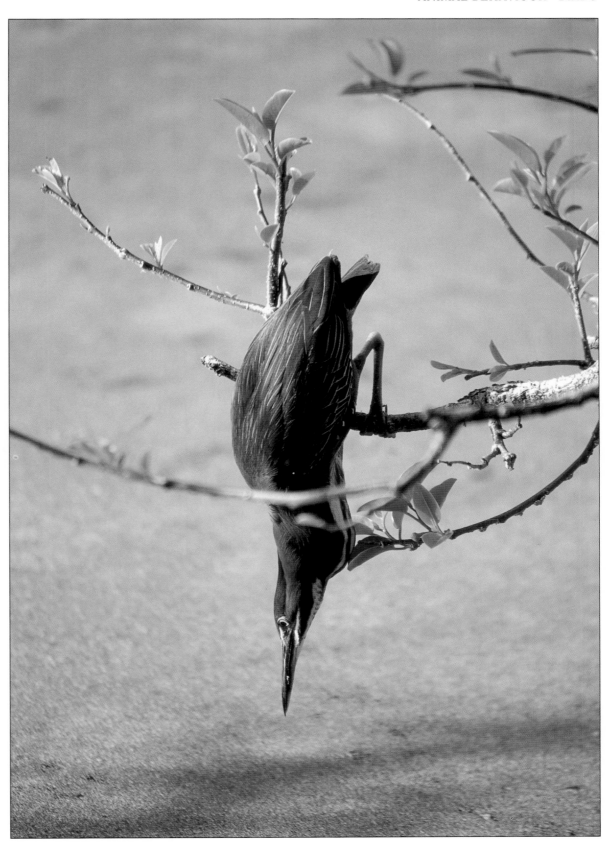

Dr Mamoru Yoshida
United States of America
HIGHLY COMMENDED

Green heron fishing

"Early one morning I saw this green heron fishing in the Loxahatchee National Wildlife Refuge in Florida. I sneaked up closer with my camera on its tripod. As the bird was almost back-lit by the morning light, I used a flash to bring out the colours on its neck and back, and to give a little sparkle to its eye."

Canon EOS A2 with 100-300mm lens; tripod; flash;
1/125 sec at f5.6; Ektachrome Elite 100

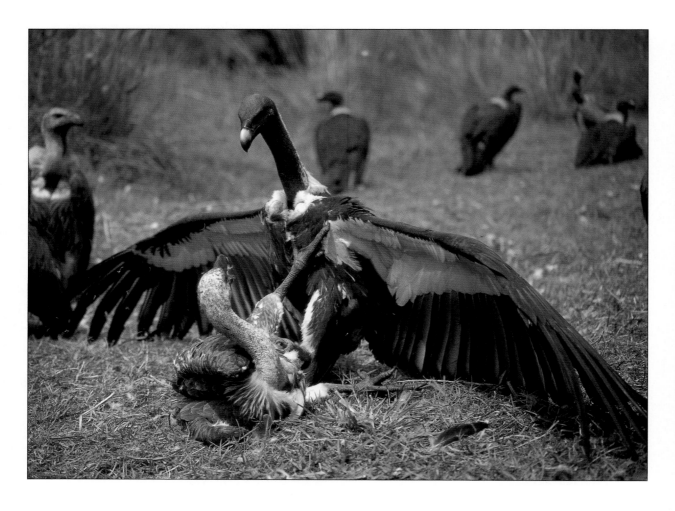

Axel Gomille
Germany
HIGHLY COMMENDED

Vultures fighting

"These white-backed vultures were fighting over the carcass of a cow that had barely died in Keoladeo Ghana National Park, India. The birds were so hungry, they did not care about my presence so I could even use a short lens."

Nikon F-801s with 70-210mm lens; shoulderpod; 1/500 sec at f5.6; Fujichrome Velvia

Jill Sneesby & Barrie Wilkins
South Africa
HIGHLY COMMENDED

Bateleur and wildebeest

"Each day that we were in the Kalahari Gemsbok National Park, the bateleur eagles came down to drink. One plucky bird stood its ground when a herd of wildebeest came to quench their thirst. Only when the wildebeest came right up to the bateleur, did it fly away."

Canon EOS 1 with 600mm lens; car cambrac; Fujichrome Provia 100

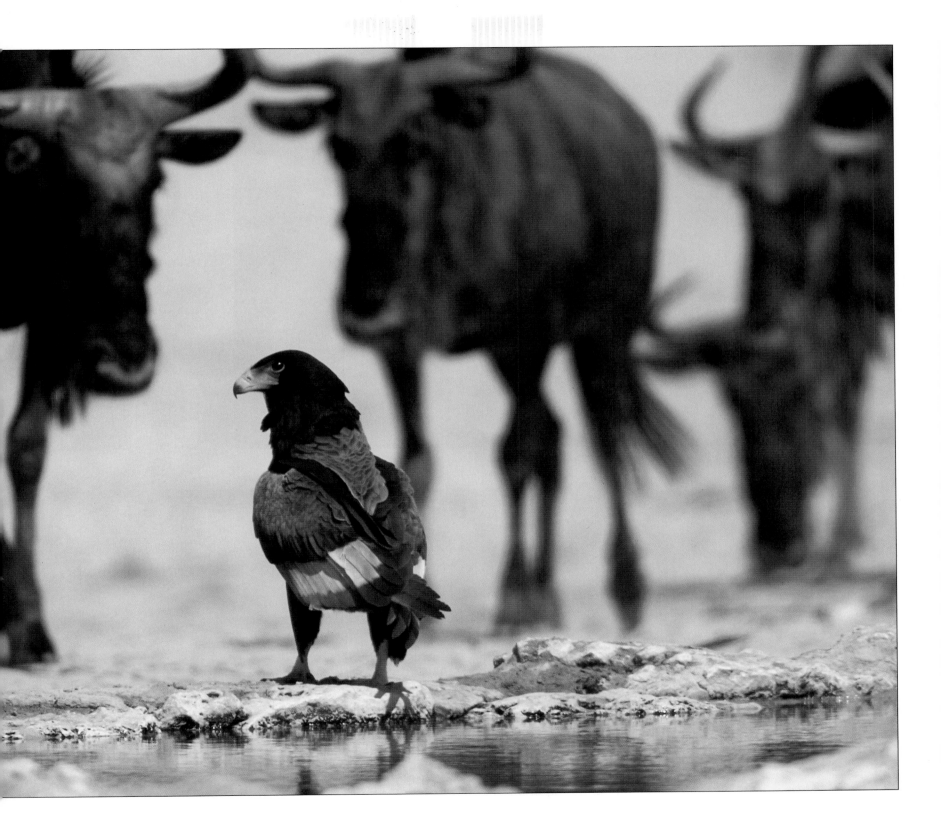

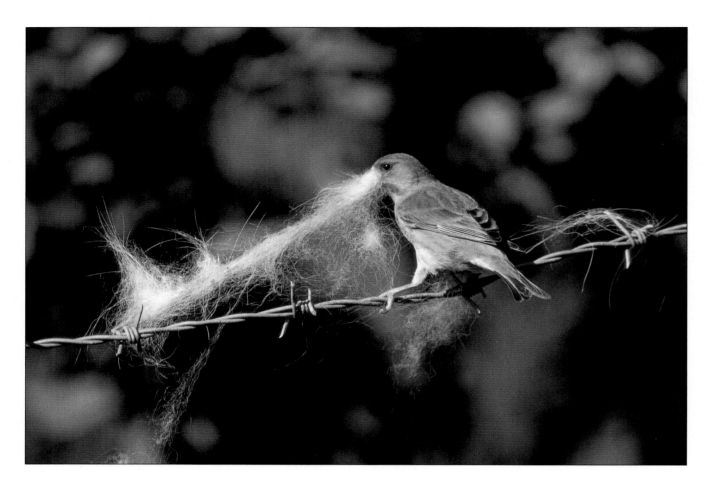

Bob Glover
United Kingdom
HIGHLY COMMENDED

Greenfinch collecting fur

"This female greenfinch was collecting fur to line her nest. During the last stage of nest-making, the pair are always together but the male does not help out. Instead he perches nearby keeping guard."

Nikon F-601 with 600mm lens; tripod; hide; 1/500 at f5.6; Kodachrome 200

Manfred Klindwort
Germany
HIGHLY COMMENDED

Greylag goose landing on ice

"I was photographing birds that were attracted to a frozen pond that had a break in the ice. It was minus 10°C and I had been out for five hours, when this goose landed and slid directly towards me."

Canon EOS 1N with 500mm lens; tripod; 1/400 sec at f5.6; Fujichrome Sensia 100

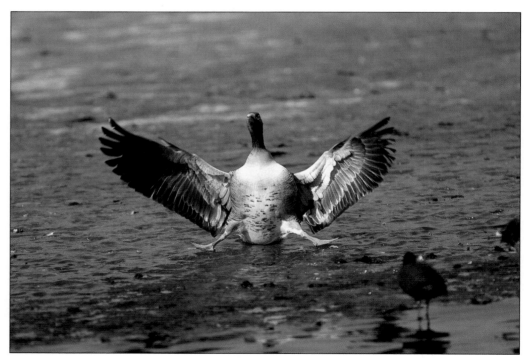

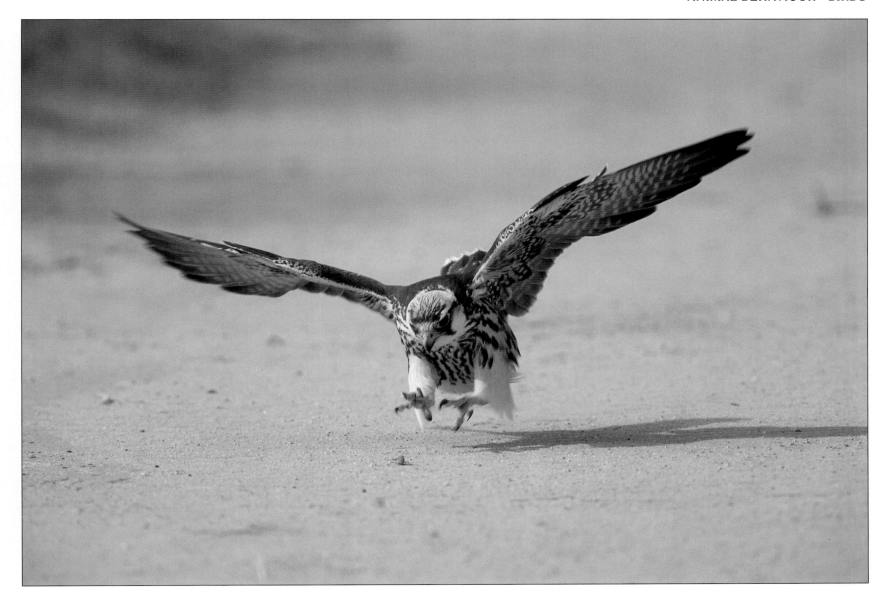

Adrian Bailey
South Africa
HIGHLY COMMENDED

Lanner falcon catching locust

"Just south of Kannaguas borehole in the Kalahari Gemsbok National Park, we came across several columns of locust hoppers crossing the road. This immature falcon ran and flew, back and forth, catching and eating locusts continuously for forty-five minutes."

Nikon F90 with 500mm lens and x1.4 converter; beanbag; 1/400 sec at f5.6; Fujichrome Velvia

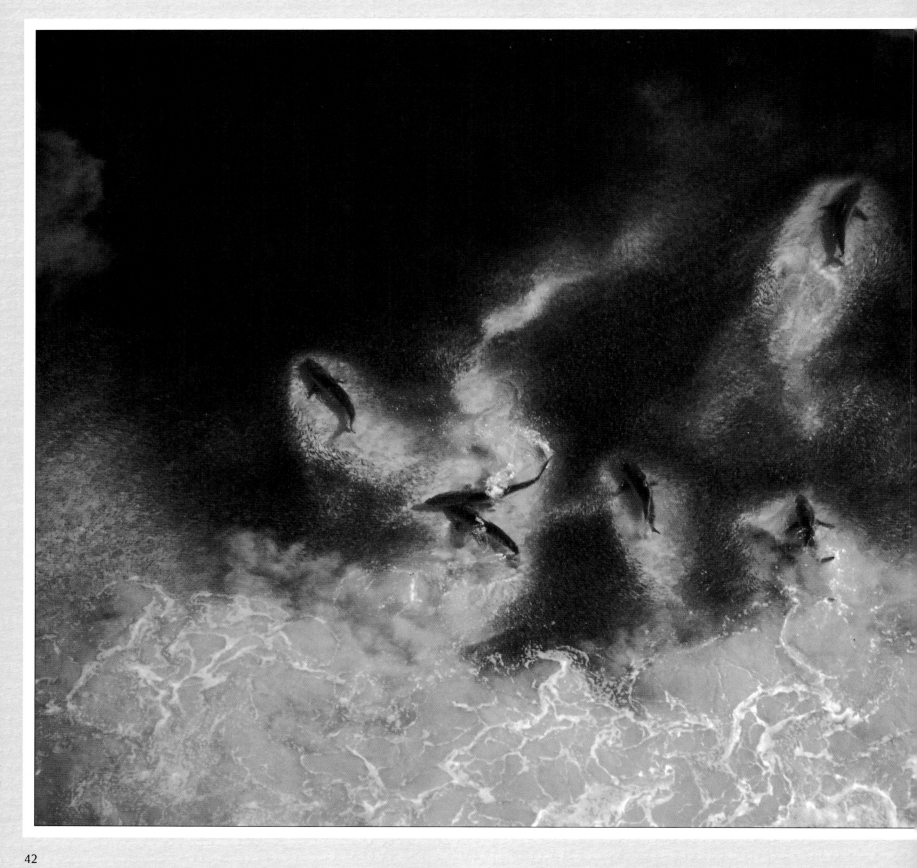

Animal Behaviour

- ALL OTHERS -

The photographs entered in this category should show the subject actively doing something. Pictures are judged on their interest value as well as their aesthetic appeal.

Patrick Baker
Australia
WINNER

Sharks feeding on anchovies

"From the high cliffs at Cape Cuvier, Western Australia, in 1993 a huge shoal of anchovies were spotted being fed on by whales and hundreds of sharks. The shoal continued to pass through, albeit in reduced numbers, for almost two months. I took this photograph when the shoal had thinned out. The 'holes' made by the anchovies escaping the sharks were then more clearly defined."

Olympus Om4 with 80-210mm lens; polarizing filter; Agfa RS100

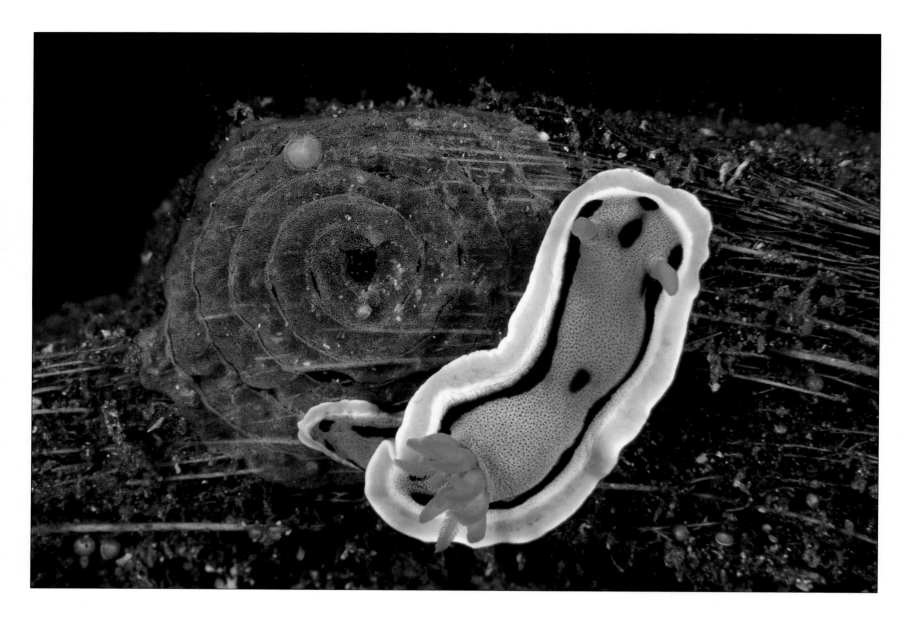

Larry P Tackett
United States of America
RUNNER-UP

Sea slug laying an egg ribbon

"Diving in Lembeh Strait, Sulawesi, I came across this nudibranch laying its spiral transparent egg ribbon on a coconut husk. Each tiny point in the ribbon is a single egg."

Nikon F-801 with 105mm macro lens in underwater housing; twin strobes; 1/60 sec at f16; Fujichrome Velvia

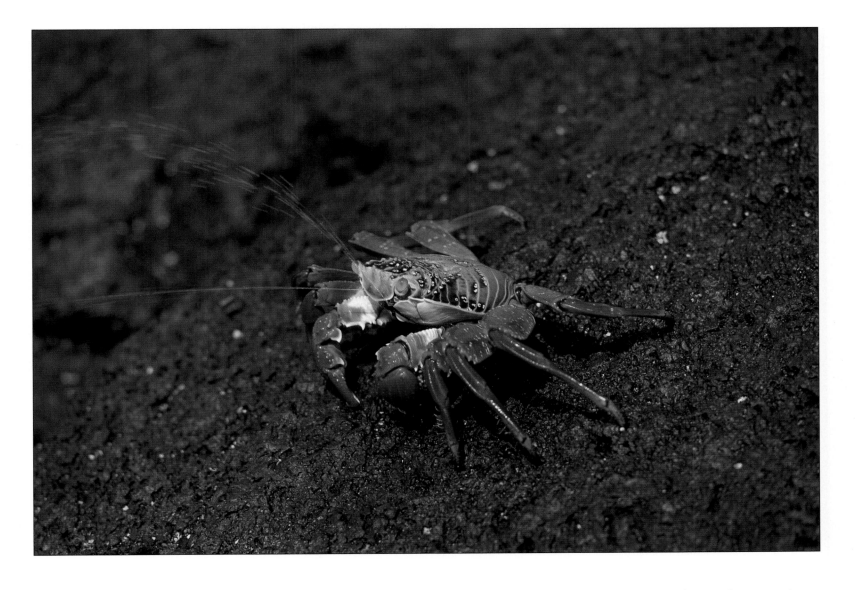

José Luis Gómez de Francisco
Spain
HIGHLY COMMENDED

Sally lightfoot crab squirting water

"On a trip to the Galapagos, I saw many of these most beautiful crabs on the black rocks of Santiago Island. When I began to take photographs, I realized that this one was squirting water. They do this to regulate their internal water balance."

Nikon F-801 with 105mm macro lens; tripod;
Fujichrome Velvia

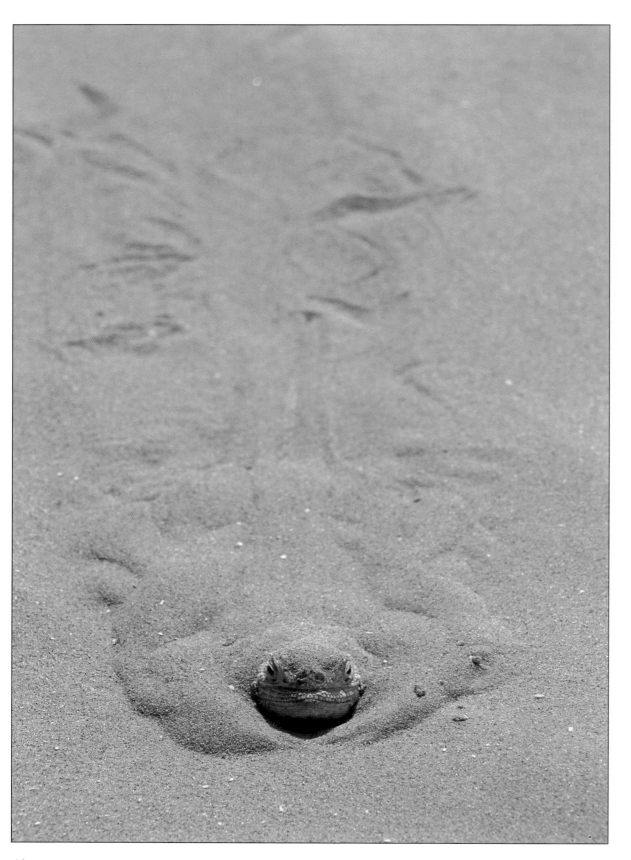

Mirko Stelzner
Germany
HIGHLY COMMENDED

Lizard under the sand

"The toad-headed agamid lizard from central and south-west Asia avoids predators by submerging rapidly into the sand. The lizard sinks vertically downwards by wiggling its body from side to side. When hunting insects, these lizards sit out in the sun and wait for prey to pass by."

Nikon F4 with 105mm lens; Fujichrome Velvia

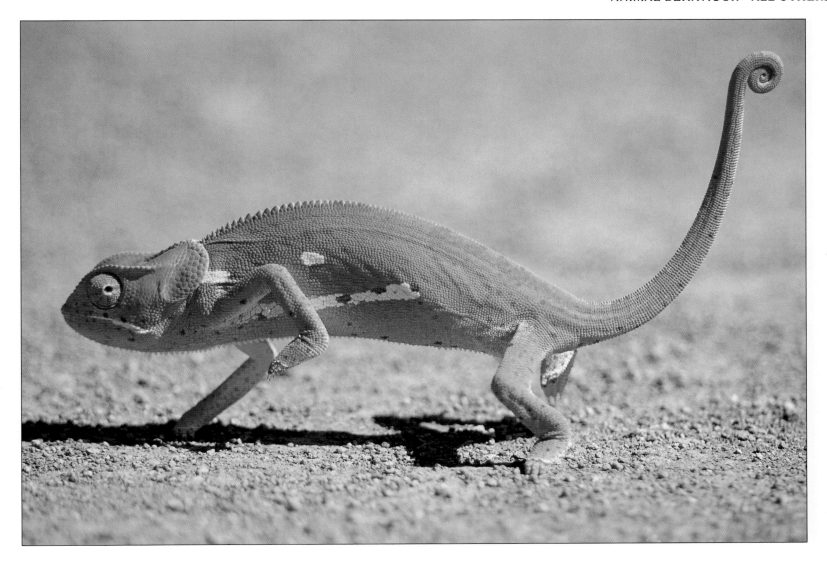

Rita Meyer
South Africa
HIGHLY COMMENDED

Chameleon crossing the road

"In Kruger National Park, we noticed a number of chameleons crossing the roads and quickly disappearing into the lush grass. This one remained like a statue in the middle of the road. It only just escaped being run-over because I used hand-signals to stop an approaching car."

Nikon F90 with 300mm lens and x1.4 teleconverter; flash; 1/250 sec at f5.6; Fujichrome Velvia rated at 40

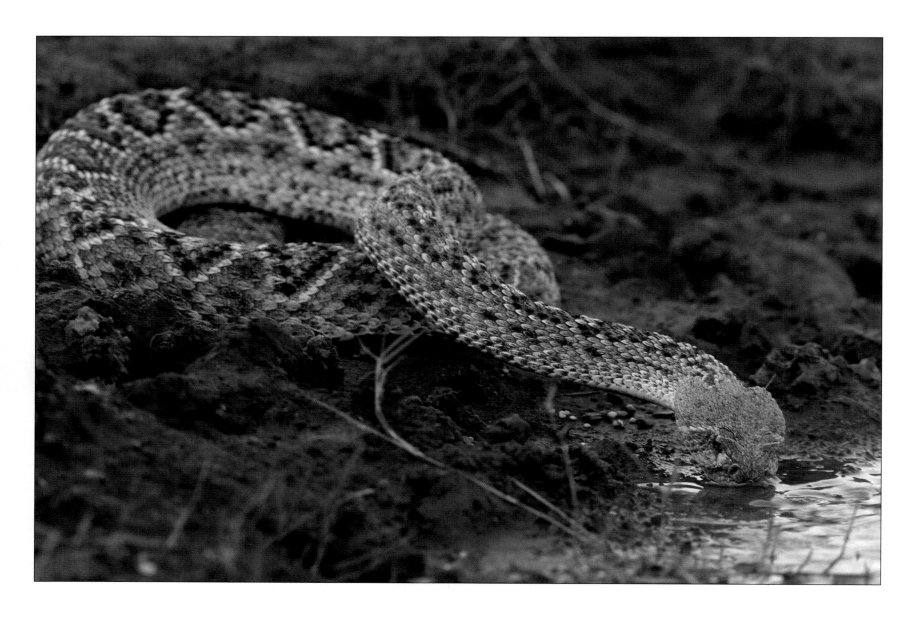

Wendy Shattil
& Bob Rozinski
United States of America
HIGHLY COMMENDED

Diamondback rattlesnake drinking

"I had been sitting in a hide in Texas for four hours waiting for birds to approach a pond. Just as the pond went into the shade for the evening, I saw a rattlesnake move past the hide. At the water's edge, the snake coiled up its body, then extended its head to drink."

Canon EOS 1N with 600mm lens; tripod;
1/30 at f11; Fujichrome

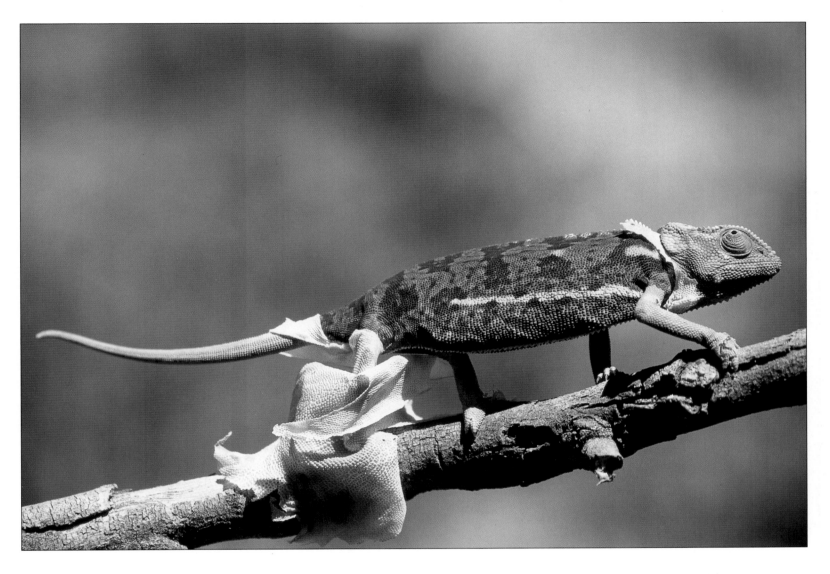

Beverly Joubert
Botswana
HIGHLY COMMENDED

Flap-necked chameleon shedding skin

"This chameleon escaped being eaten by a boomslang snake and fell 18 metres to the ground. It stayed around our camp for a few days and then disappeared. Maybe the snake caught it after all!"

Canon EOS 1N with 80-200mm lens; tripod;
1/250 sec at f5.6; Fujichrome Velvia

The Gerald Durrell Award for Endangered Wildlife

This award was introduced in 1995 to commemorate Gerald Durrell's long-standing involvement with The Wildlife Photographer of the Year Competition and his work with endangered species. The subjects illustrated must be officially listed as endangered or threatened at an international or national level. The winner, Martyn Colbeck, received a cheque for £1,000 and a trophy.

The 1996 winner, Martyn Colbeck is a wildlife film-maker and photographer. He took the award-winning photograph of a bonobo or pygmy chimpanzee, while on assignment for BBC television. The programme about the rare and little known bonobos of Zaire will be shown next year. Martyn was overall winner of this competition in 1993 with his image of a bull elephant dustbathing in Amboseli National Park.

Martyn Colbeck
United Kingdom
WINNER

Male bonobo
(pygmy chimpanzee)

"This 29-year-old adult male bonobo is known as Mon. He is a member of a group of bonobos that live in the Luo Reserve, Central Zaire. The group has been studied by Japanese scientists and local African trackers for over twenty years. Usually, there is little direct light in the rainforest but on this occasion the sunlight filtered through."

Canon EOS 1 with 300mm lens; tripod; Fujichrome Velvia rated at 100

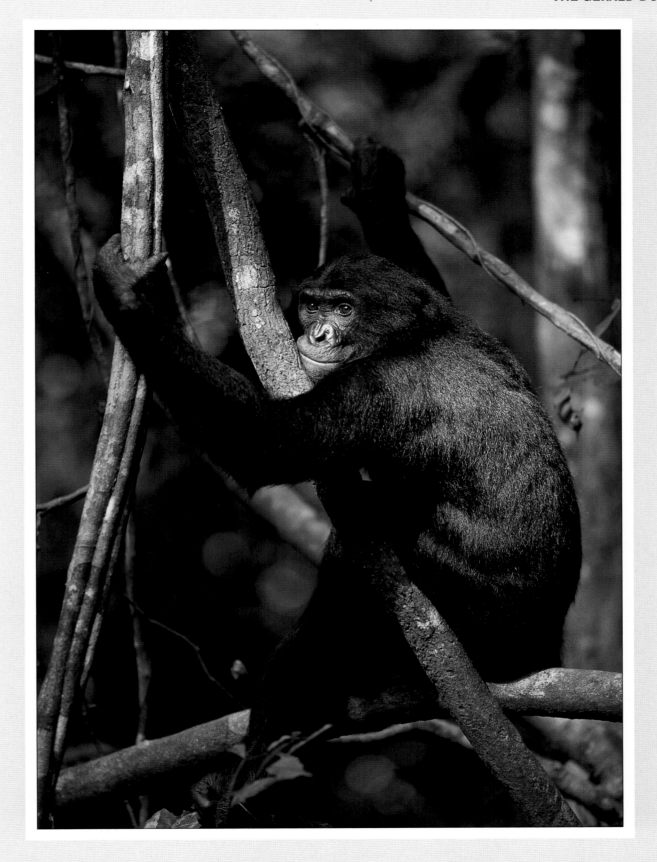

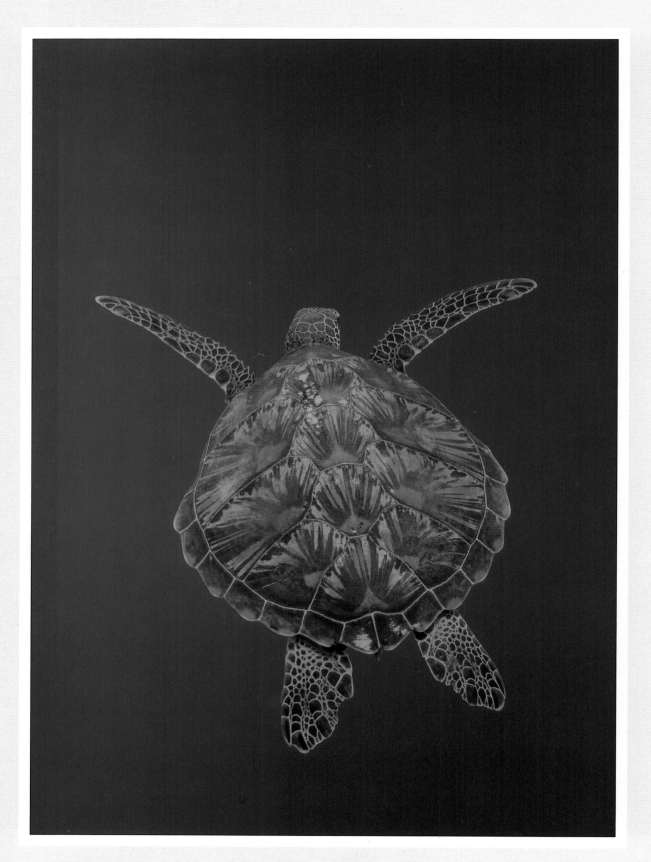

Malcolm Hey
United Kingdom
RUNNER-UP

Green turtle

"I spotted this turtle with perfect shell markings while diving at Sipadan in Sabah, Borneo. It was resting on a ledge of the sheer wall that plummets down into the ocean depths. As the turtle swam towards the surface, I photographed it from the right angle and depth to get the blue-water background and lighting on its shell."

Nikon F-801 with 24-50mm lens in underwater housing; flash; 1/60 sec at f8; Fujichrome Velvia

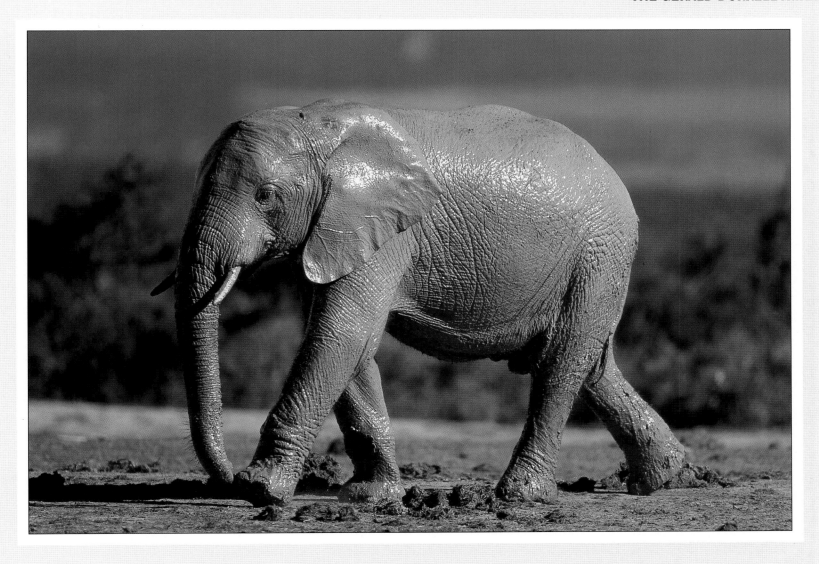

Steve Bloom
United Kingdom
HIGHLY COMMENDED

Young elephant walking

"*A group of elephants were having a mud bath in South Africa's Addo Elephant Park, when I photographed this young male as it walked away from the others. The elephant glistened in the morning sun before its mud coat dried. Addo is home to Africa's southernmost elephants which have much smaller tusks than other African elephants.*"

Canon EOS 1N with 600mm lens; beanbag; f4;
Fujichrome Velvia

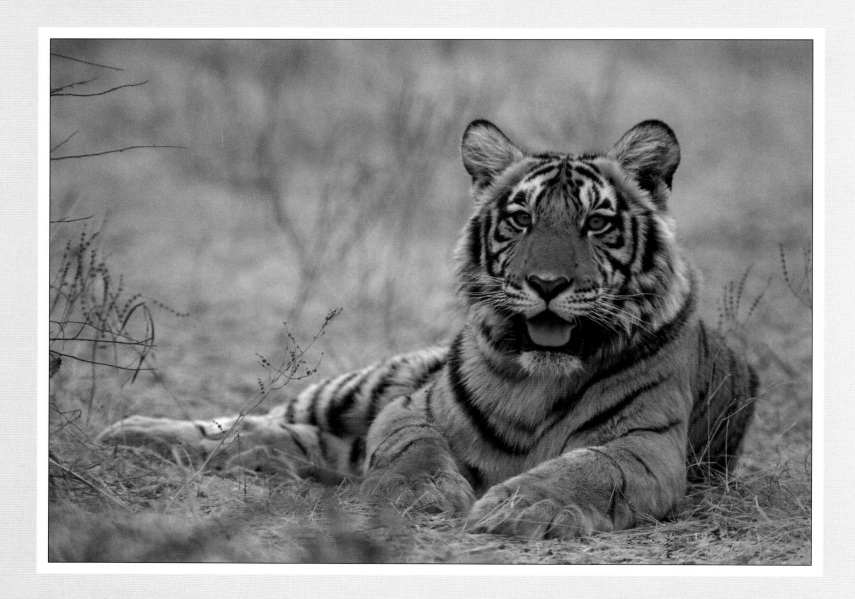

Henri Ciechowski
France

HIGHLY COMMENDED

Tigress

"I am bewitched by the power of the tiger and concerned how it can survive under today's pressures. I was thrilled to see tigers in Ranthambore National Park, India. This tigress was resting in the middle of day, unconcerned by the presence of our jeep."

Nikon F4s with 400mm lens; tripod;
Ektachrome 100

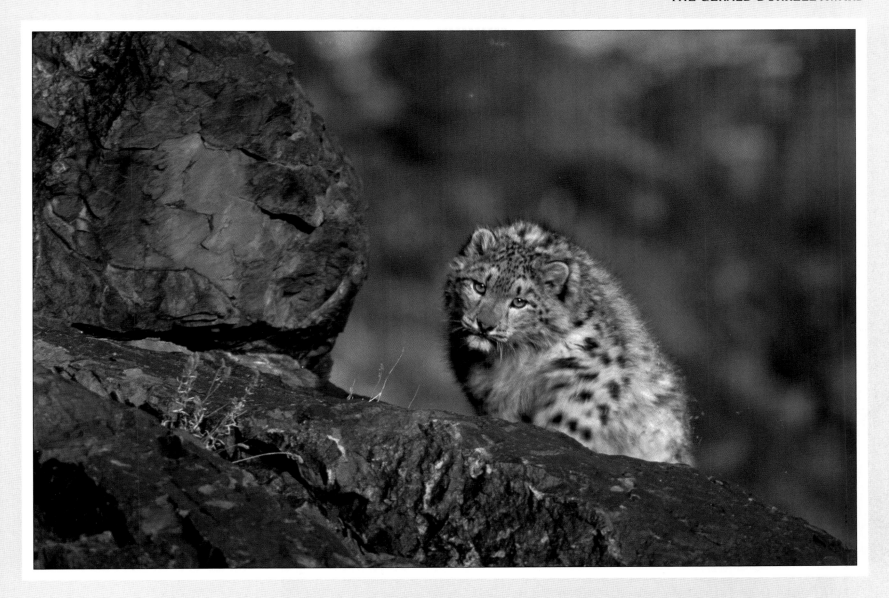

Fritz Pölking
Germany
HIGHLY COMMENDED

Snow leopard

"Only a few westerners have ever seen a snow leopard. There are not many photographs that have been taken of this elusive cat in the wild. I was lucky enough to get a photograph of one in the Altai Mountains on a visit to Mongolia."

Nikon F4 with 80-200mm lens; tripod; Fujichrome Sensia 100

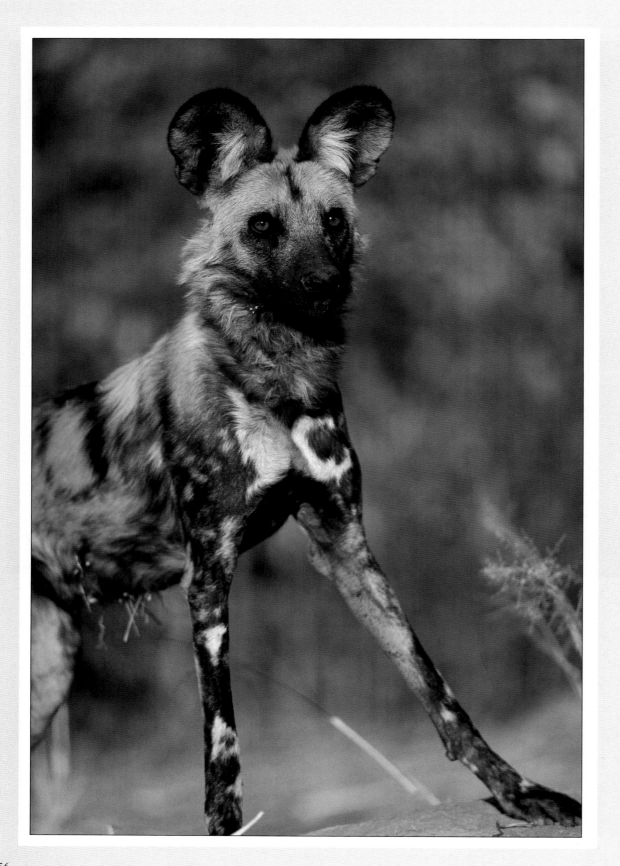

Richard du Toit
South Africa
HIGHLY COMMENDED

Wild dog

"At San-ta-Wani, Botswana, ten wild dogs were being raised by nine adults at a den in Mopani Woodland. This individual was on lookout as other members of the group returned from an early morning hunt."

Nikon 801s with 500mm lens; 1/250 sec at f4; Fujichrome Velvia

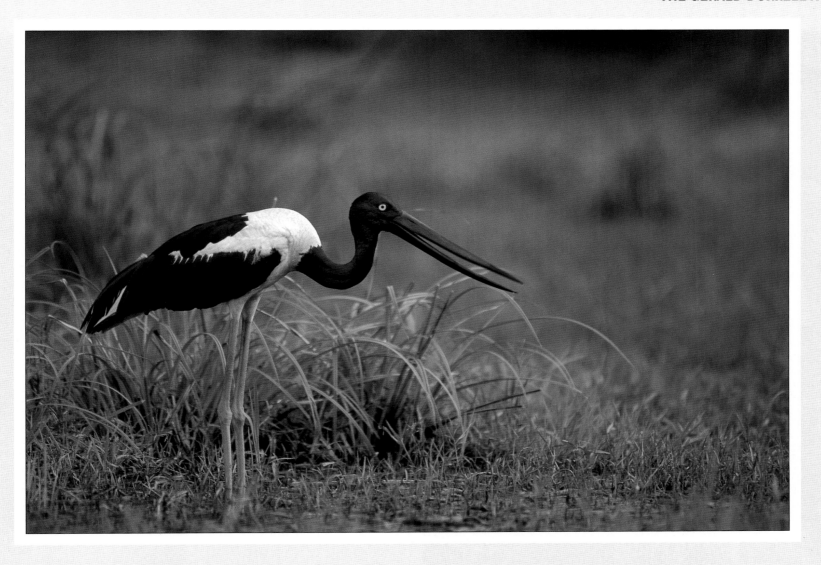

Bernard Castelein
Belgium
HIGHLY COMMENDED

Black-necked stork

"In India's Keoladeo Ghana National Park, I got close enough to take a picture of this female stork feeding, due to the skill of our boatman who did not disturb her. The western population of the black-necked stork is designated as threatened. There are only three pairs of these birds breeding in the park."

Nikon F4 with 400mm lens; tripod;
Fujichrome Velvia

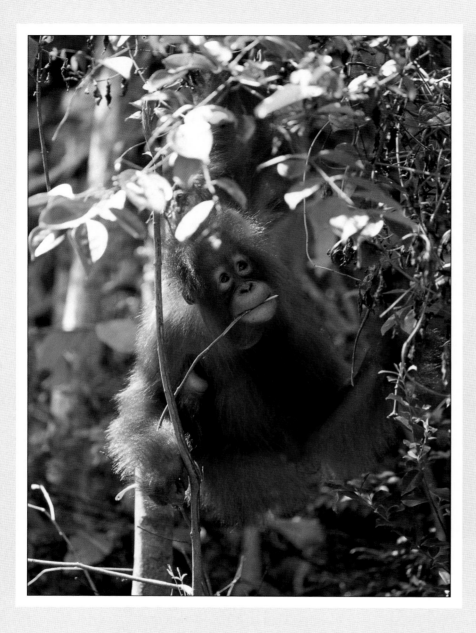

Jean-Jacques Alcalay
France
HIGHLY COMMENDED

Young orang-utan

"In Tanjung Puting National Park, Borneo, there is an unfenced area of forest which is both a rehabilitation and research centre devoted to orang-utans. This young orang-utan is now too old to stay with his mother."

Canon EOS 5 with 300mm lens; tripod; Fujichrome 100

Martin Harvey
South Africa
HIGHLY COMMENDED

Sifaka and baby

"Sifakas have such long back legs that they are unable to walk normally and have to 'dance' to cross open areas. Because their movement is so fast and erratic, it took days and many attempts to get one picture in focus showing this behaviour. The photograph was taken in the Berenty Reserve, Madagascar"

Canon EOS 1 with 70-200mm lens; 1/500 sec; Fujichrome Velvia

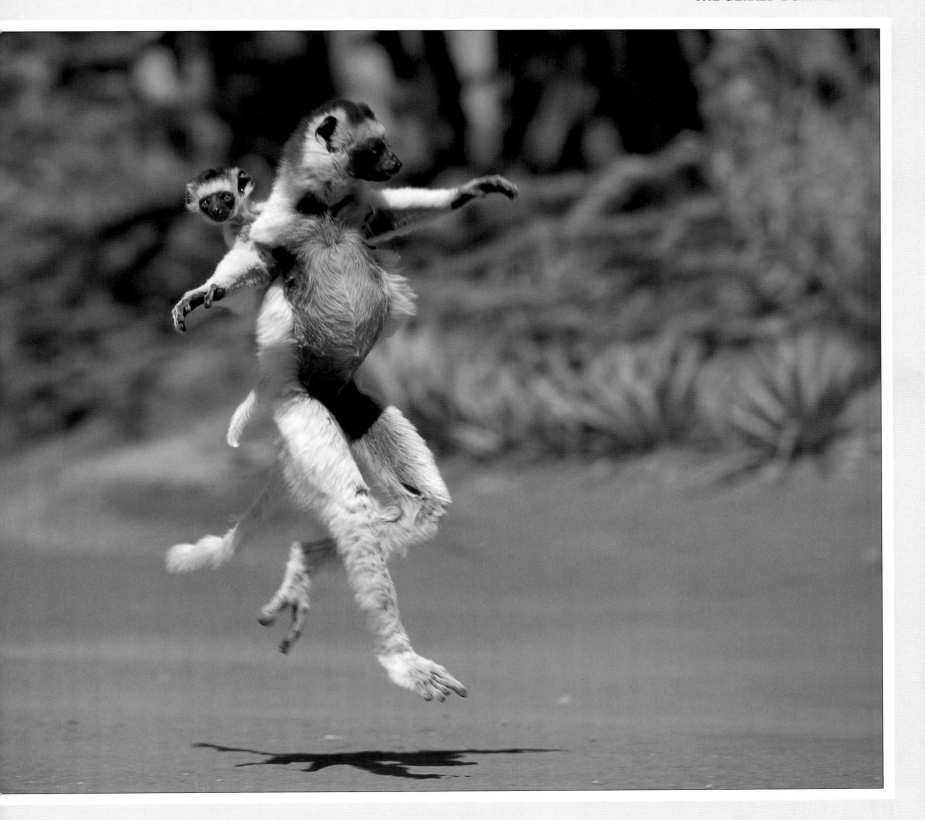

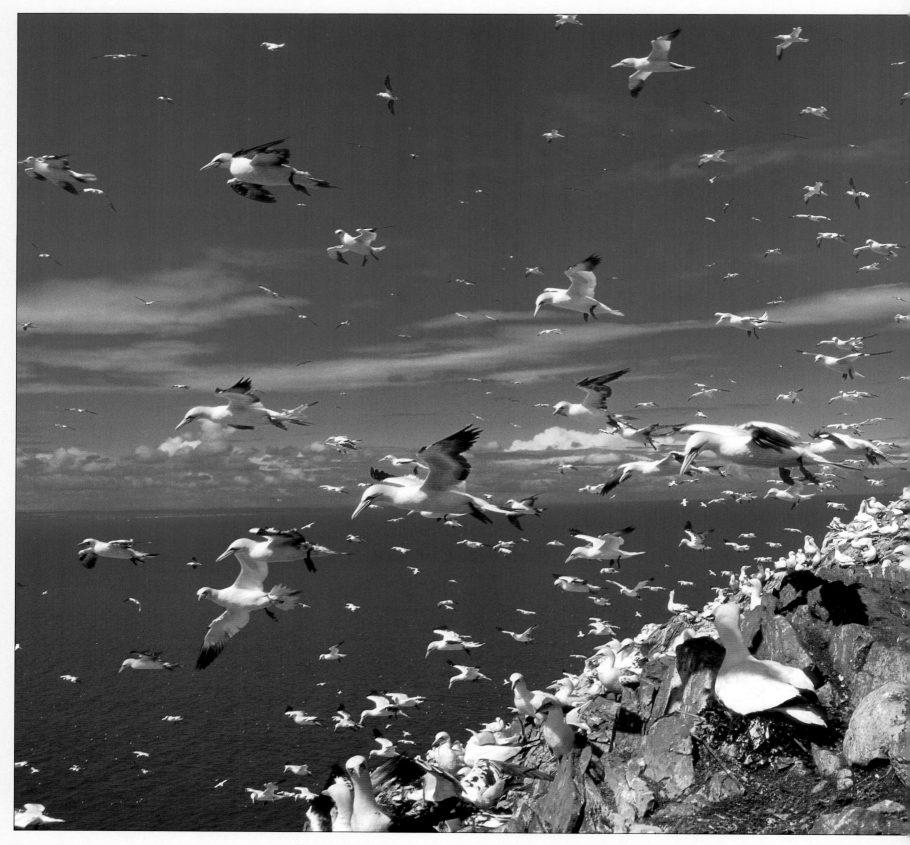

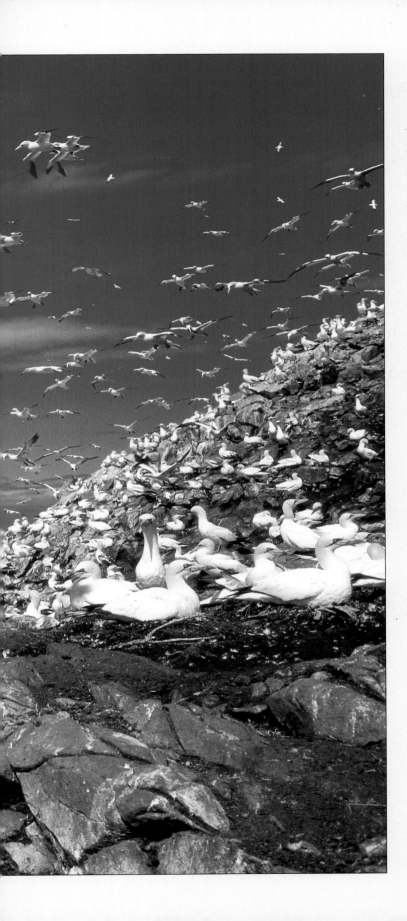

British Wildlife

Entries must feature wild plants or animals, which can be in wild or urban settings. No prizes were awarded this year but the judges commended 8 images.

Mike Cruise
United Kingdom
HIGHLY COMMENDED

Gannets

"During a trip to Bass Rock, Scotland, I photographed these gannets against a backdrop of blue sea and sky. The upward draft of wind from the adjacent cliffs meant the birds were almost suspended in the breeze."

Canon EOS 1 with 28-70mm lens; tripod; 1/250 second at f8; Fujichrome Velvia

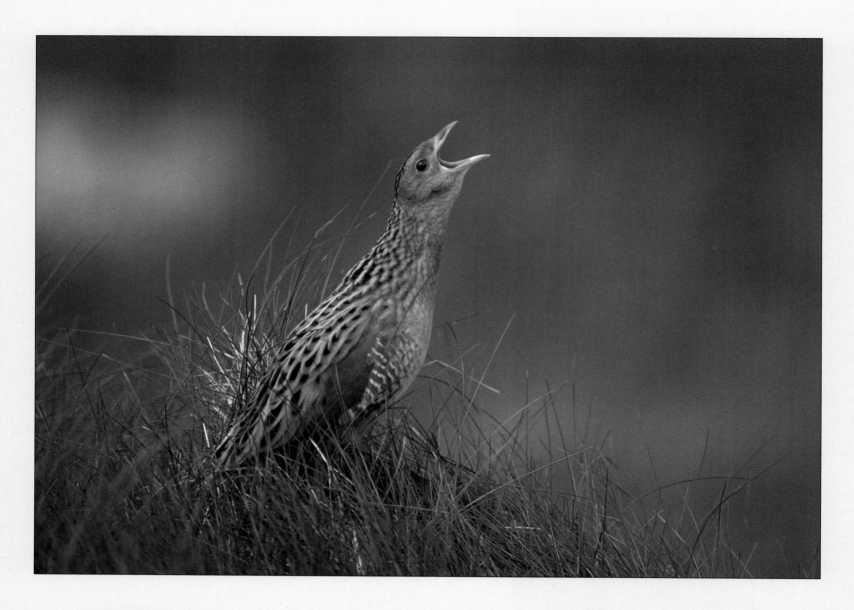

Alan Williams
United Kingdom

HIGHLY COMMENDED

Corncrake calling

"I photographed this corncrake from my car on a May evening on South Uist in the Outer Hebrides. I was in a lay-by and during a quiet moment this bird came out to call. Corncrakes use this behaviour to warn away other males who may be on their territory."

Nikon F4 with 600mm lens; 1/125 sec at f5.6;
Kodachrome 64 rated at 80

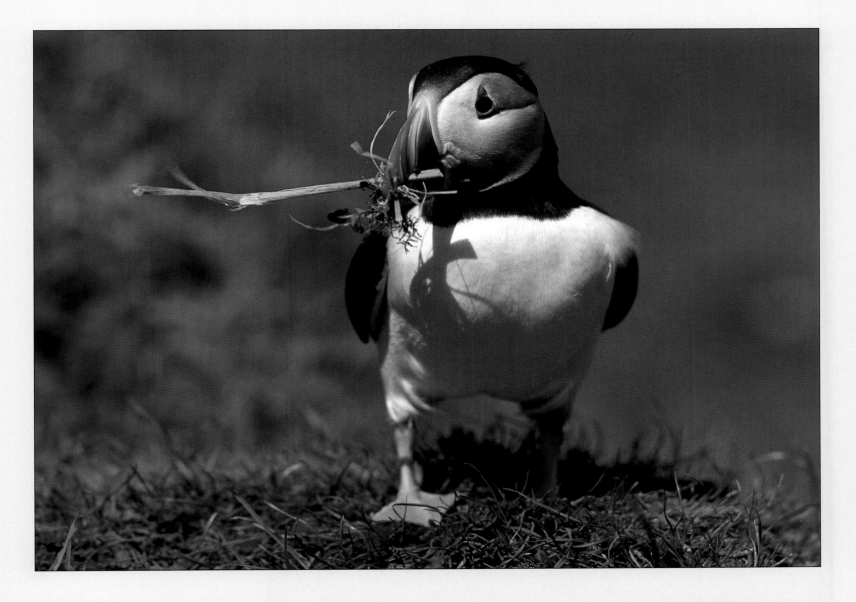

Pete Oxford
United Kingdom
HIGHLY COMMENDED

Atlantic puffin

"On Staffa Island in the Inner Hebrides, this puffin picked up nesting material before disappearing down its burrow. Visiting the burrow a few weeks later, I was gratified to see the parent birds returning with beakfuls of fish which indicated a chick had hatched."

Nikon F4s with 500mm lens; tripod; 1/125 sec at f5.6; Fujichrome Velvia

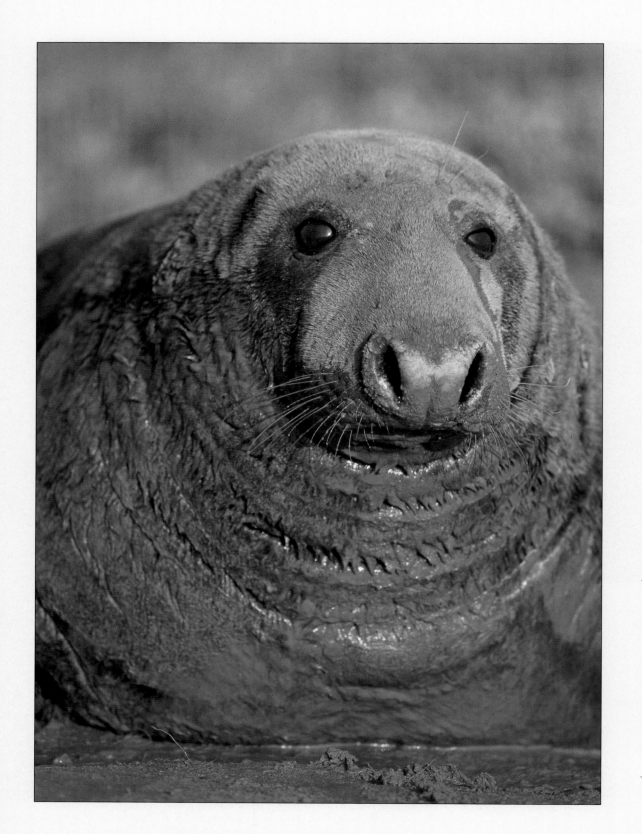

Rob Jordan
United Kingdom
HIGHLY COMMENDED

Bull grey seal

"Each year between late October and December, female grey seals land on the Lincolnshire coast to give birth. The males also come ashore to mate with the females as they come into season again shortly after giving birth. Fierce fighting can break out between the rival males but there are also long periods when the males lie around on the sand and wallow in the mud."

Nikon F4s with 500mm lens; tripod; 1/60 sec at f5.6; Fujichrome Provia 100

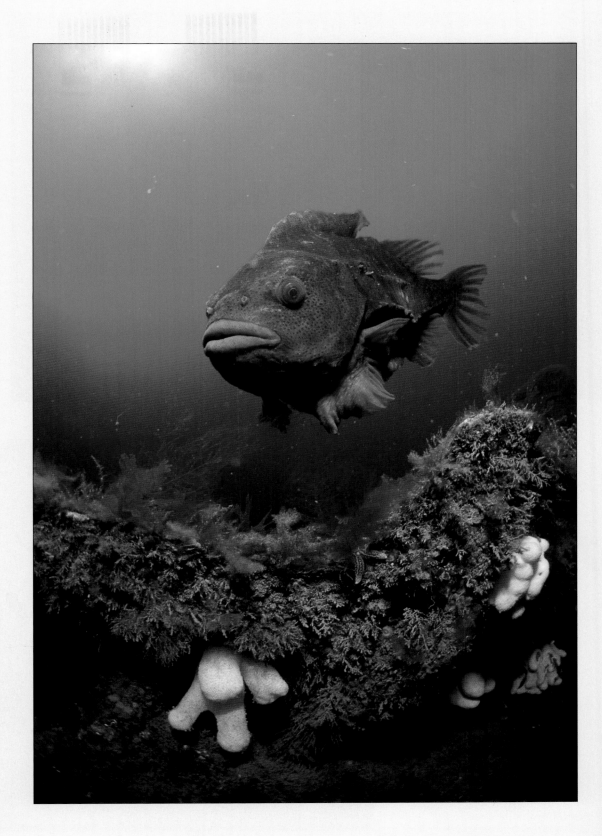

Mark Webster
United Kingdom
HIGHLY COMMENDED

Lumpsucker

"Male lumpsuckers are left in sole charge of the egg mass laid by their mates. Apart from guarding the eggs from predators, the male also oxygenates them by puffing water through his mouth. Lumpsuckers are normally found in cooler northern waters and are not common in Cornwall where this splendid male was photographed, chasing off a wrasse that was intent on feeding on the eggs."

Nikon F-801 with 16mm fisheye lens in underwater housing; flash; 1/60 at f8; Fujichrome Velvia

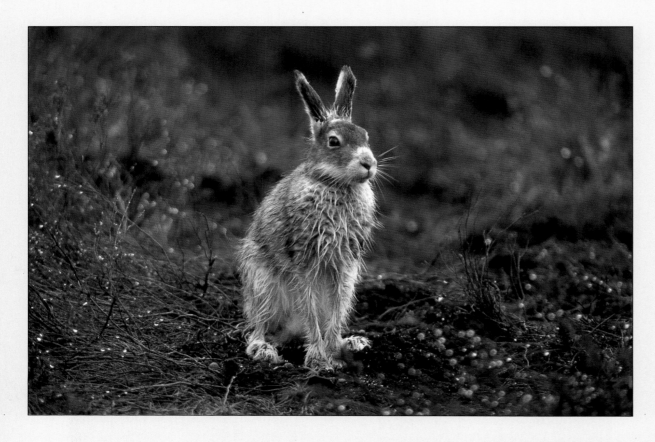

Ian Andrews
United Kingdom
HIGHLY COMMENDED

Mountain hare in rain

"*I photographed this hare on a cold wet April morning in the north of Scotland. The light was low and dull, making photography difficult as slow shutter speeds were required. The mountain hare was in the process of changing its white winter coat to a darker summer coat.*"

Nikon F90 with 300mm lens and x2 teleconverter; 1/30 sec at f5.6; Fujichrome Sensia 100

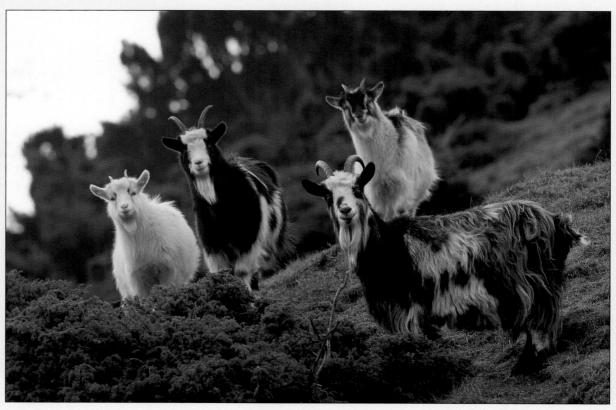

Brian Lightfoot
United Kingdom
HIGHLY COMMENDED

Feral goats

"*These goats are living in the wild near Aviemore, Scotland, having escaped from captivity some time in the past. I took the photograph because I liked the way all the goats were looking towards the camera.*"

Nikon F4s with 500mm lens; beanbag; 1/250 sec at f4; Fujichrome Velvia

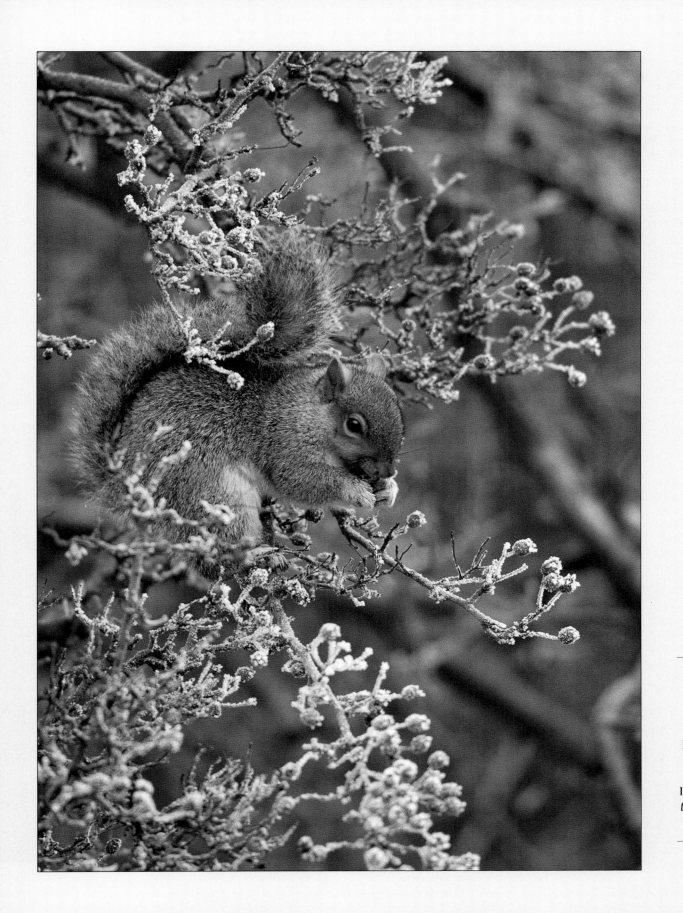

Ernie Janes
United Kingdom
HIGHLY COMMENDED

Grey squirrel eating hawthorn berries

"I had driven to Whipsnade Heath hoping to photograph redwings, when I spotted a grey squirrel in the middle of a hawthorn thicket. Fortunately I was able to park the car in camera range. I waited for about forty-five minutes until the squirrel worked its way out on a limb where I was able to get a clear shot."

Canon EOS 1 with 500mm lens; 1/20 sec at f4.5; Kodachrome 64

In Praise of Plants

Pictures can illustrate flowering and non-flowering plants in close-up or en masse, and should highlight their beauty and importance.

Theo Allofs
Germany
WINNER

Quiver trees after sunset

"In the Namib desert near Blutkuppe, I found this appealing arrangement of quiver trees. First I photographed these bizarre plants in the golden light of the setting sun. But the best image was yet to come. The afterglow cast a reddish light on the trees while the sky behind was dark enough to be in harmony. Then I wished the full moon would rise, and it did!"

Nikon F4s with 80-200mm lens; tripod;
1/4 sec at f8; Fujichrome Velvia rated at 40

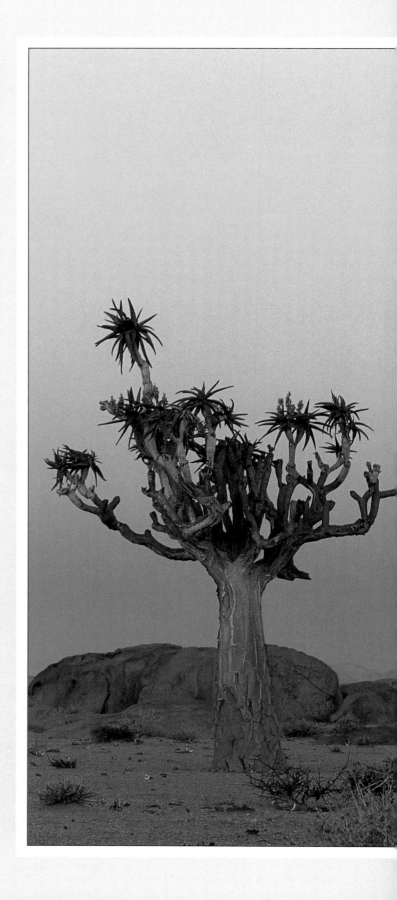

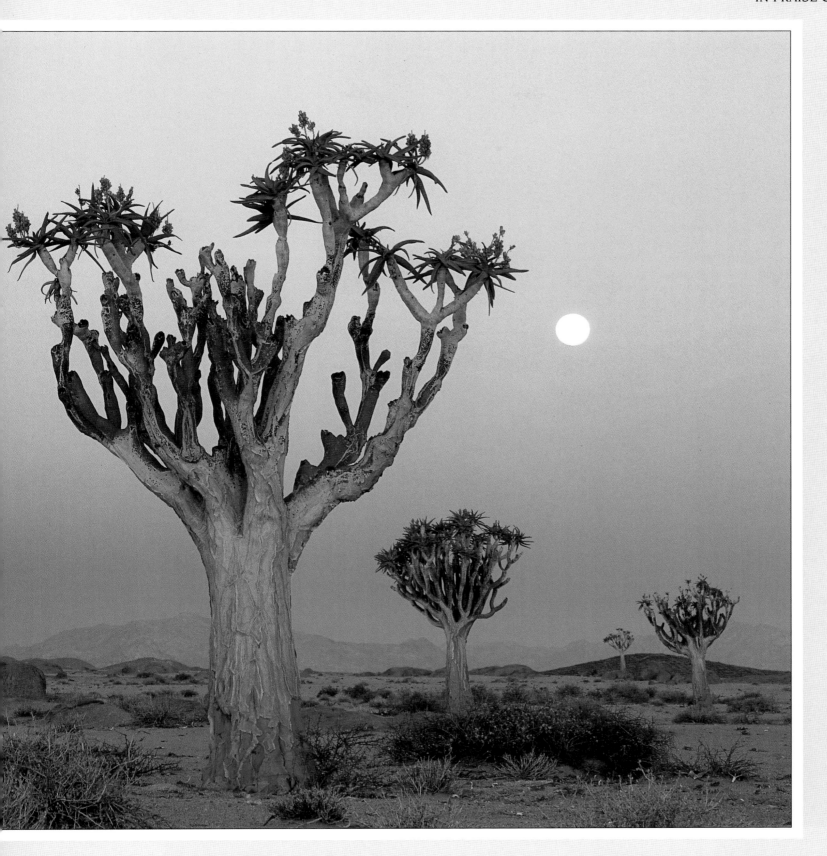

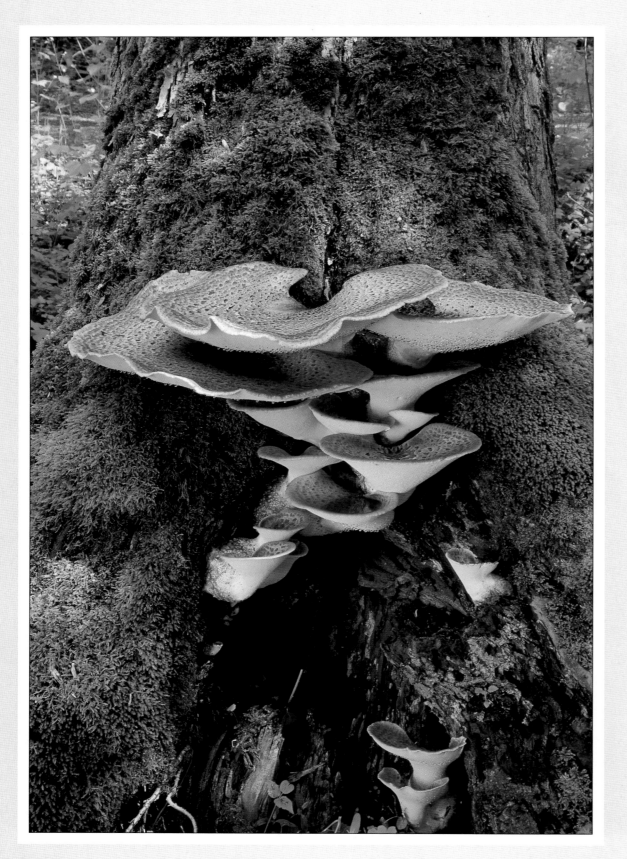

Dr Hermann Brehm
Germany
RUNNER-UP

Bracket fungus

"After driving down a small road in Germany, I found this bracket fungus (Polyporus squamosus) at the base of a moss-covered tree near a little river. As soon as I saw the fungus, I thought it would make a wonderful picture."

Canon EOS 1N with 35-350mm lens; tripod; gold coloured reflector; Fujichrome Velvia

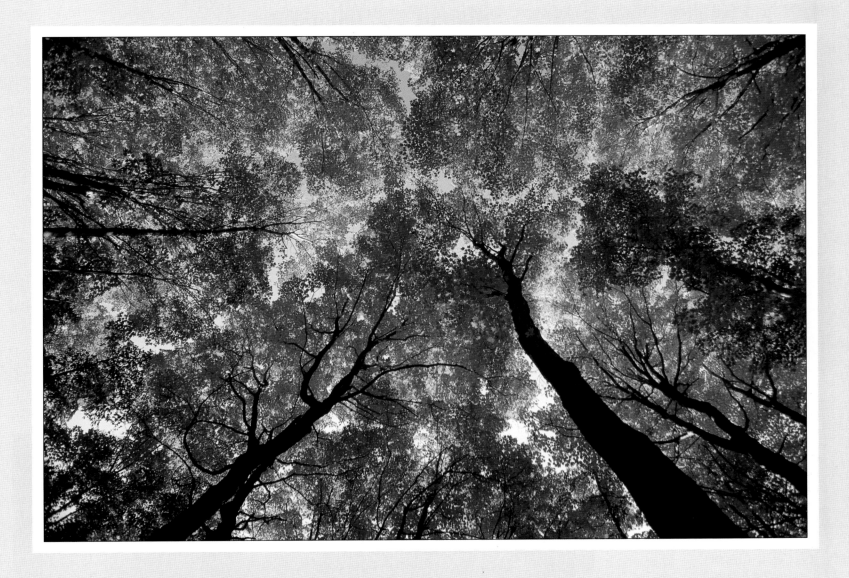

Yva Momatiuk
& John Eastcott
USA / New Zealand
HIGHLY COMMENDED

Sugar maples

"Looking upwards in this wild sugar maple grove, the intricate pattern of overlapping leaves is revealed. The trees are tapped for sugar when the sap rises in the spring."

Canon T90 with 17mm lens; Fujichrome Velvia

Jean-Jacques Alcalay
France
HIGHLY COMMENDED

Mountain ash

"At the end of an overcast November day in the Corsican mountains, the soft even light made the colours of the mountain ash trees stand out. It was a delightful sight before the rain set in."

Canon EOS 1 with 80-200mm lens; tripod; Fujichrome Velvia

Bill Coster
United Kingdom
HIGHLY COMMENDED

Poppies in an olive grove

"Early one morning in Lesbos, Greece, I passed this olive grove but most of the poppies were in the shade. I returned after lunch when the lighting was directly overhead and took some photographs. I usually prefer to photograph in less contrasty light but this would have meant the poppies would be back in the shade of the olive trees."

Canon EOS 5 with 28-70mm lens; tripod; Fujichrome Sensia 100

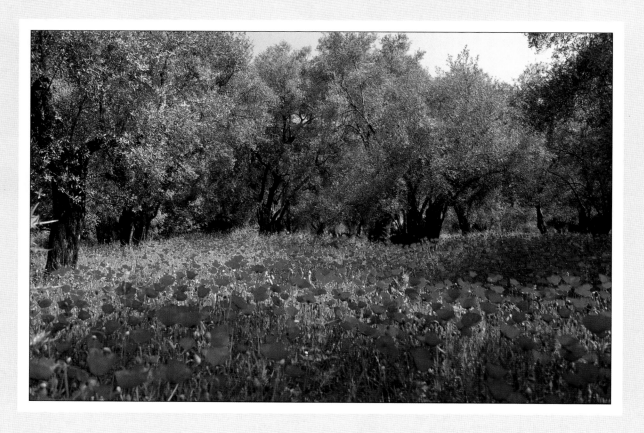

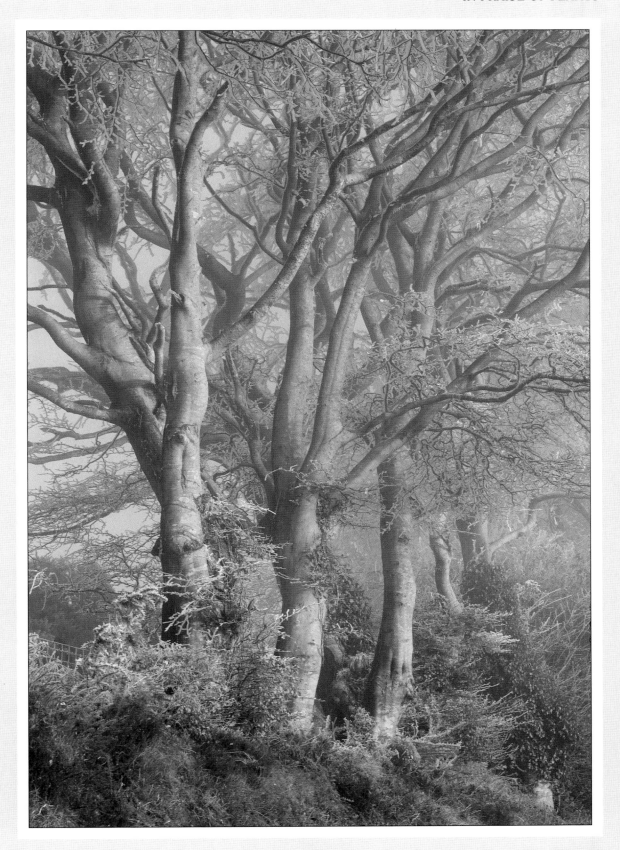

Colin Varndell
United Kingdom
HIGHLY COMMENDED

Beech trees in hoar frost

"The ethereal effect of the hoar frost on the twigs of these beech trees as the mist cleared, inspired me to take this photograph. The lighting changed rapidly and a few seconds later, the trees were in brilliant sunlight and the frost had melted."

Minolta X300 with 135mm lens; tripod; 1/30 at f8; Kodachrome 64

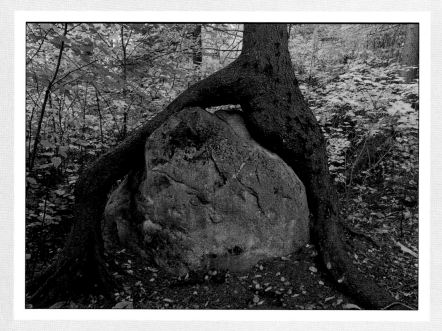

Bruce Montagne
United States of America
HIGHLY COMMENDED

White pine growing over a boulder

"Even a large boulder couldn't stop this majestic white pine's desire to grow. The boulder is one of many scattered across the Canadian Shield that were released as the glaciers retreated after the last ice age."

Nikon F4s with 28-70mm lens; 1/4 sec at f22; Fujichrome Velvia

Monika Paulat
Germany
HIGHLY COMMENDED

Baobabs

"These impressive baobab trees are growing on the savanna in western Madagascar. They store water in their trunks to help them survive the long dry season. Legend has it that God tore down the baobabs in anger and planted them again upside down."

Minolta 9xi with 70-210mm lens; 1/125 sec at f2.8; Fujichrome Sensia 100

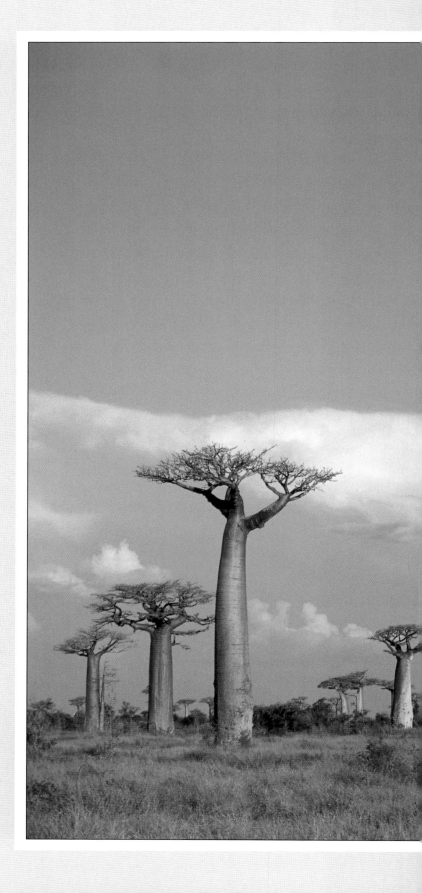

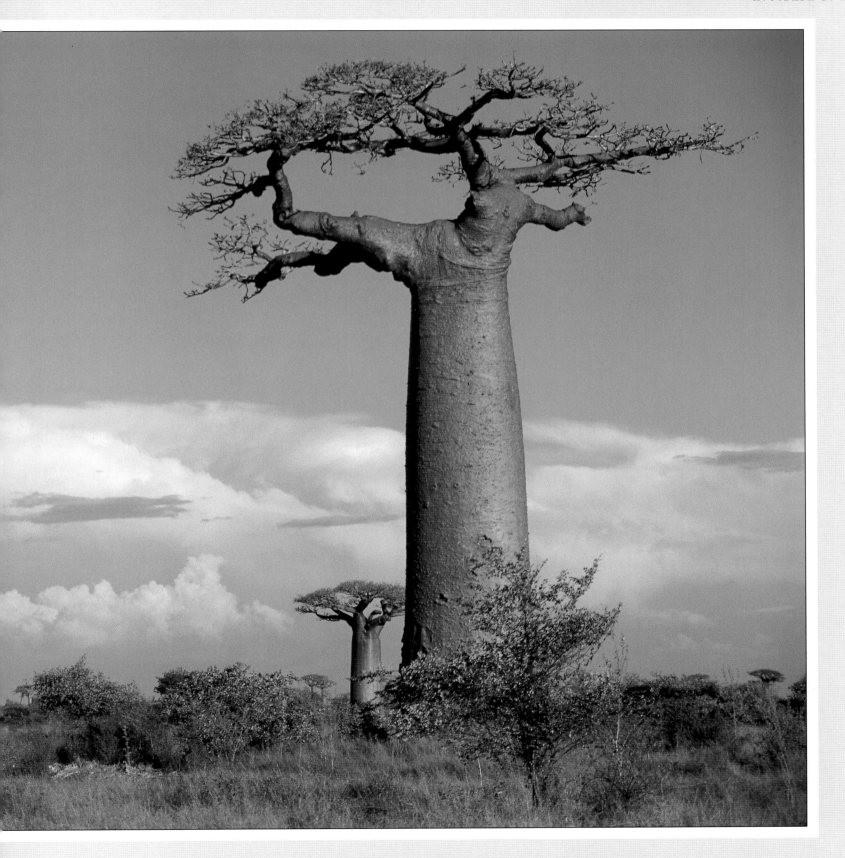

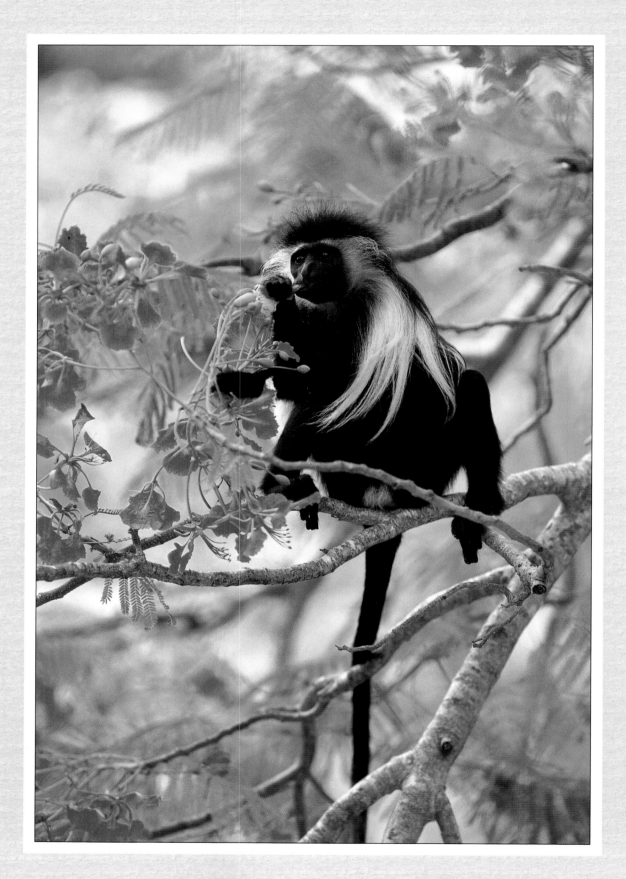

Konrad Wothe
Germany
WINNER

Colobus eating red flowers

"When I first saw these wonderful monkeys sitting in a red-flowering tree near Mombasa, Kenya, I knew I wanted to get a picture of them. One day when the sky was slightly overcast but still bright enough, this monkey moved into just the right position and I got the shot I wanted"

Canon EOS 1N with 300mm lens; tripod; 1/125 sec at f4; Fujichrome Sensia 100

Animal Portraits

The photographs entered in this category should show the subjects in close-up.

Johannes Lahti
Finland
RUNNER-UP

Red fox

"I met this young fox early one morning in southern Finland. After visiting the fox in the same place on several mornings, it accepted my presence and was unconcerned when I took this photograph."

Canon EOS 5 with 300mm lens; Fujichrome Velvia

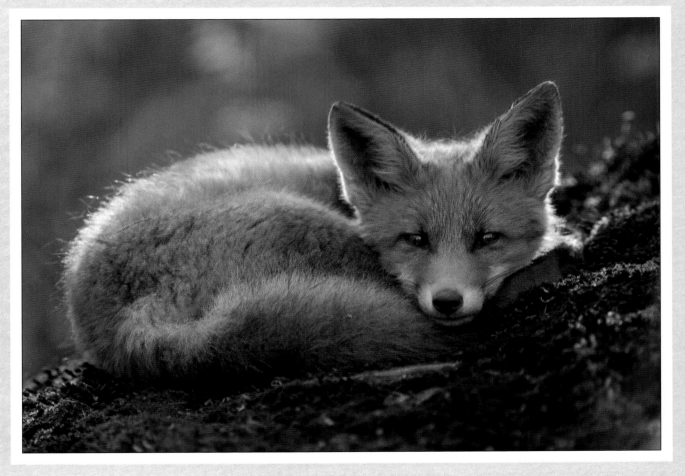

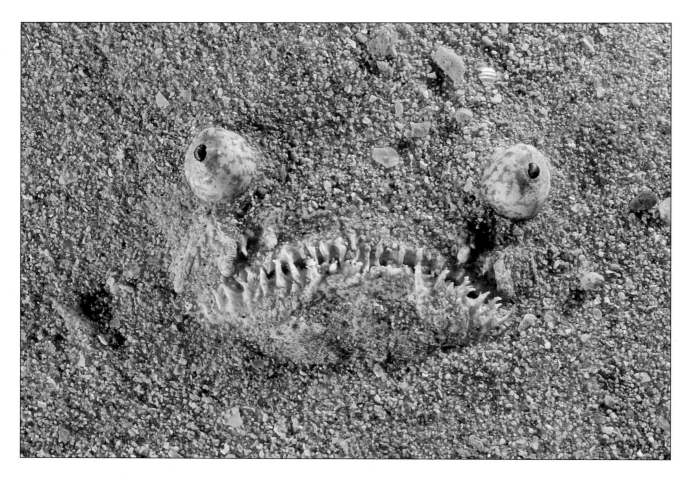

Fred Bavendam
United States of America
SPECIALLY COMMENDED

Stargazer waiting for prey

"Waiting to ambush any small fish that come close, the stargazer fish buries itself in the sand with only its eyes and lips visible. This also helps the stargazer avoid being seen by larger predators which might attack it. The photograph was taken while diving off South Australia."

Nikon F4 with 105mm macro lens in underwater housing; twin strobes; 1/1250 sec at f22; Fujichrome Velvia rated at 100

Wendy Shattil & Bob Rozinski
United States of America
HIGHLY COMMENDED

Yellow mud turtle

"We found the eyes of this mud turtle most appealing. To accentuate its eyes, we photographed the turtle at ground level and tightly framed the image, homing in on its face. The turtle was photographed in Texas."

Canon EOS 1N; with 180mm macro lens; two flashes; 1/250 at f22; Fujichrome Velvia

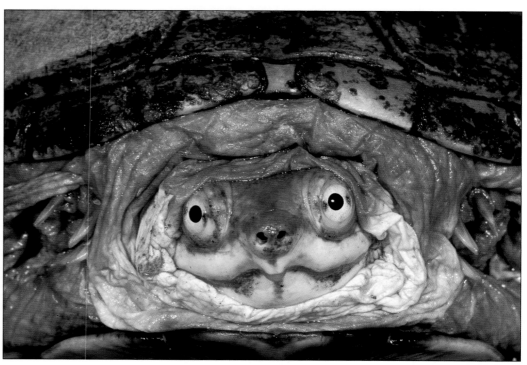

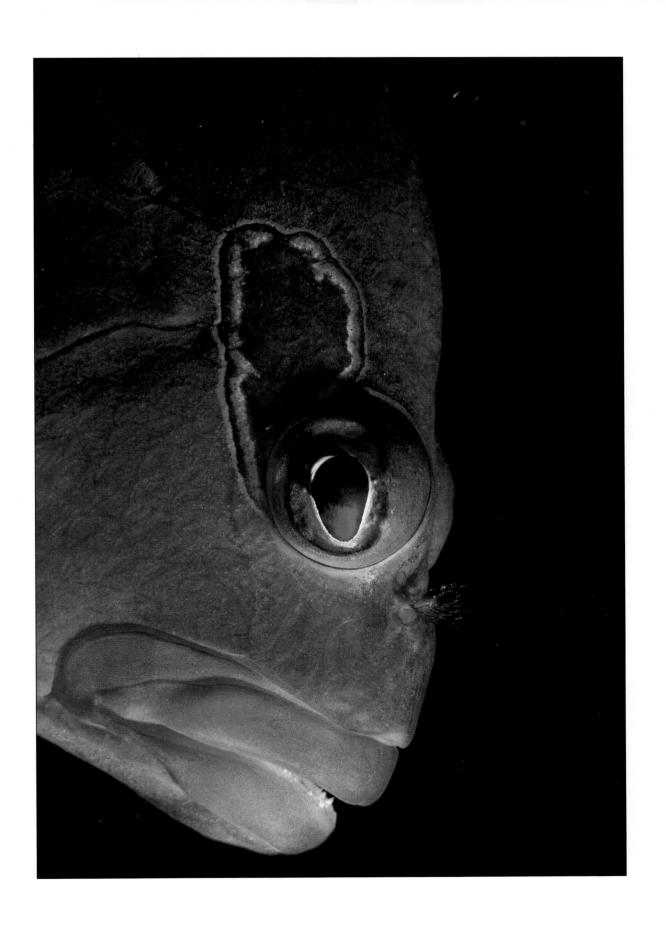

Pete Atkinson
United Kingdom
HIGHLY COMMENDED

Arc-eye hawkfish

"Normally arc-eye hawkfish cannot be approached too closely. But in Kona, Hawaii, I managed to get this close-up by visiting the same fish on several dives until it got used to my presence."

Nikon F4 with 105mm micro lens in underwater housing; flashes; 1/250 sec at f16; Fujichrome Velvia

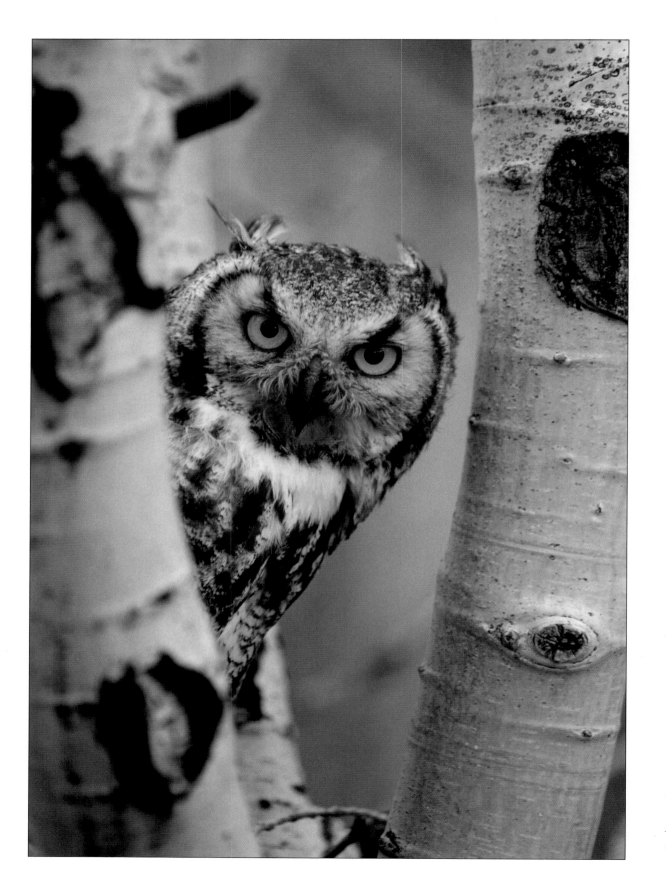

Scott McKinley
United States of America
HIGHLY COMMENDED

Great horned owl

"This photograph was taken from a hide in an adjacent tree during the owl's nesting season. Resting during the day, this owl still kept an eye on what was going on. Horned owls hunt rodents at night. The large eyes have big pupils which allow the owl to make the most of the available light."

Canon AE-1 Progam with 400mm lens; 1/60 sec at f5.6; Kodachrome

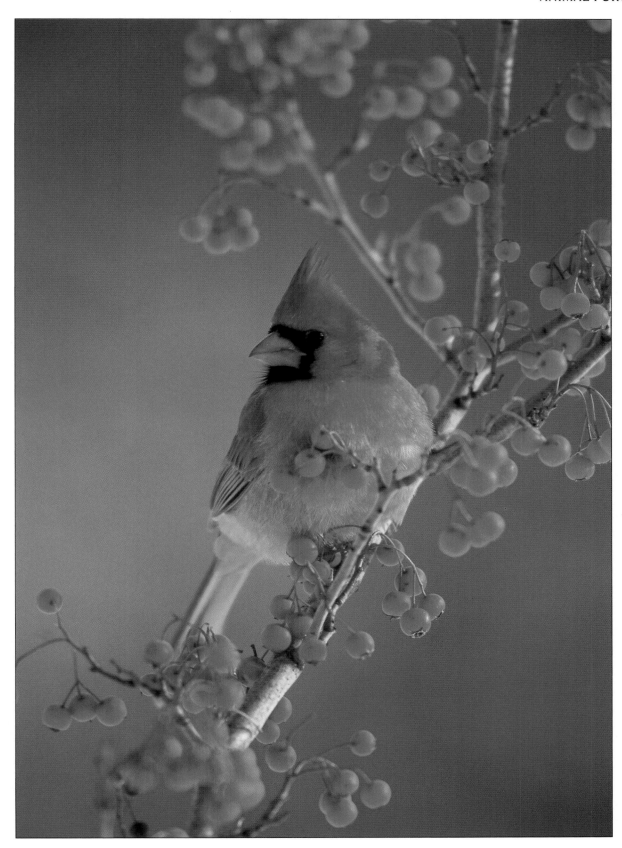

Adam Jones
United States of America
HIGHLY COMMENDED

Northern cardinal in a hawthorn tree

"When I photographed this male northern cardinal in Kentucky, there was masses of snow on the ground. The light was reflected onto the bird from the deep snow below the tree."

Pentax PZ-1 with 300mm lens; tripod; 1/60 sec at f4.5; Fujichrome Sensia 100

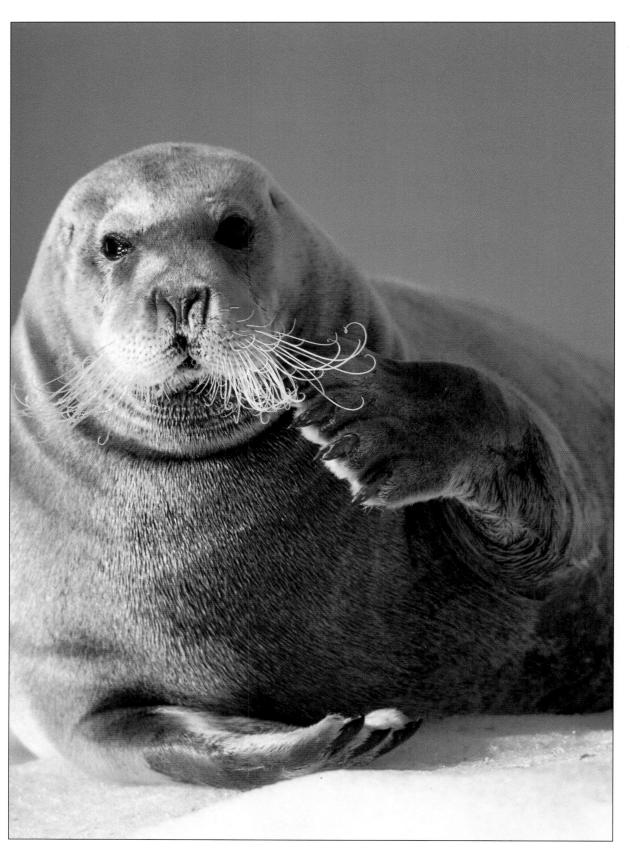

Tui De Roy
New Zealand
HIGHLY COMMENDED

Bearded seal

"Chugging our way through the brash ice
in an inflatable, we spotted this seal
sound asleep on an ice floe during a visit
to the Arctic island of Spitzbergen.
As we cut the engine and paddled closer,
the seal looked up. He kept staring at us
and scratching his moustache before
going back to sleep for a while.
His whiskers were all curled up and
completely dry, showing that he'd been
there for a long time."

Nikon N90 with 300mm lens; Fujichrome 100

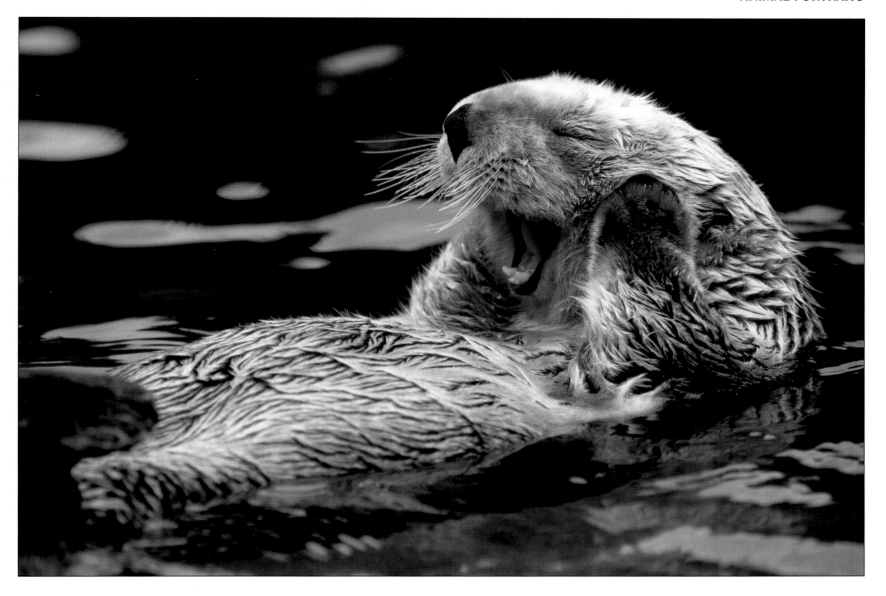

Jeff Foott
United States of America
HIGHLY COMMENDED

Sea otter yawning

"I still enjoy watching sea otters, the subjects of my scientific research and first film in 1970. This photograph was taken in Monterey Bay, California, for a book on sea otters."

Nikon F4 with 80-210mm lens; 1/250 sec at f4;
Kodachrome 64

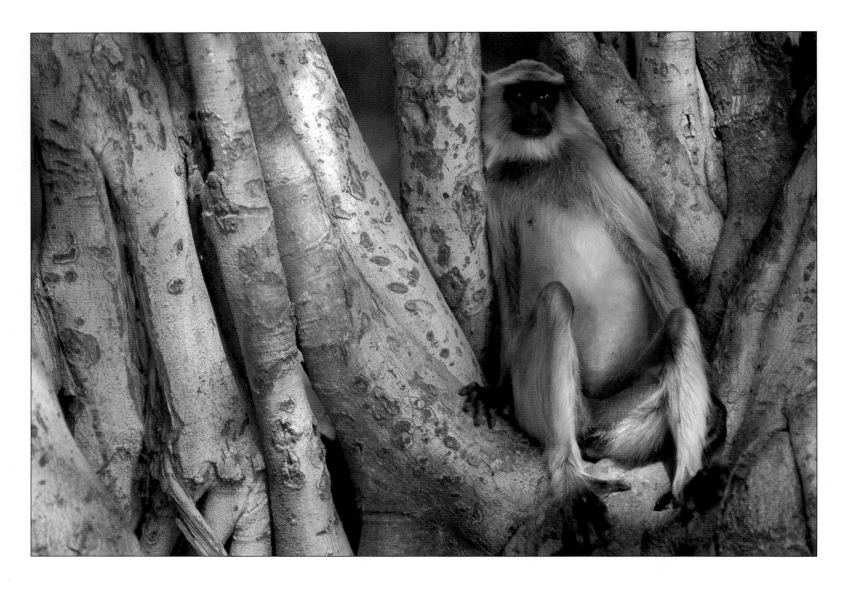

Bernard Castelein
Belgium
HIGHLY COMMENDED

Langur in banyan tree

"After the early morning game drive at Ranthambore National Park, visitors, drivers and guides gather at the main gate. The langur monkeys lurk around the gate in the hopes of snapping up some fruit or other food from the crowd. I concentrated on taking this photograph in the soft light, using flash to light up the langur's dark eyes and face."

Nikon F4 with 400mm lens; tripod; flash; Fujichrome Sensia 100

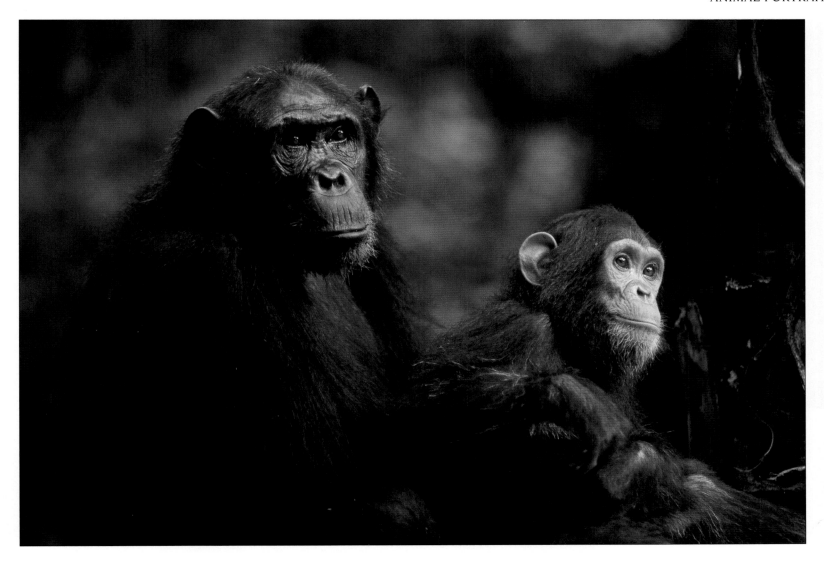

John Giustina
United States of America
HIGHLY COMMENDED

Mother and baby chimpanzee
"The mother chimpanzee is named Gremlin and the baby is named Guy. They were sitting in a tree at the feeding station in Gombe National Park, Tanzania. Both were serene and calm, looking out over the valley. I spent forty-five minutes with them before they decided to move on."

Nikon F4 with 80-200mm lens; 1/125 sec at f2.8; Fujichrome 100

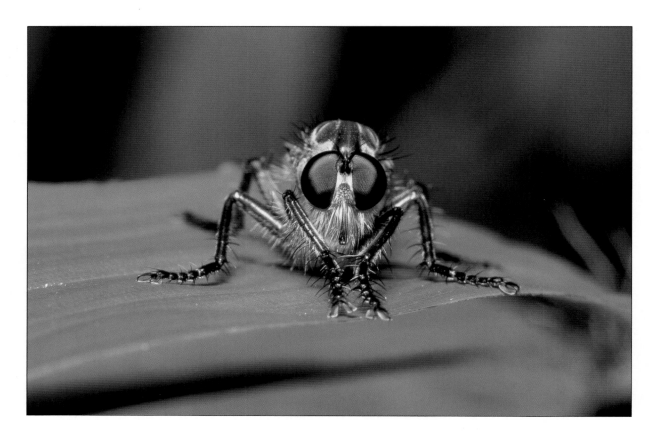

Hiroshi Ogawa
Japan
HIGHLY COMMENDED

Robber-fly

"I had to home in slowly on this robber-fly, bringing my camera closer and closer without scaring it away. These flies are predators, capturing other insects. The long hairs on the face protect its eyes from damage as its victims try to escape."

Pentax 645 with 135mm lens; bellows; flash; 1/60 sec at f22; Fujichrome Provia 100

Ingrid van den Berg
South Africa
HIGHLY COMMENDED

Cape elephant shrew

"We were driving slowly through a dry river bed in the Kalahari Gemsbok National Park, when this elephant shrew crossed the road in front of us. It was my first proper sighting of an elephant shrew. It paused on the elevated side of the road as we drew level, before vanishing into the scrub."

Canon EOS 5 with 300mm lens and x1.4 teleconverter; Fujichrome Velvia

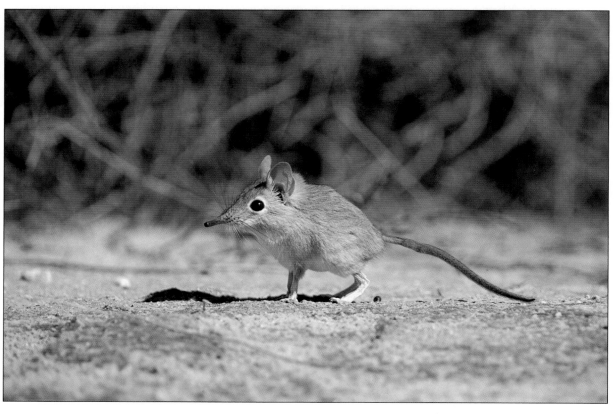

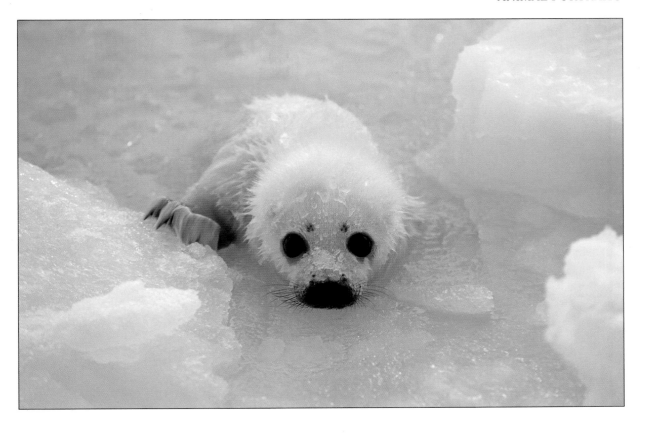

Gabriela Staebler
Germany
HIGHLY COMMENDED

Baby harp seal
"Among the Canadian ice floes, this baby harp seal had slipped through a hole in the ice into the water. The mother was watching but left her distressed baby to swim for itself. Finally, the youngster succeeded in getting back onto the ice to be with its mother."

Canon EOS 1 with 100-300mm lens;
Fujichrome Velvia rated at 40

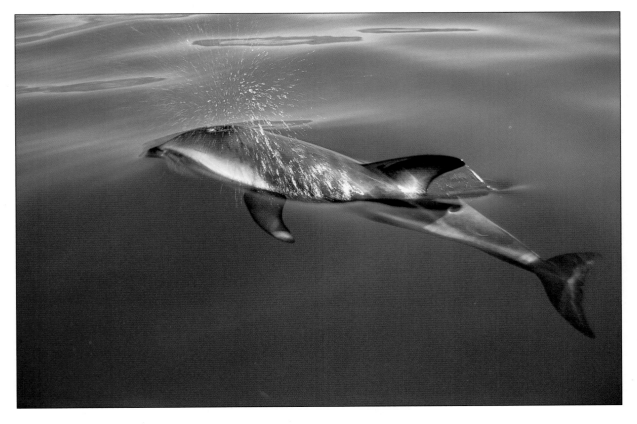

Darryl Torckler
New Zealand
HIGHLY COMMENDED

Dolphin breath
"Dusky dolphins congregate off New Zealand's Kaikoura coast, during late summer. This dolphin is surfacing in mirror calm water, clearing its blowhole before taking another breath of air. I took the photograph, hanging off the front of an inflatable. After clicking the shutter I did not pull the camera away fast enough so the dolphin's spray got on the lens."

Nikon F90 with 28-70mm lens; 1/60 sec at f5.6;
Fujichrome Velvia

87

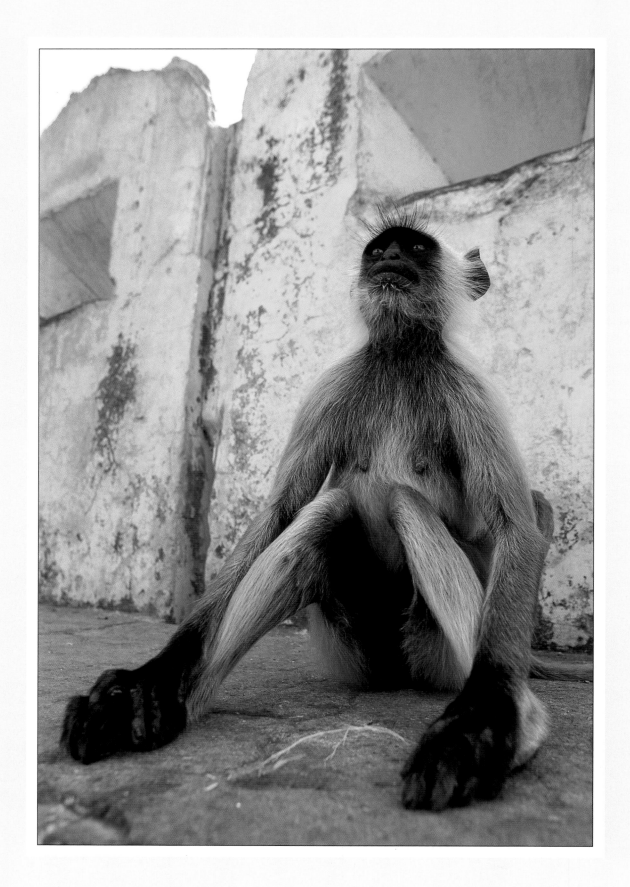

Nick Garbutt
United Kingdom
WINNER

Hanuman langur

"Troops of these monkeys live wild among the ruins of the Amber Fort in Jaipur, India. They are an attraction for visitors but can be a nuisance when they steal food. This female hanuman langur was warming herself in the early morning sun in rather a comical pose."

Nikon FE2 with 24mm lens; Fujichrome Velvia

Urban and
Garden
Wildlife

Pictures must show animals or plants in a garden
or an obviously urban or suburban setting.

Staffan Widstrand
Sweden
RUNNER-UP

Kittiwakes nesting on an
old store house

*"For years kittiwakes have
nested on this old harbour
storehouse in the fishing town
of Vardø, Norway. People put
up boards on walls in many
places in town to attract nesting
gulls, not only for the joy of
seeing the breeding birds but
also because the eggs are
harvested as a traditional
part of the local diet."*

Nikon F4 with 80-200mm lens; tripod;
1/60 sec at f11; Fujichrome Velvia 50

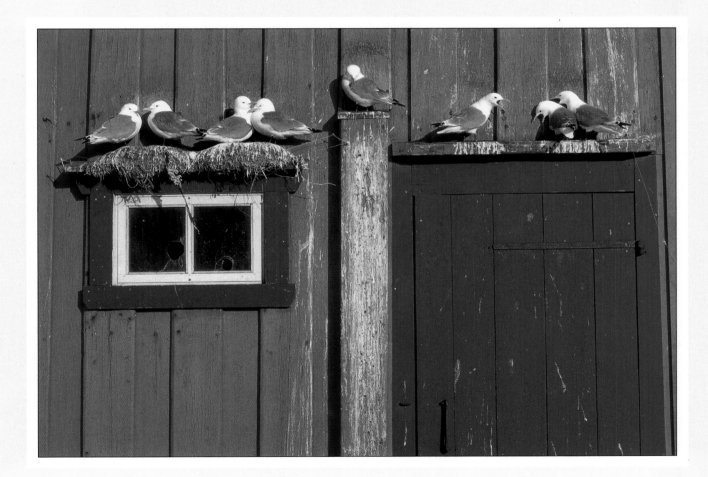

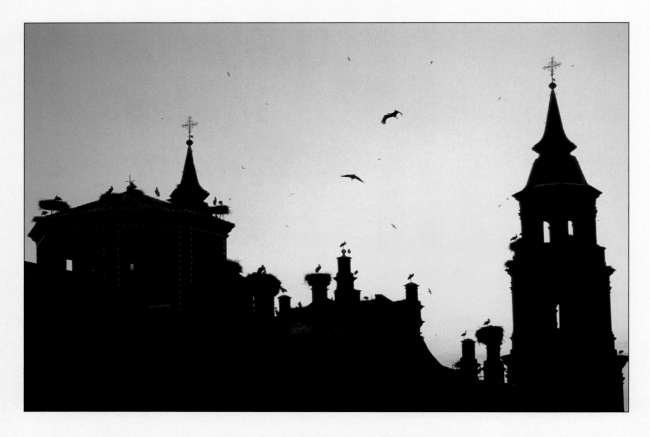

Fritz Pölking
Germany
HIGHLY COMMENDED

White storks on a monument

"In Alfaro, Spain, the church of San Miguel is a favourite nesting place for white storks. As many as one hundred and nine pairs make their nests on this church. San Miguel is often called the world capital of the white stork."

Nikon F4 with 80-200mm lens; tripod;
Fujichrome Sensia 200

Francesc Muntada
Spain
HIGHLY COMMENDED

Thirsty starling

"In a campsite in Fish River Canyon, Namibia, the starlings have become very tame often landing on taps and even on people. The main problem I had in taking this photograph was to keep far enough away from the bird for the lens I wanted to use, and to wait for it to look in the right direction."

Nikon F4 with 80-200mm lens; tripod;
Fujichrome Velvia rated at 40

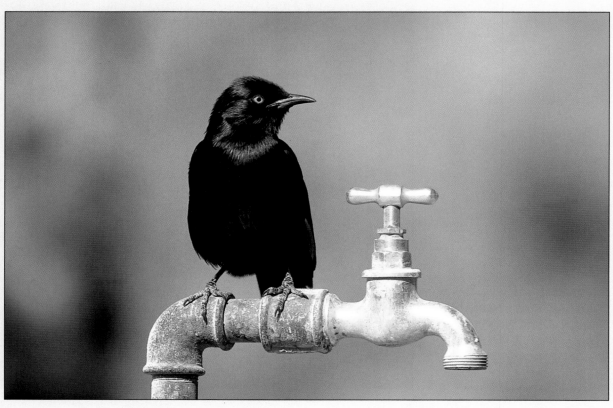

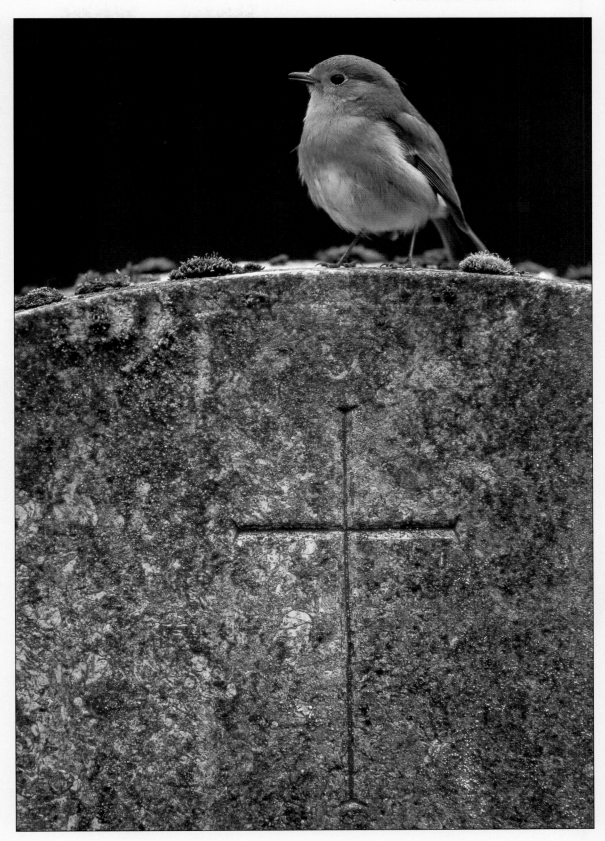

Duncan Usher
United Kingdom
HIGHLY COMMENDED

Robin on a gravestone

"In a local cemetery, I spent several days watching and photographing the territorial behaviour of the resident robins. The whole cemetery seemed alive with their songs. This bird had various singing-posts in his territory, including a gravestone. One day he disappeared. The culprit seemed to be a cat lurking around his old territory."

Nikon F4s with 300mm lens; tripod;
1/125 sec at f2.8; Fujichrome 100

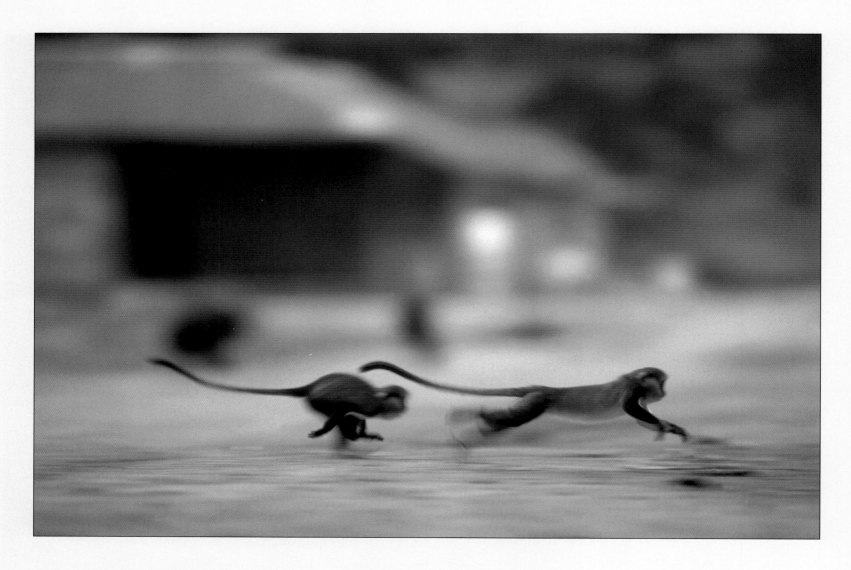

Ingo Bartussek
Germany
HIGHLY COMMENDED

Mona monkeys

"In the villages of Boabeng and Fiema in Ghana, mona and colobus monkeys are protected by a religious taboo. On the local people's initiative, a sanctuary was set up in 1974 to protect them.
The monkeys are treated with respect although they are chased away from the villager's food stores. These two mona monkeys are running back to the forest after they tried to steal maize cobs."

Canon EOS 1N with 300mm lens; tripod; 1/90 sec at f2.8; Agfachrome CTx 100

Richard Price
United Kingdom
HIGHLY COMMENDED

Fox yawning

"On seeing this fox in a communal garden in London, I expected it to run away. It turned out to be a bit of a poser and not at all phased by my presence. By gradually getting closer and closer, it became accustomed to me. Foxes are quite common in suburban areas of London often living near railway tracks. But I'd never seen one so close to central London."

Minolta 700 SI with 100mm macro lens; flash; 1/125 sec at f4.5; Fujichrome Sensia 100

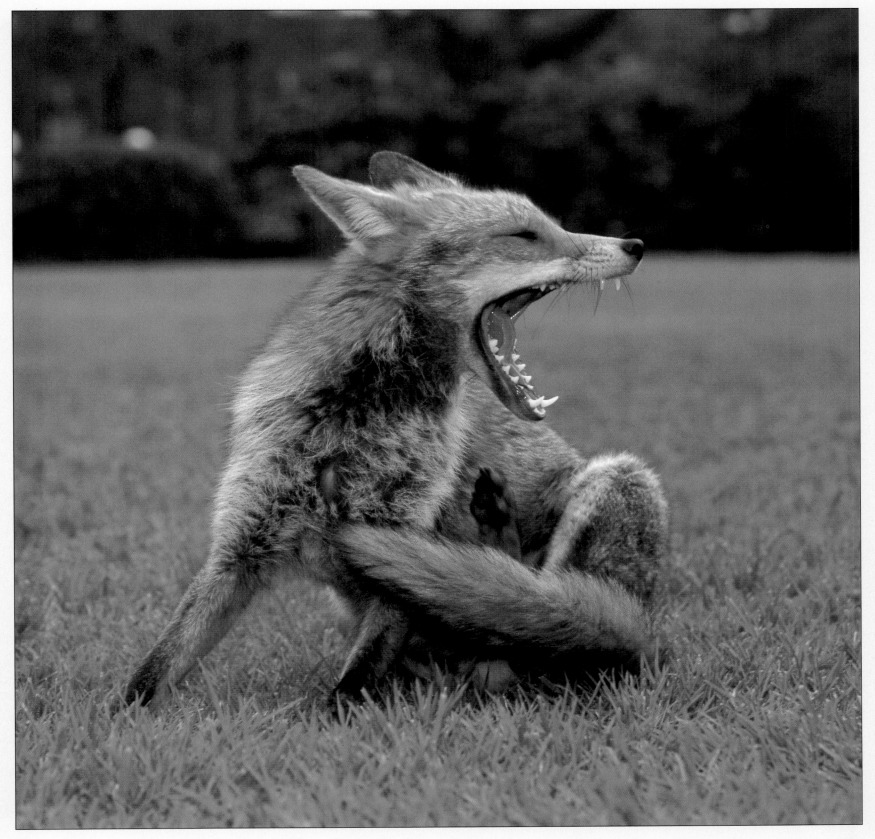

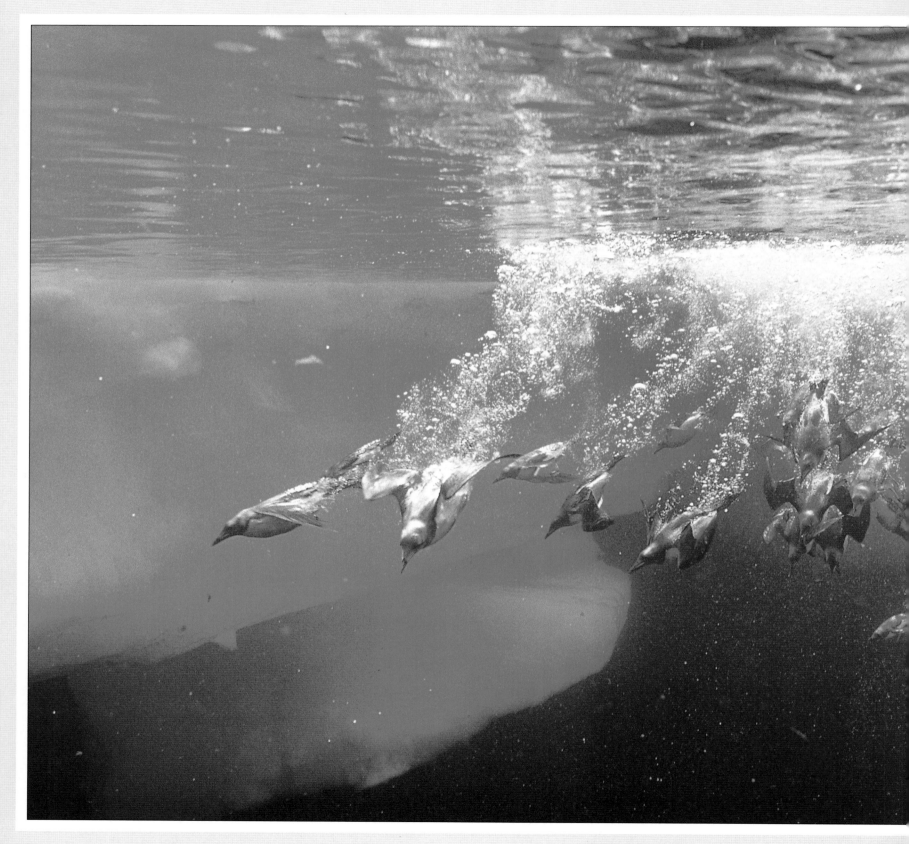

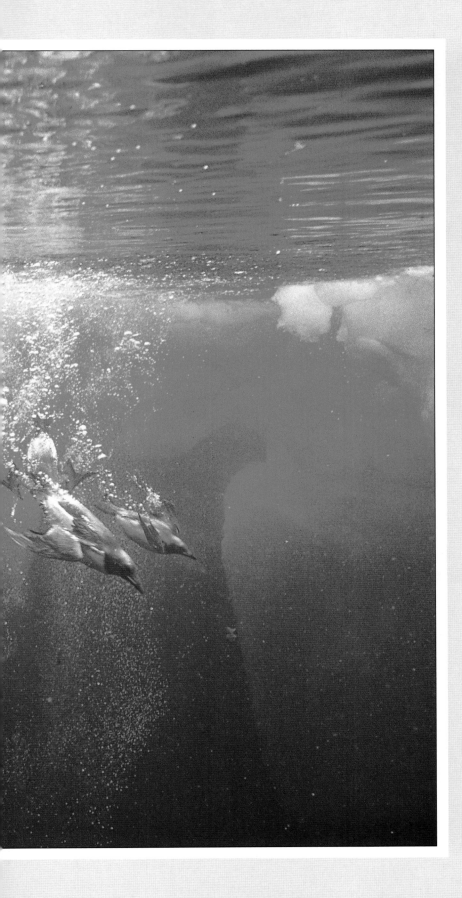

The Underwater World

The photographs entered in this category must have been taken under water and can illustrate any marine or freshwater subject.

Doug Allan
United Kingdom
WINNER

Guillemots diving

"While filming in the Arctic, I grabbed this shot after a three hour spell in the water. Groups of up to one hundred guillemots gathered to feed through a crack in the ice. By snorkelling, I could approach close enough to catch their synchronous dives. They would flap down to the depths and return about two minutes later, streaming bubbles like those from an uncorked champagne bottle."

Nikonos V with 20mm lens; 1/125 sec at f8; Kodachrome 200

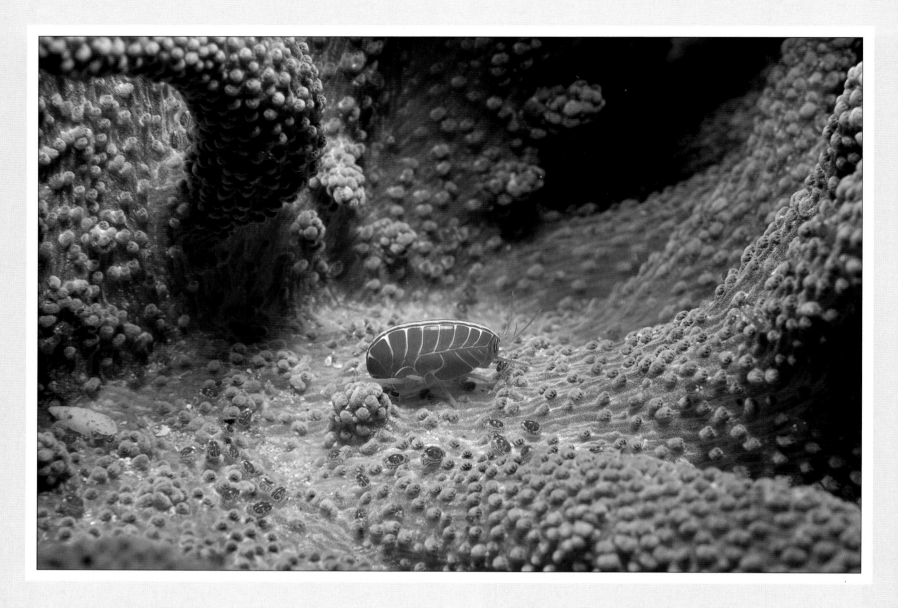

Tony Karacsonyi
Australia
RUNNER-UP

Red amphipod

"Off the coast of New South Wales, a red
amphipod feeds by nipping off the corals'
anemone-like polyps. On one occasion when
I was kneeling on the seafloor trying to
photograph these amphipods, I watched in
frustration as each one stepped off a sponge
and scooted towards my camera lights."

Nikon F with 55mm micro lens in underwater housing;
strobe light; 1/60 sec at f22; Fujichrome Velvia

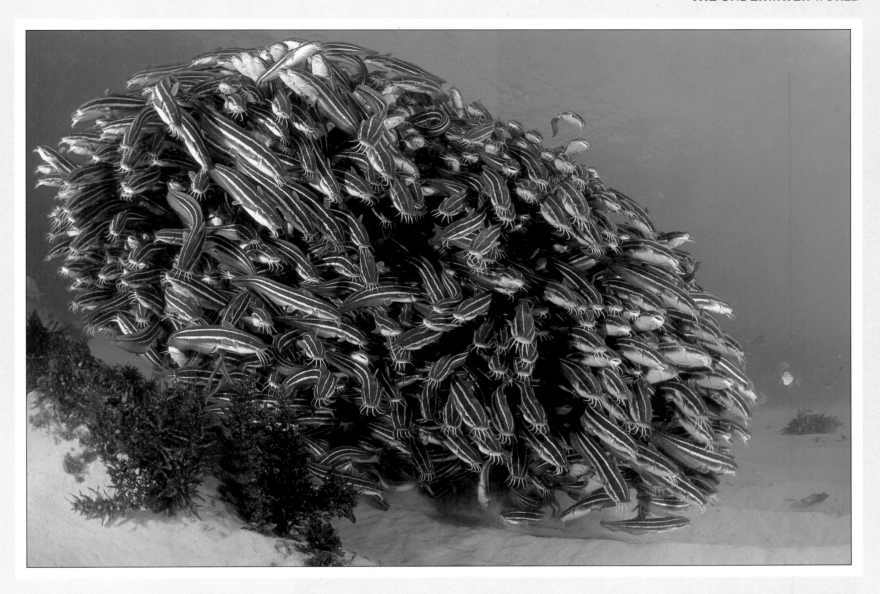

Fred Bavendam
United States of America
SPECIALLY COMMENDED

Schooling striped catfish

"These catfish form dense schools as a protection against predators. Such a writhing mass may confuse an attacker, making it difficult for it to home in on one particular fish. The photograph was taken during a dive off New South Wales, Australia."

Nikon F4 with 16mm lens in underwater housing; twin strobes; 1/250 at f.5.6; Fujichrome Velvia rated at 100

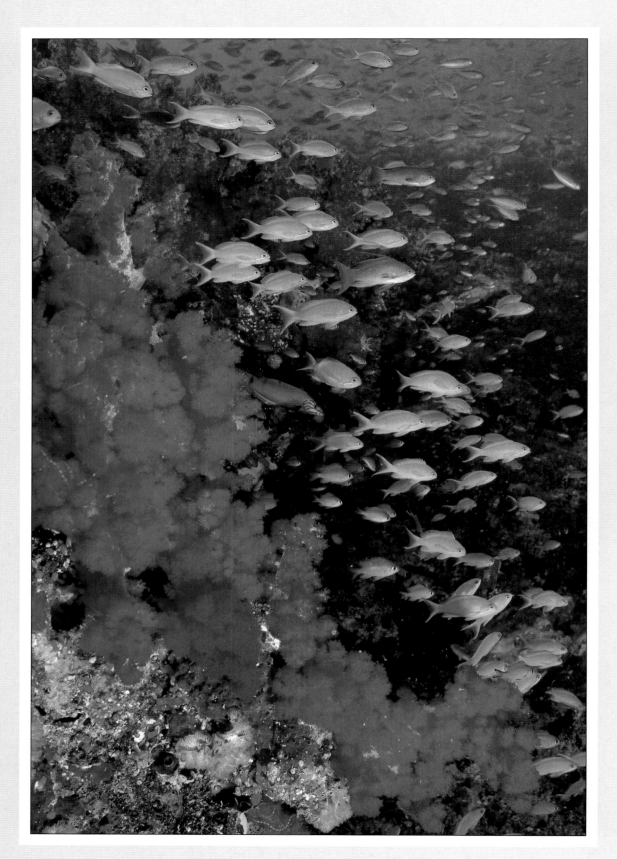

Constantinos Petrinos
Greece
HIGHLY COMMENDED

Orange anthias

"Diving in the Somo-Somo Straits, Fiji, I photographed a shoal of orange female anthias with two larger purplish males. Anthias live in harems with a dominant male. When the male dies, the largest female changes her sex and replaces the deceased as a fully functioning male. Both the anthias and soft corals looked their best when feeding in a strong current which made photographing them a real challenge."

Nikon RSAF with 28mm lens; two strobes; 1/125 sec at f8; Fujichrome Velvia

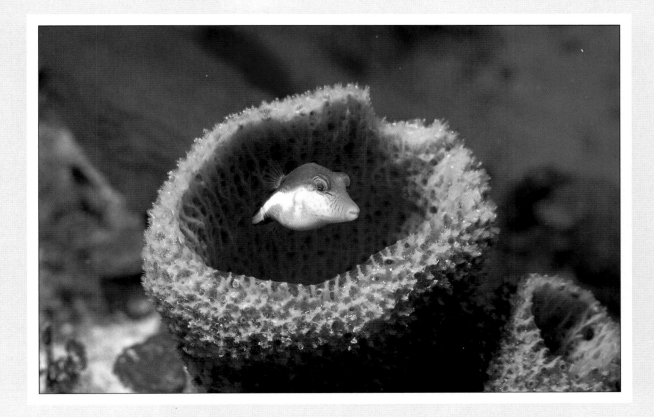

Lawson Wood
United Kingdom
HIGHLY COMMENDED

Pufferfish in a sponge

"During the late afternoon and early evening off Cozumel, Mexico, the pufferfish start to look for a safe place to spend the night. This sharpnose pufferfish was checking out a pink vase sponge when I came along."

Nikon F-801 with 60mm lens in underwater housing; flash; 1/60 sec at f16; Fujichrome Velvia

Marc C Chamberlain
United States of America
HIGHLY COMMENDED

Jellyfish

"Taking a dive at twilight, I discovered this surreal jellyfish far off Ningaloo Reef, Australia. I photographed the jellyfish in the top four metres but the water was over 150 metres deep."

Nikon F3 with 50mm macro lens; flash; 1/60 sec at f5.6; Fujichrome Velvia rate at 56

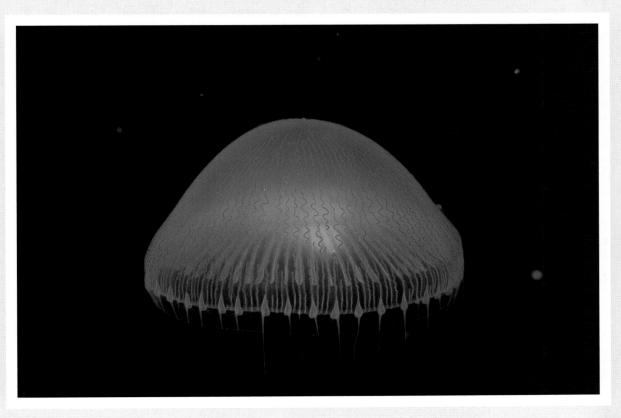

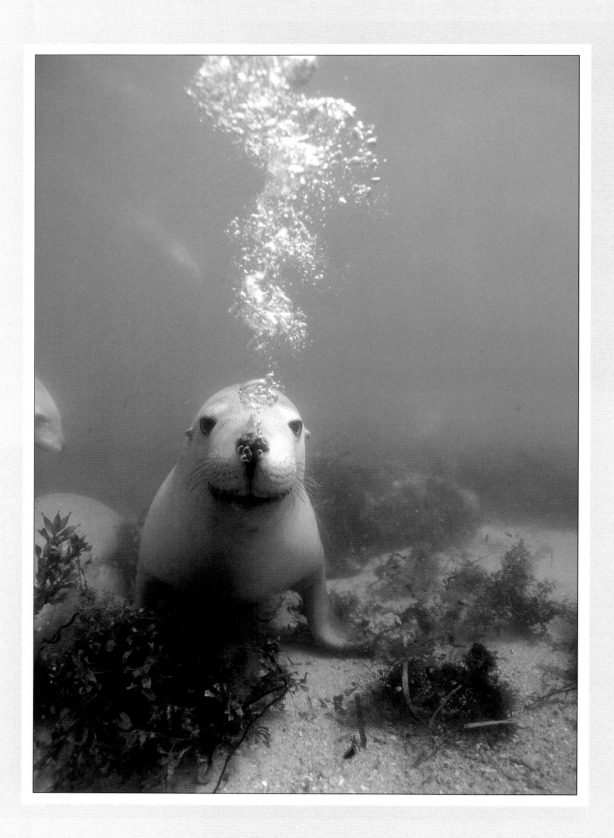

Brent Hedges
Australia
HIGHLY COMMENDED

Australian fur seal

"We were returning from an unsuccessful trip to look for great white sharks off southern Australia, when despite the rough weather we decided to go for a dive with seals. Normally the water is crystal clear at the Hopkins Island dive site but on this occasion it was murky green. So I used a wide angle lens and got very close to take the picture."

Nikon F4 with 24mm lens in underwater housing; 1/60 sec at f5.6; Kodachrome 64

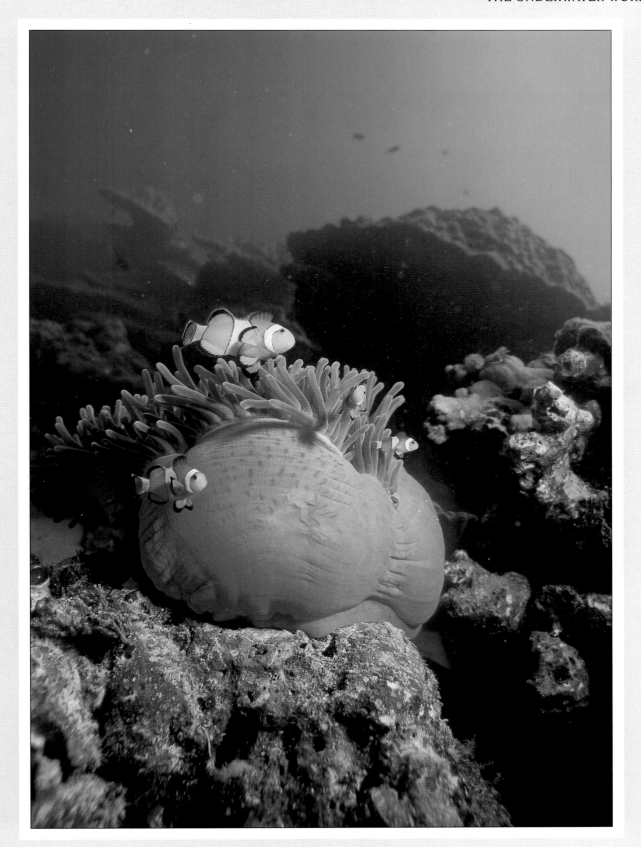

Georgette Douwma
The Netherlands
HIGHLY COMMENDED

Anemone with clownfish

"False clown anemonefish get shelter and protection from the anemones they live with. This anemone was photographed at about nine metres depth in the Indian Ocean, off the Similan Islands, Thailand. At this depth the colour of the anemone does not show up because the water acts like a blue filter. Only by using a flash are the anemone's true colours revealed."

Pentax LX with 20mm lens in underwater housing; flash; 1/60 sec at f8; Fujichrome Velvia

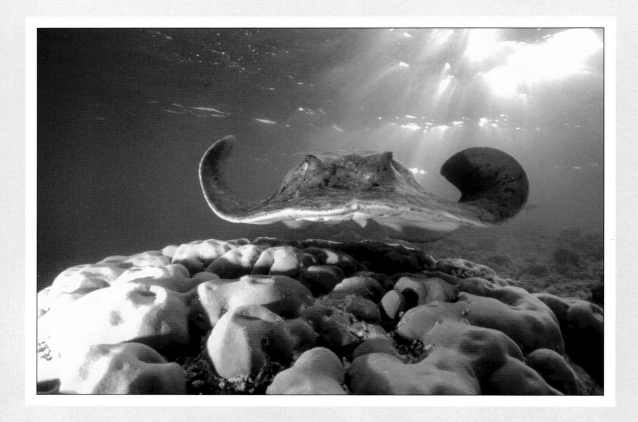

Kurt Amsler
Switzerland
HIGHLY COMMENDED

Spotted stingray

"Stingrays are common off the island of Ihuru in the Maldives. Every evening at sunset, they would swim across the reef to reach the shelter of a shallow lagoon. By positioning myself on the reef and waiting I was able to get this shot."

Nikonos RSAF with 30-35mm lens; 1/30 sec at f5.6; Fujichrome Velvia

Kurt Amsler
Switzerland
HIGHLY COMMENDED

Giant barracuda

"Barracudas can be shy of divers but this one, photographed off Key Largo, Florida, was attracted by the light reflected from my camera lens. It was an enormous fish, well over a metre long. The barracuda swam in circles around me, and I waited until the sun was behind it to get a sunburst pattern on its back."

Nikon F4 with 16mm lens in underwater housing; 1/125 sec at f8; flash; Fujichrome Velvia

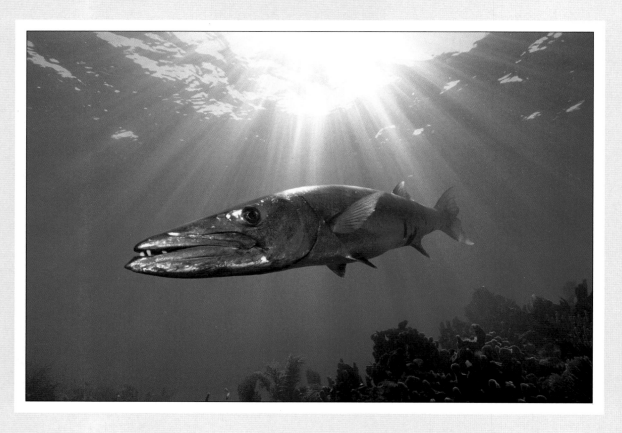

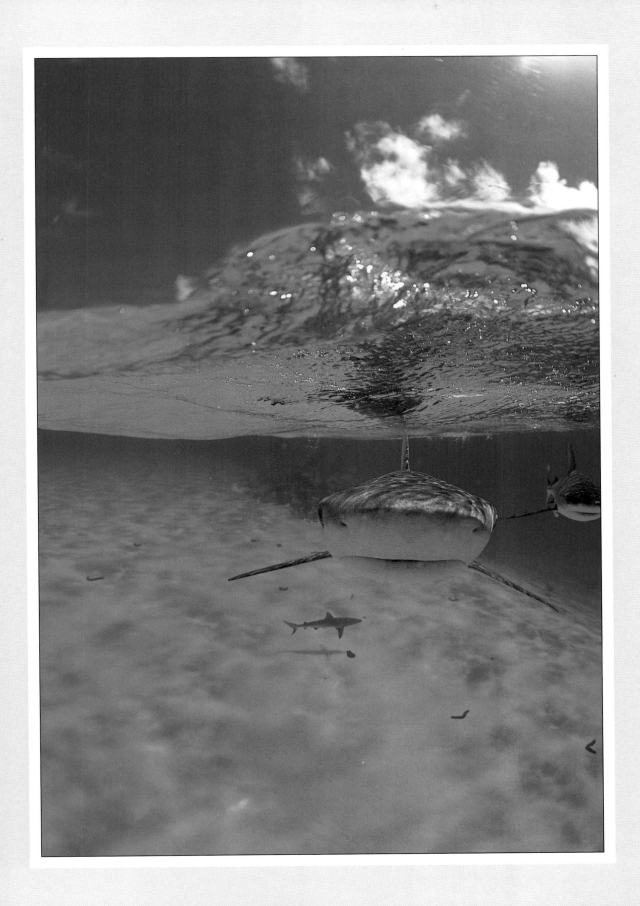

Pete Atkinson
United Kingdom
HIGHLY COMMENDED

Grey reef sharks

*"We dived with these sharks off an
oceanic reef, miles from anywhere
between the Cook Islands and Tonga.
The water was crystal clear and the
sharks behaved impeccably. I took this
photograph by holding the camera over
the side of my old yacht while a friend
attracted the sharks with a piece
of fish on a stick."*

Nikon F4 with 15mm fisheye lens in underwater
housing; 1/125 sec at f11; Fujichrome Velvia

Composition and Form

Pictures in this category must illustrate natural subjects in abstract ways, and are judged for their aesthetic values. No prizes were awarded this year but the judges commended 10 images.

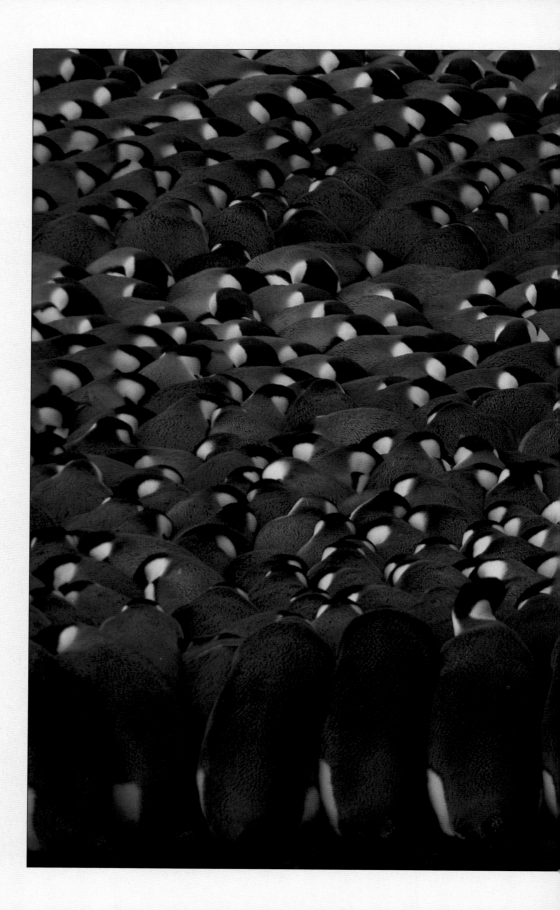

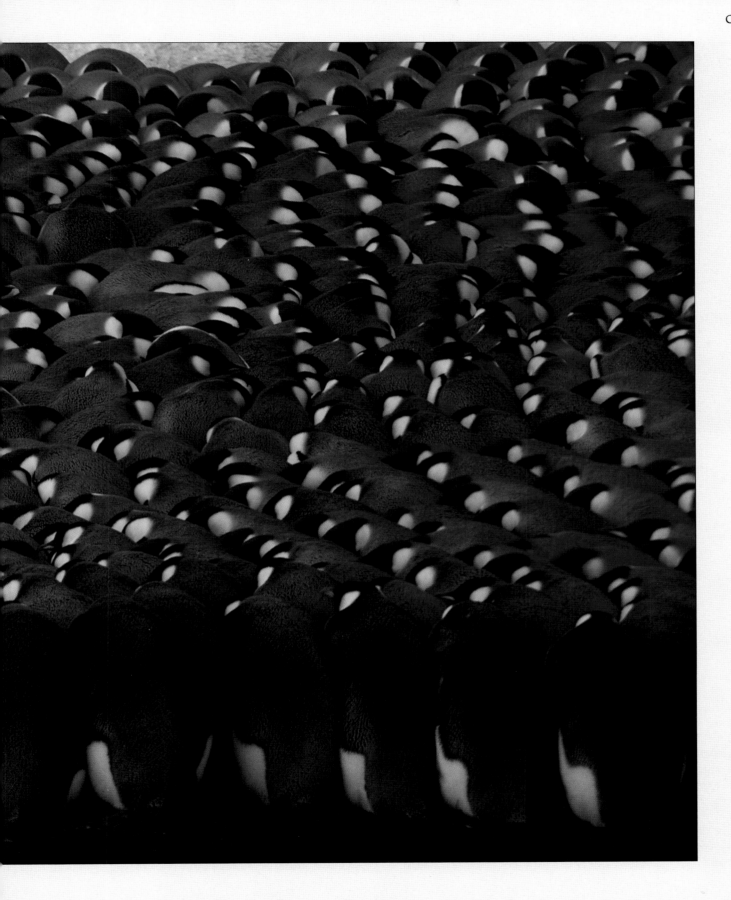

Stephen de Vere
United Kingdom
HIGHLY COMMENDED

Emperor penguin huddle

"One week after mid-winter's day on the Mawson coast of Antarctica, I photographed this group of emperor penguins. They are all males, huddling together to keep warm in an air temperature of minus 29°C plus wind-chill. Each one is incubating a single egg on top of his feet."

Nikon FM2 with 300mm lens and x2 teleconverter; tripod; 1 sec at f5.6; Kodachrome 64

Fred Bavendam
United States of America
HIGHLY COMMENDED

Moon jellyfish

"At Ningaloo Reef, Western Australia, moon jellyfish sometimes occur in vast numbers. I took this photograph without any artificial light because the jellyfish looked so good against the blue-sea background."

Nikon F4 with 20-35mm lens in underwater housing; 1/125 at f16; Fujichrome Sensia 100

Shaun Tierney
United Kingdom
HIGHLY COMMENDED

Coral carpet

"The Lembeh Straits dive site, north-east Sulawesi, is known for the elusive mandarin fish. As I only caught a fleeting glimpse of them, I decided to concentrate on photographing the carpets of coral. The colour and graphic shape of this coral (Euphyllia ancora) stood out among the staghorn and lettuce corals."

Nikonos V with 35mm lens with Ikelite 1x3 extension tube; f11; Fujichrome Velvia 100

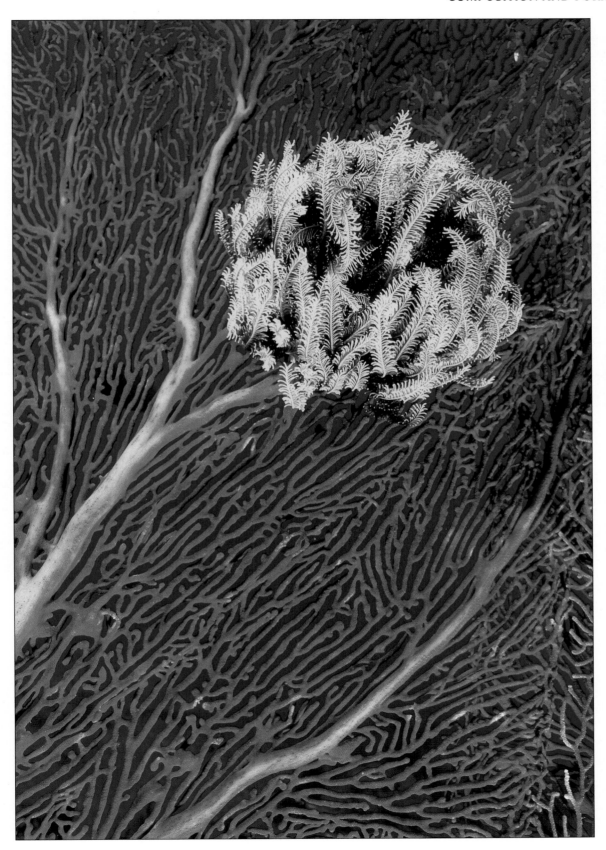

Fred Bavendam
United States of America
HIGHLY COMMENDED

Yellow crinoid on a red sea fan

"Crinoids, also known as featherstars, often crawl up prominent points on the reef, like this one on a red gorgonian sea fan. Here they are in a good position to feed in the current, using their feathery arms to strain food particles from the water. This crinoid was photographed off the coast of Papua New Guinea."

Nikon F4 with 28mm lens in underwater housing; twin strobes; 1/30 at f11; Fujichrome Velvia rated at 100

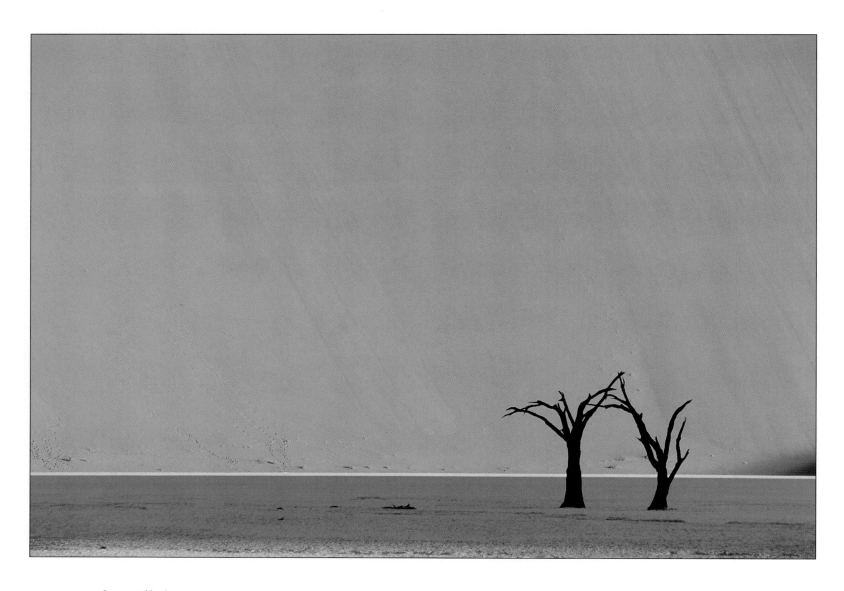

Theo Allofs
Germany
HIGHLY COMMENDED

Dead acacia trees and sand dune

"The simplicity and stark beauty of this Namib desert landscape particularly struck me. The mighty red sand dunes contrasted with the low-lying parched white clay. For me the two dead acacia trees seemed to enhance the absolute loneliness of this awe-inspiring place."

Nikon F4s with 80-200mm lens; 1/250 sec at f11; Fujichrome Velvia rated at 40

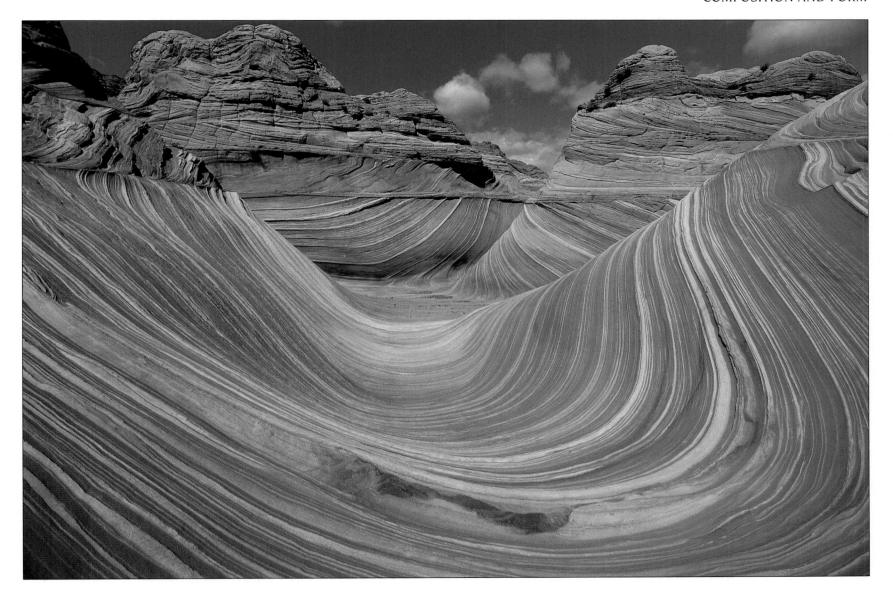

Norbert Rosing
Germany
HIGHLY COMMENDED

Sandstone formations

"The Paria Wilderness Area in northern Arizona is one of the most breathtaking landscapes on earth. It is remote and only accessible by a walk of several hours. The patterns on this particular rock really caught my attention."

Leica R6.2 with 15mm lens; 1/60 sec at f16; Fujichrome Velvia

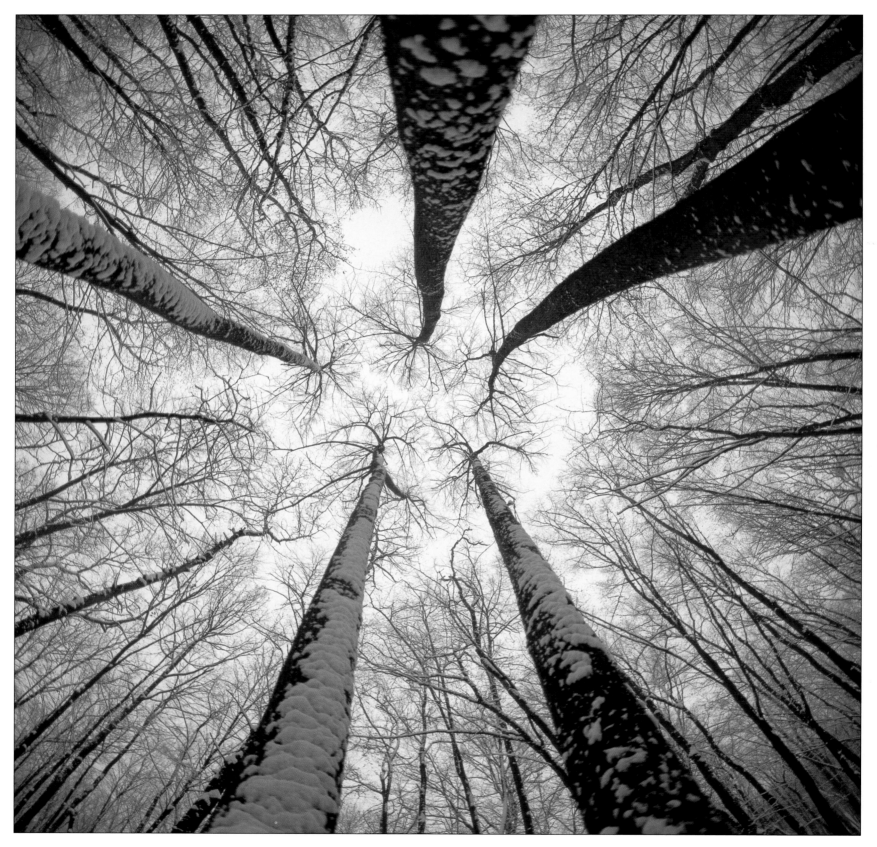

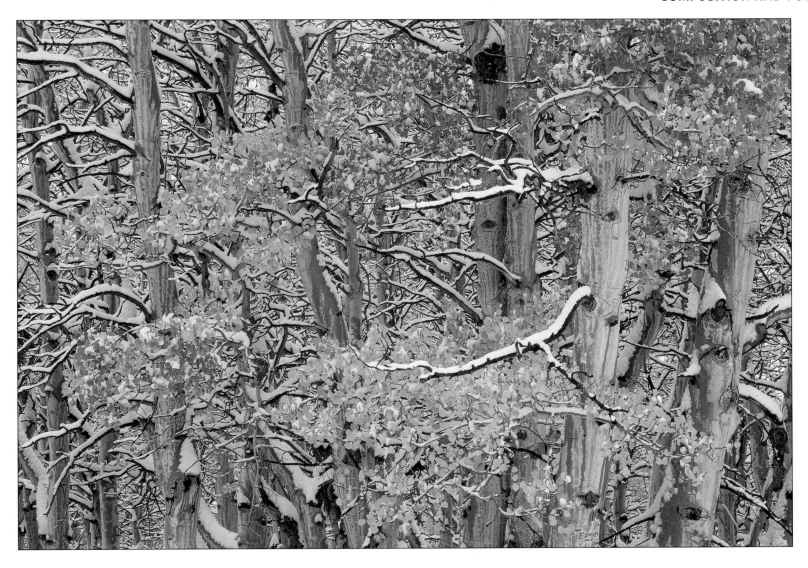

Roman Radaci
Czech Republic
HIGHLY COMMENDED

Winter forest

"When I reached these trees in the early morning, the snow was falling. I waited for a moment in the hope that the snow would stop but I realised I might lose the light so I started taking photographs. Trees without leaves remind me of the structure of human lungs. By providing us with oxygen trees act as the lungs of our planet"

Kiev 88TTL with 30mm fisheye lens; blue filter; 1/30 sec at f4; Fujichrome Velvia

Jeff Foott
United States of America
HIGHLY COMMENDED

Aspens in the snow

"When the first snow of the season came, the aspen leaves still had some colour. I liked the contrast between the snow-covered bark and the bright colours of the leaves."

Arca Swiss 4x5 with 180mm lens; tripod; 1 sec at f32

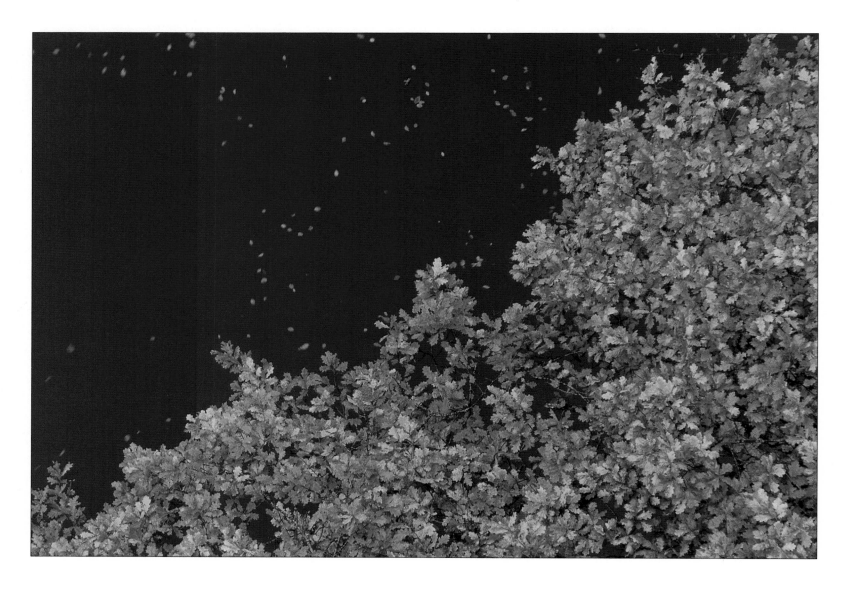

Steve Austin
United Kingdom
HIGHLY COMMENDED

Autumn oak

"The steep sides of Killiecrankie Pass in Scotland allow you to get unusual viewpoints looking down on the trees. I liked the effect of this picture because it looks as if the leaves are blowing off the oak tree, when in fact they were floating on the river under an overhanging branch."

Ricoh XR-X with 70-200mm lens; tripod;
1/30 sec at f8; Fujichrome Velvia

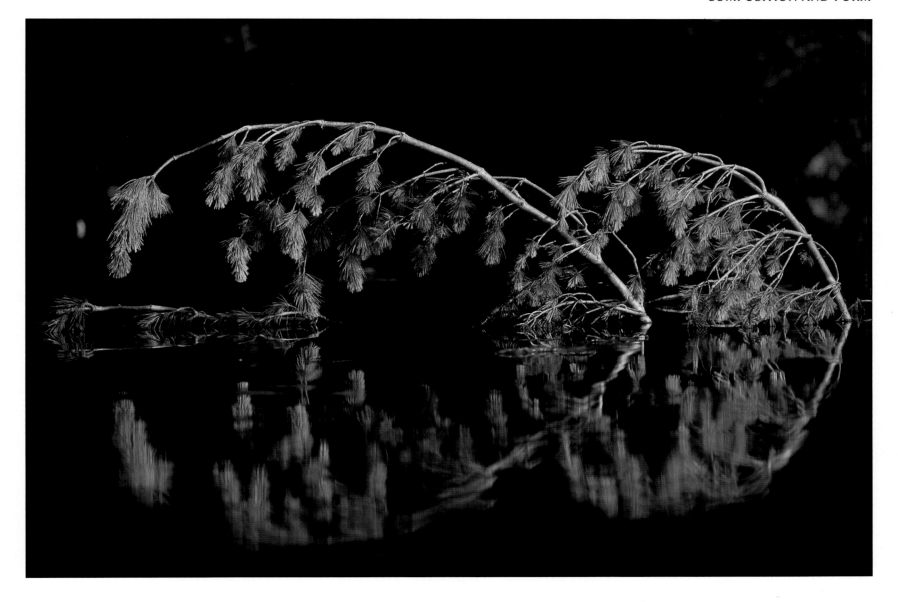

Stephen Kirkpatrick
United States of America
HIGHLY COMMENDED

Dead pine tree and reflection

"After taking photographs from a boat in
a small swampy bay in Quebec, I was
leaving at sunset when this fallen pine
tree caught my eye. I stopped the boat
and waited for all the water motion to
subside then shot several frames of this
wonderful combination of form and light."

Nikon F4 with 400mm lens; 1/60 sec at f5.6;
Fujichrome Velvia

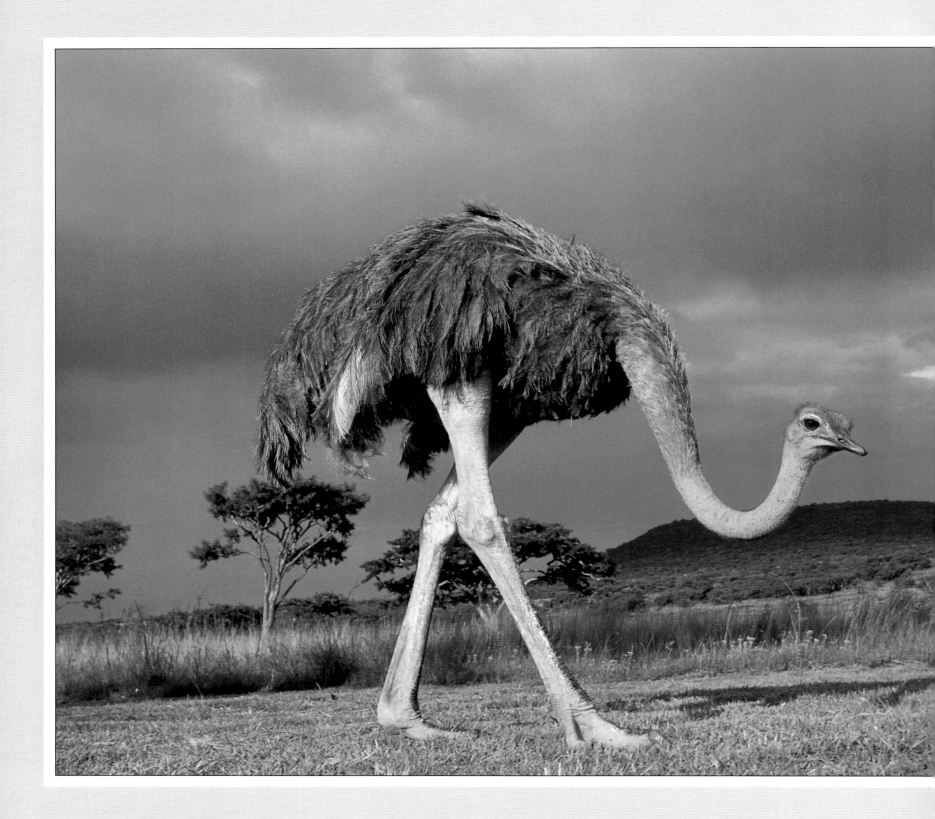

The Eric Hosking Award

This award goes to the best portfolio of six images taken by a photographer aged 26 or under. The award was introduced in 1991 in memory of Eric Hosking - probably Britain's most famous wildlife photographer. Eric was a supporter of the competition from its earliest days. The prize is a specially commissioned trophy and a cheque for £1,000.

The 1996 winner, Heinrich van den Berg from South Africa, comes from a family of enthusiastic wildlife photographers, and won his first photographic competition when he was 14 years old. He is a civil engineer but spends most of his holidays and weekends in the wild or game reserves taking pictures. He likes to find innovative and creative ways of capturing aspects of animal behaviour, and has a particular interest in birds. Heinrich is a fellow of the Photographic Society of South Africa

**Heinrich
van den Berg**
South Africa
WINNER

Female ostrich

"This ostrich was grazing close to a picnic site in the Weenen Game Reserve when I saw the dark storm clouds gather behind her. I waited for the sun to come out but only managed to get two shots before it went in."

Canon EOS 5; 20-35mm lens; 1/60 sec at f11; Fujichrome Velvia

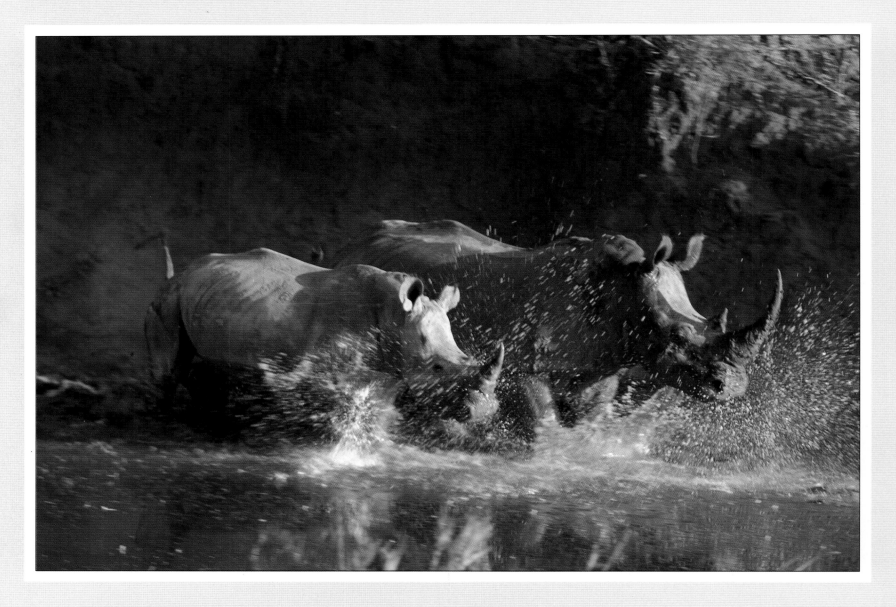

Heinrich van den Berg
South Africa

White rhinos

*"We frequently visit the Tala Game
Ranch but had never encountered white
rhinos before. The cow and her calf were
wading in one of the water holes.
They were skittish and took fright as we
got closer. Fortunately I was ready to
capture the action as they ran through
the shallow water."*

Canon F1 with 500mm lens; 1/250 sec at f4.5;
Fujichrome Velvia

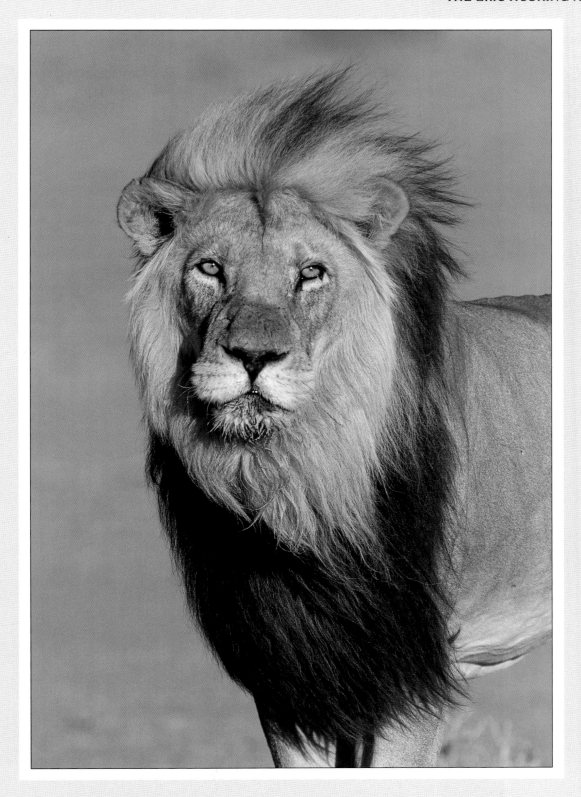

Heinrich van den Berg
South Africa

Lion portrait

"After an early summer shower in the Kalahari Gemsbok National Park, a pride of thirteen lions quenched their thirst at a temporary roadside pool. This magnificent lion granted me only a few seconds for a portrait."

Canon F1 with 500mm lens; 1/500 sec at f4.5; Fujichrome Velvia

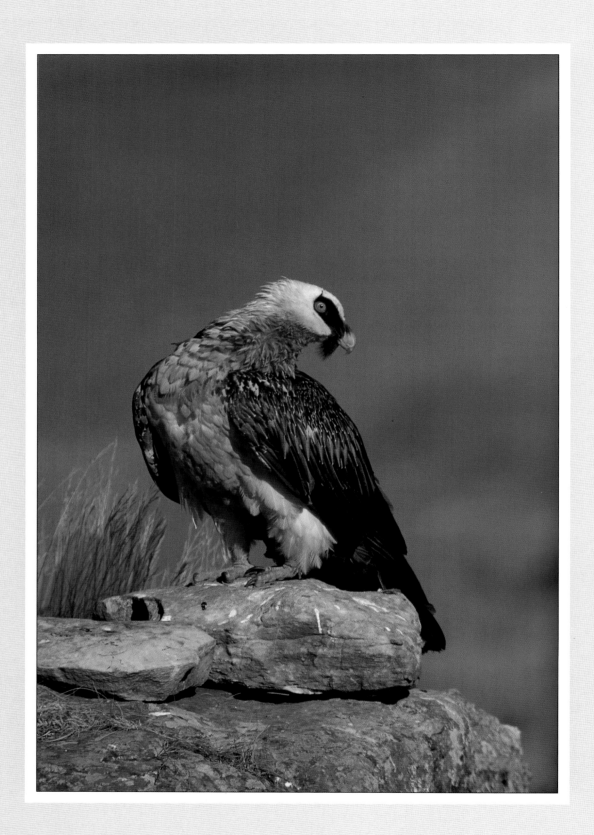

Heinrich van den Berg
South Africa

Bearded vulture

"To watch this magnificent bird, with its three metre wingspan, sweep past one of the vulture hides in the Drakensberg mountains is an exhilarating experience. The bearded vulture is an endangered species. It is timid and does not easily settle down to feed. When a vulture does come for a bone, you are so much in awe that it is easy to forget to press the camera trigger."

Olympus OM4 with 600mm lens; 1/250 sec at f11; Fujichrome Velvia

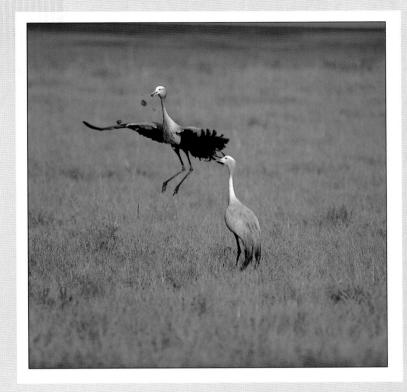

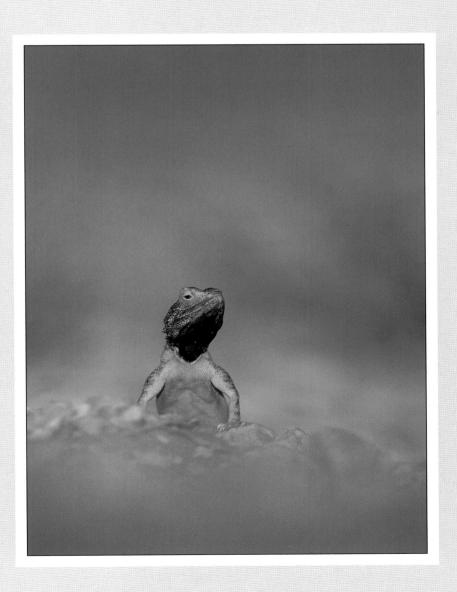

Heinrich van den Berg
South Africa

Ground agama male in breeding colours

"Late one afternoon in the Kalahari Gemsbok National Park, just before sunset, the gaudy colours of this male agama lizard caught my eye. He was sunning himself on a rock. I preferred to keep the background out of focus by getting down to his eye level."

Canon T90 with 500mm lens and x1.4 teleconverter; 1/500 sec at f6.3; Fujichrome Velvia

Heinrich van den Berg
South Africa

Blue cranes

"In spring, blue cranes perform a courtship dance. Dung is thrown into the air as part of the dance. Blue cranes are the national bird of South Africa so I was particularly excited to record their courtship behaviour."

Canon F1 with 50mm lens; 1/500 sec at f4.5; Fujichrome Velvia

119

Wild Places

Pictures in this category should be landscapes
that convey a feeling of wildness and create
a sense of wonder or awe.

Werner Reuteler
Switzerland
WINNER

Mana Pools National Park, Zimbabwe

"I have been captivated by the beauty of
Africa and have dedicated many years
to capturing it on film. I was camping in
the Mana Pools National Park in
October, and got this shot one morning as
the light filtered through the leaves and
the animals went about their morning
activities. The absence of any young
trees indicates that this magnificent
acacia forest is slowly dying."

Hasselblad 553ELX with 500mm lens; tripod;
1/15 sec at f22; Fujichrome Velvia

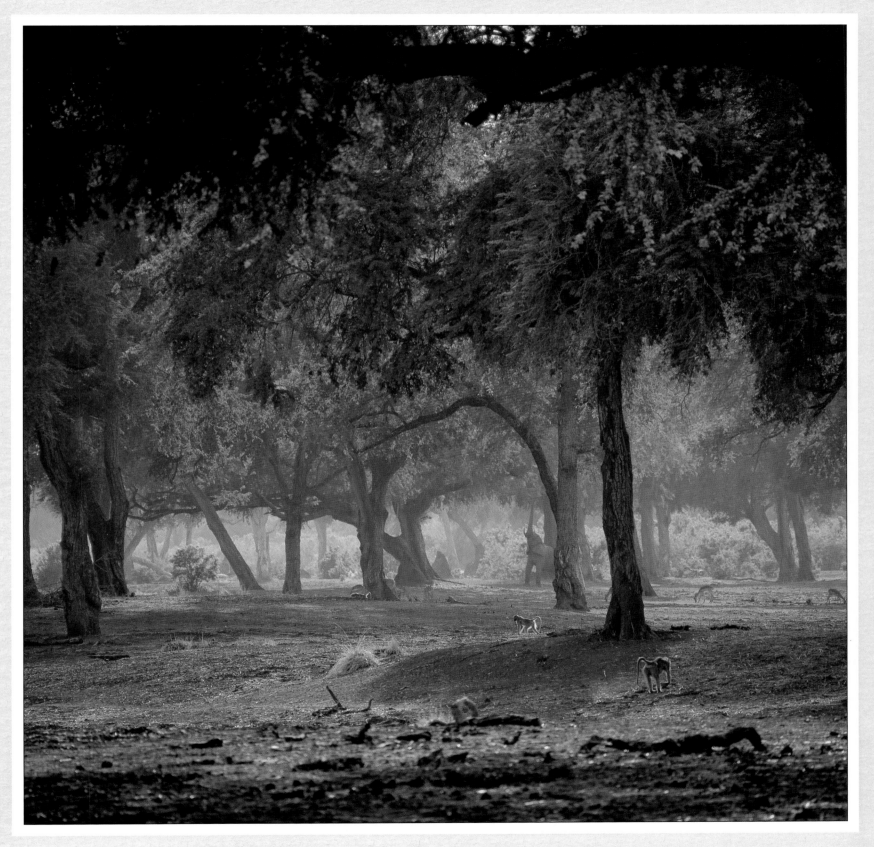

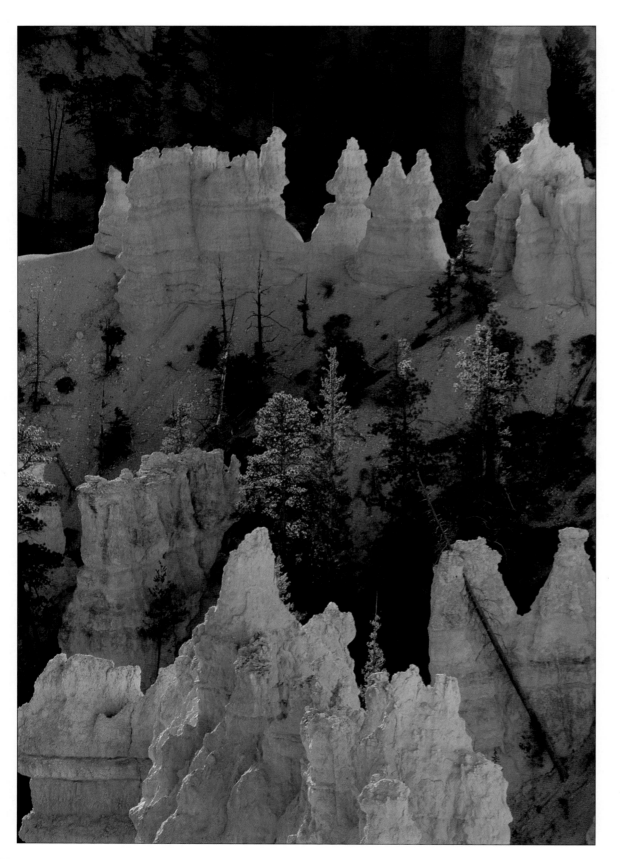

Doug Locke
United States of America
RUNNER-UP

Bryce Canyon, Utah
*"The early morning light gave the rocks
intense colour and an interesting glow.
The rock formations in Bryce Canyon are
truly spectacular and have to be among
the most beautiful in the world."*

Nikon 8008 with 300mm lens; tripod;
Fujichrome Velvia

122

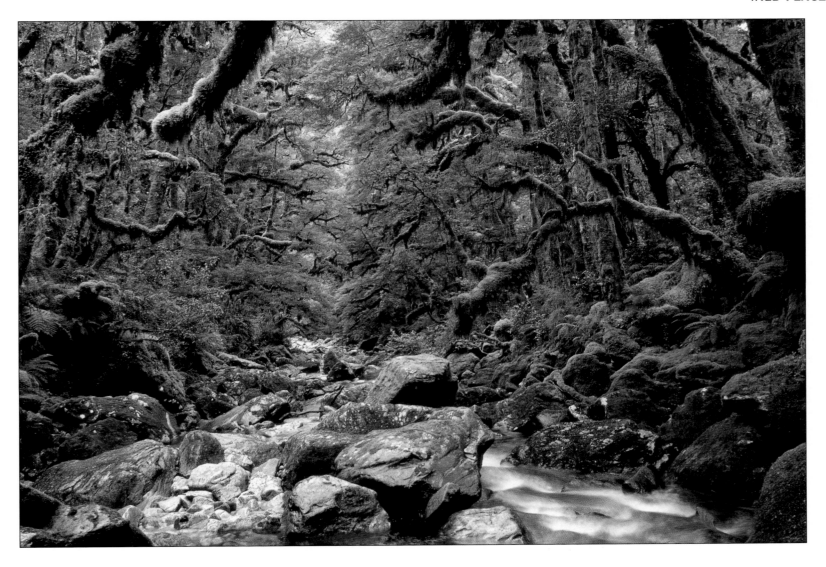

Peter Ittak
Australia
HIGHLY COMMENDED

Rainforest, New Zealand

"Walking in the Spey Valley, I noticed this beautiful rainforest scene. The day was bright but overcast with some mist, producing just the right light for capturing the damp forest with the trees draped in moss. I didn't have a tripod but balanced my camera on some rocks in the middle of the stream."

Olympus OM2 with 35-70mm lens;
Agfachrome 100

123

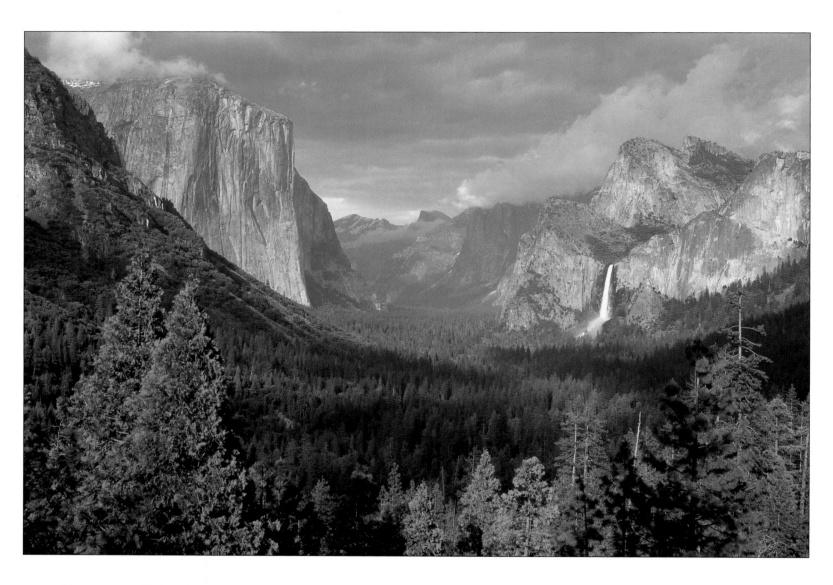

Rosemary Calvert
United Kingdom
HIGHLY COMMENDED

Yosemite National Park, California

"This view was taken from Inspiration Point looking across at El Capitan and Bridalveil Falls. It had been a week of overcast skies with flat, uninspiring light. On the last day, breaks in the clouds caused light to flood the valley intermittently. So from time to time this lovely scene came to life."

Canon EOS 10 with 28-105mm lens; tripod; 1/20 sec at f16; Fujichrome Velvia

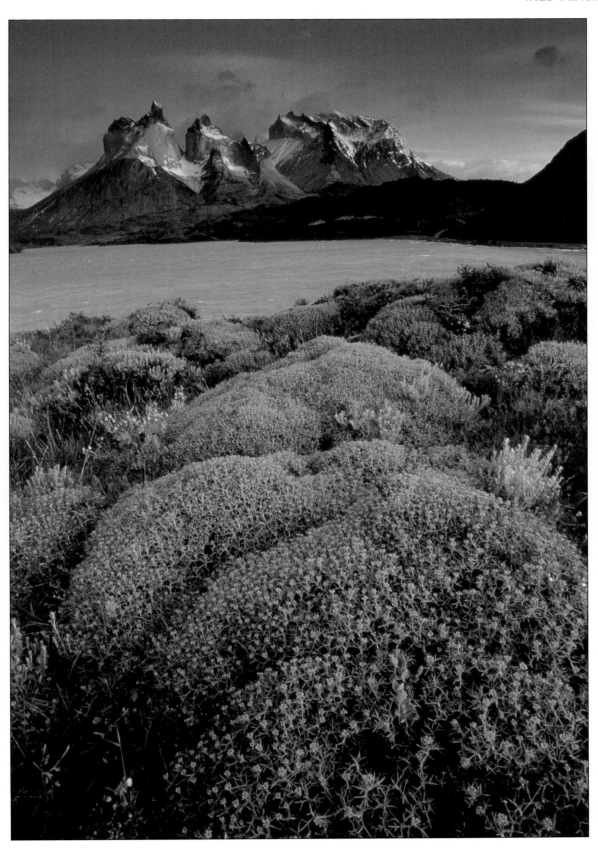

Galen Rowell
United States of America
HIGHLY COMMENDED

***Torres del Paine,
Patagonia, Chile***

*"I had been at this spot the year before,
but the light was flat and grey because
of stormy weather. The special quality of
this image is due to the warm light of the
sunrise on the peaks of the Cuernos or
horns, contrasting with the cool light of
the sky, lake, and foreground."*

Nikon F4 with 24mm lens; 1/4 sec at f16; tripod;
Fujichrome Velvia

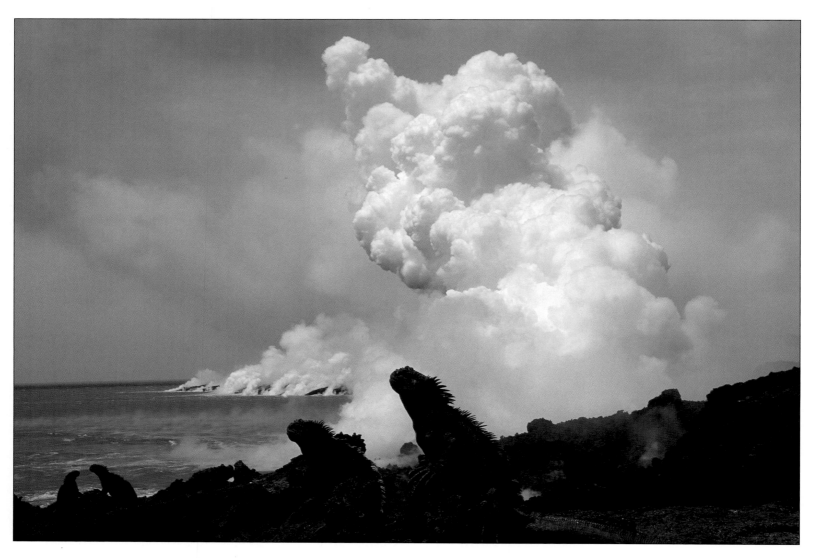

Tui De Roy
New Zealand
HIGHLY COMMENDED

Iguanas and lava flow

*"During the 1995 eruption on Fernandina,
one of the Galapagos Islands, a lava flow
entered the sea close to a cluster of marine
iguanas. Their innate reaction to overheating
is to sky-point by facing into the sun with
the body raised. Not understanding the
source of the heat, they sky-pointed for hours
even at night. Some iguanas in the path of
the lava, scrambled on top of it
and burst into flames."*

Nikon N90 with 18mm lens; tripod; f22; Fujichrome
Velvia rated at 40

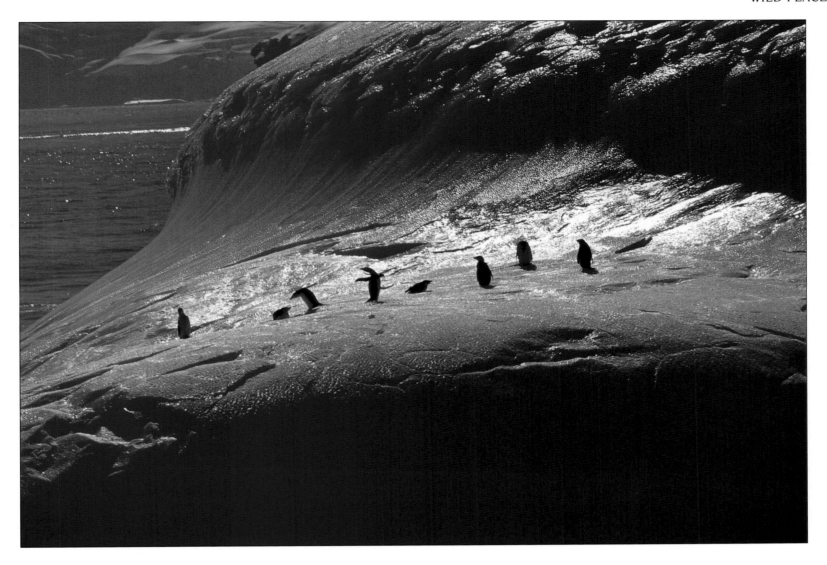

Angela Scott
Kenya
HIGHLY COMMENDED

Gentoo and chinstrap penguins on an iceberg

"Penguins thrive along the coast of the Antarctic Peninsula where I took this photograph. The light reflected off the iceberg was so bright that the penguins appear in silhouette."

Canon EOS 1N with 70-200mm lens;
1/250 sec at f11; Fujichrome Velvia rated at 80

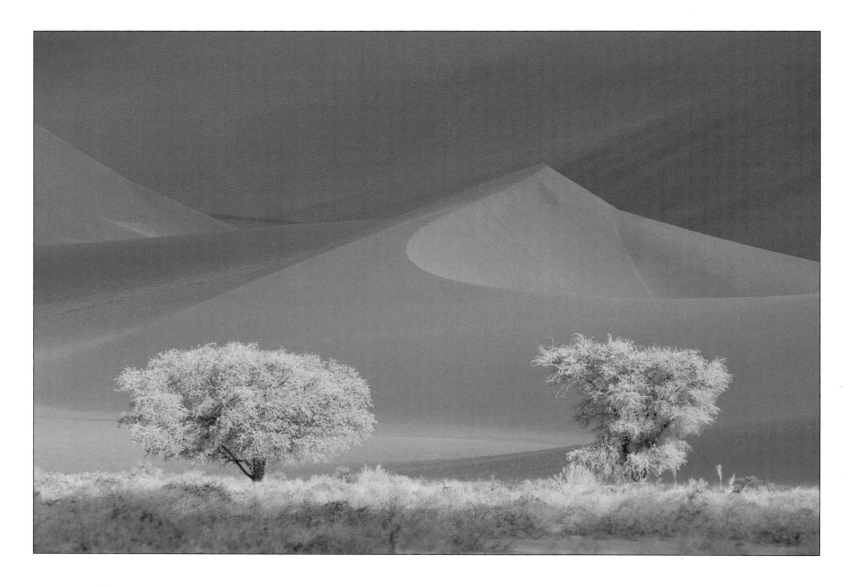

Gil Lopez-Espina
United States of America
HIGHLY COMMENDED

Namib trees

"The pale colour of these Namib desert trees is partly due to the build up of sand on their branches caused by many years of sand storms. I had a problem with severe gusts of wind. To steady the camera I rested a beanbag on it. I shielded the equipment from the wind by stretching my arms out with my jacket open. Then I triggered the camera via a cable release."

Nikon F4s with 600mm lens; tripod; 1/500 sec at f4; Kodachrome 25 rated at 32

Jan Töve Johansson
Sweden
HIGHLY COMMENDED

Riisitunturi National Park, Finland

"The trees in this park are over one hundred years old. The winter landscape is dominated by trees with heavy loads of snow on their branches and crowns. We had to ski a long distance before we could see all the snow-covered trees standing together like an army of statues."

Pentax 645 with 600mm lens; tripod; 1/2 sec at f4.5; Fujichrome Velvia

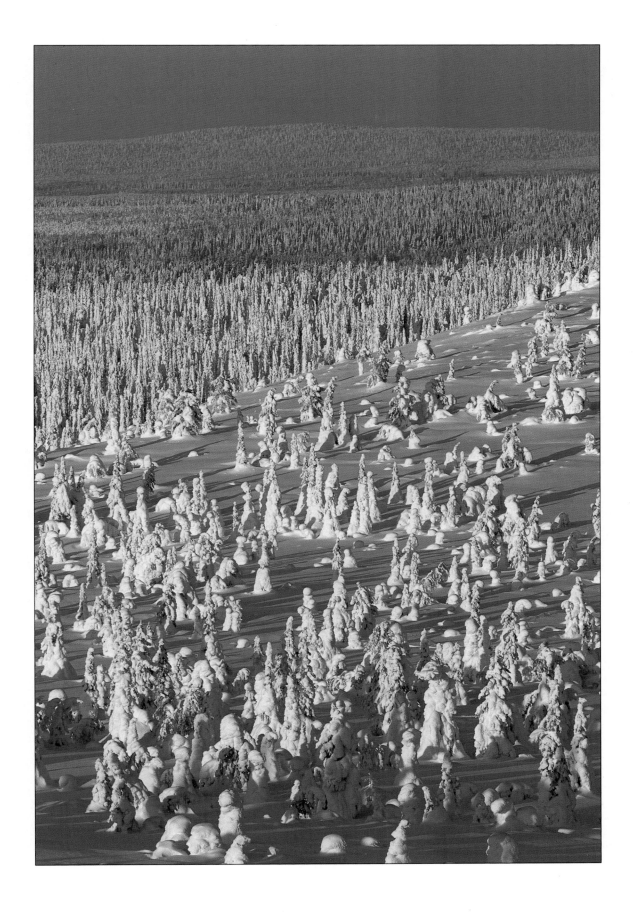

The World In Our Hands

Pictures must illustrate in a symbolic or graphic way our dependence on the natural world or our capability of inflicting harm on it.

Karl Ammann
Switzerland
WINNER

Tree felling, Cameroon

"A pygmy villager oversees a tree being felled near his village in eastern Cameroon. One criterion for cutting the tree was that it should not fall on any huts. The villagers had high hopes that the new road constructed by the logging company would allow them to take their bush meat and other produce to town markets."

Nikon F90 with wide angle zoom lens; flash; Fujichrome Velvia

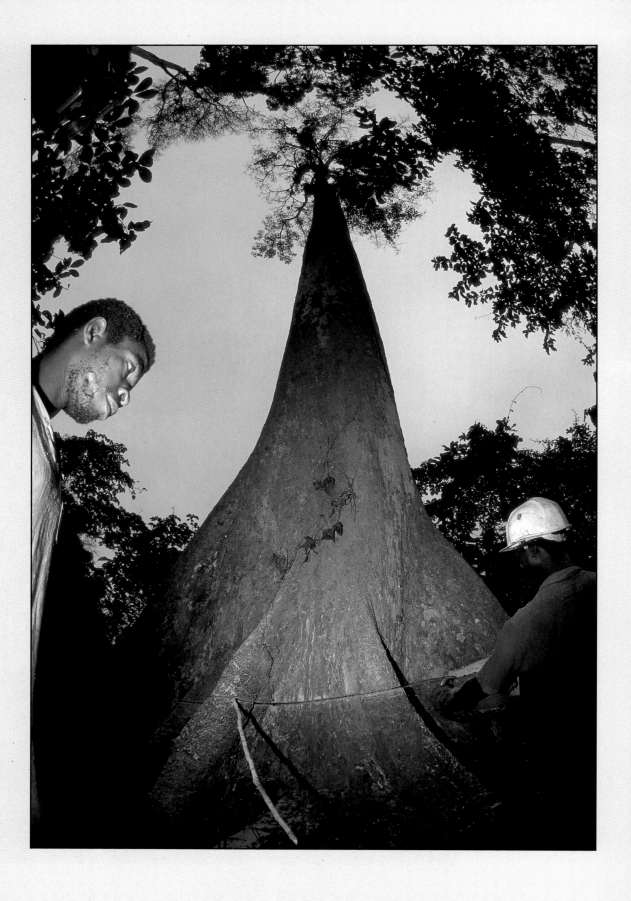

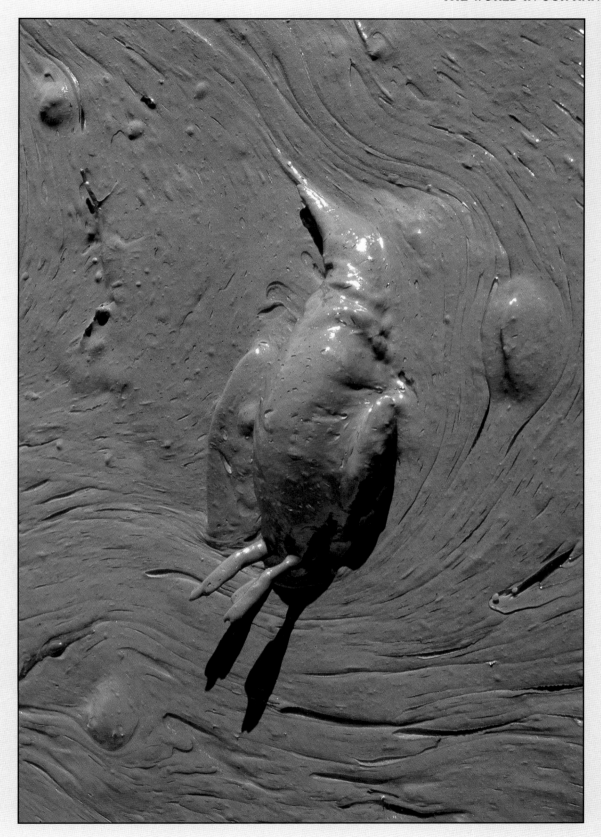

Paul Kay
United Kingdom
RUNNER-UP

Oil spill victim

"During the 'Sea Empress' oil spill disaster on the Pembrokeshire coast in February 1996, corpses of seabirds were brought in with the oil mousse. To take this shot, I waded into the mousse feeling thoroughly disgusted and disheartened. The beautiful, blue sky and brilliant sunlight seemed to light the corpses incongruously as if to highlight the disaster. A heavy oily smell permeated the air."

Nikon F4 with 24-50mm lens; 1/500 sec at f8;
Fujichrome Provia 100

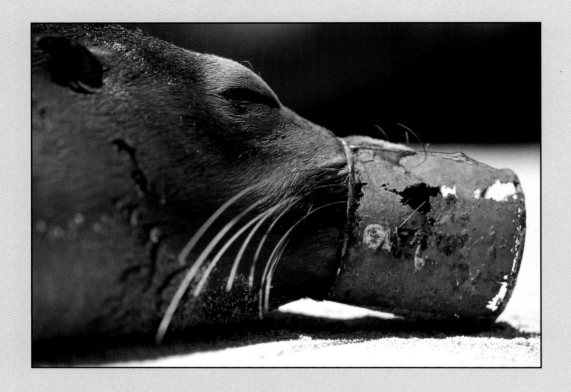

Aldo Brando
Colombia
HIGHLY COMMENDED

Sea lion's nose trapped in a rusty can

"While photographing a sea lion colony in the Galapagos Islands, I was appalled by the shocking state of this individual. The unfortunate sea lion had trapped its nose in a rusty can. Perhaps it had thrust its snout into the can out of curiosity or while looking for food. With the National Park guide we tried to approach the animal, but it kept rushing back into the sea. All I could do was to record its tortuous agony."

Nikon 8008s with 300mm lens and teleconverter; tripod; 1/125 sec at f4; Kodak 1046 PRP

William E Middleton
United Kingdom
HIGHLY COMMENDED

Young rabbit with myxomatosis

"In a local wood, I photographed one of a pair of young rabbits suffering from myxomatosis, a disease originally introduced to Britain in 1953 to control rabbit populations. Fortunately both rabbits recovered but I wanted to convey my own disgust at the way wildlife suffers from our actions."

Canon EOS 100 with 75-300mm lens; hide; tripod; 1/250 sec at f6; Fujichrome Sensia rated at 125

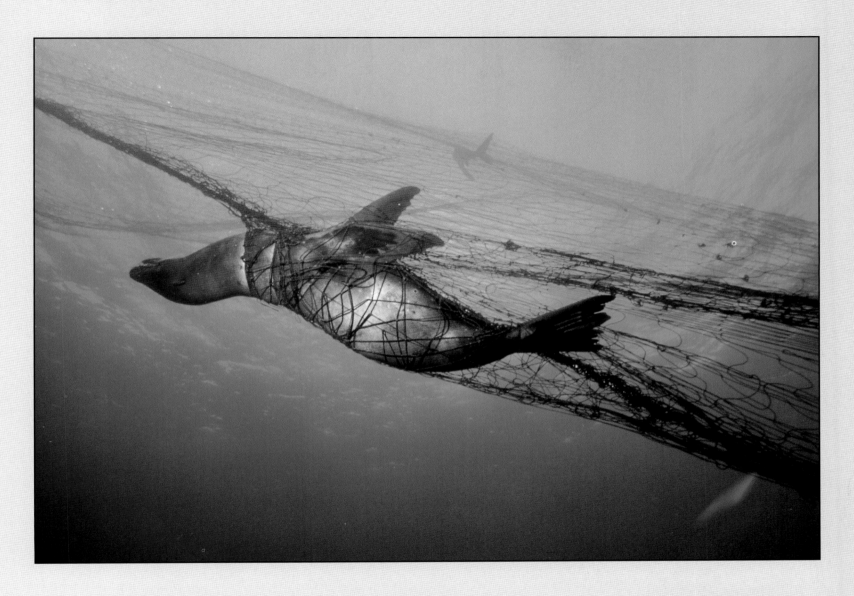

Tom Campbell
United States of America
HIGHLY COMMENDED

Sea lion drowned in a gillnet

"Drifting gillnets are notorious for trapping and drowning air-breathing animals, such as sea lions, seals, dolphins, seabirds and turtles. I photographed this unfortunate sea lion off the California coast at Santa Barbara."

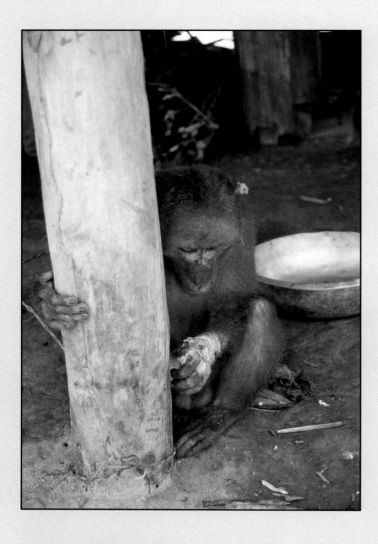

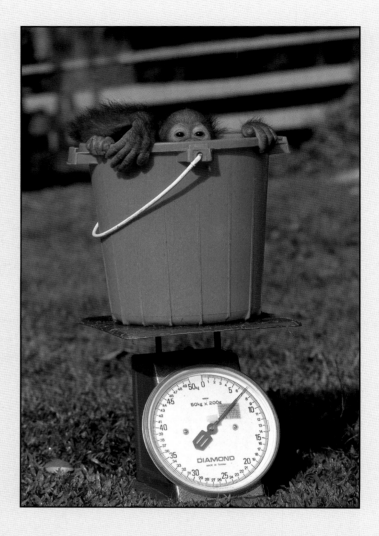

Karl Ammann
Switzerland
HIGHLY COMMENDED

Pig-tailed macaque with rotting hand

"In a village outside Vu Quang Reserve in Vietnam, a macaque is held captive by a hunter who found it in his snare. He planned to use its bones to make glue and kept the macaque alive until he was ready to do so. The hand that had been in the snare was in very bad shape. It looked like gangrene had set in. The animal was obviously in agony but quite docile."

Nikon F4 with 28-85mm lens; Kodachrome

Martin Harvey
South Africa
HIGHLY COMMENDED

Baby orang-utan at rehabilitation centre

"At the Sepilok Rehabilitation Centre in Sabah, Borneo, orphaned baby orang-utans are regularly weighed to monitor their progress. It was easy to set up the camera to photograph the babies as they were being weighed."

Canon EOS 1 with 80-200mm lens; tripod; Fujichrome Velvia

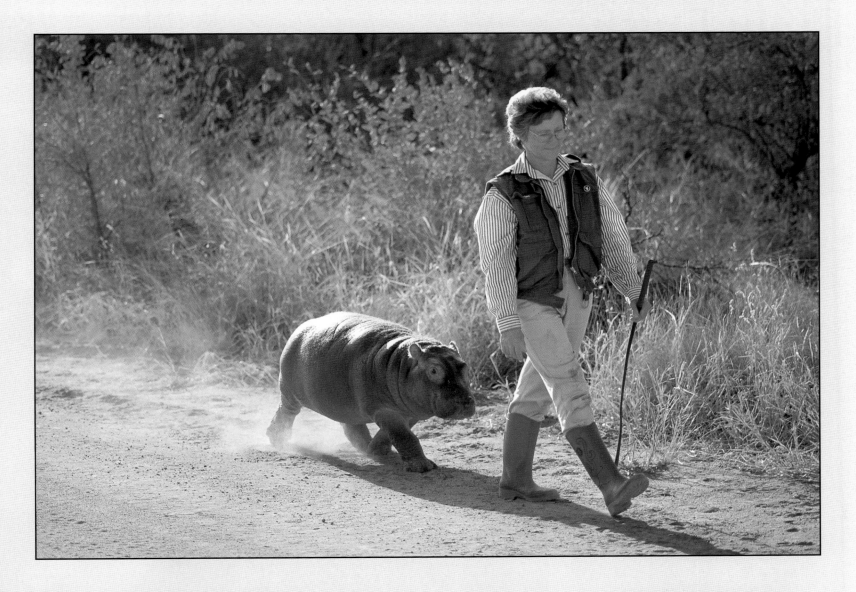

Luiz Claudio Marigo
Brazil
HIGHLY COMMENDED

Orphaned baby hippo

"This baby hippo had to be adopted when it was found as an orphan in the Lepalala Biological Reserve, South Africa. Baby hippos suckle for almost a year as well as taking solid food from about the age of three weeks."

135

From Dusk to Dawn

Pictures must have been taken between sunset and sunrise (the sun may be on but not above the horizon) and must feature animals.

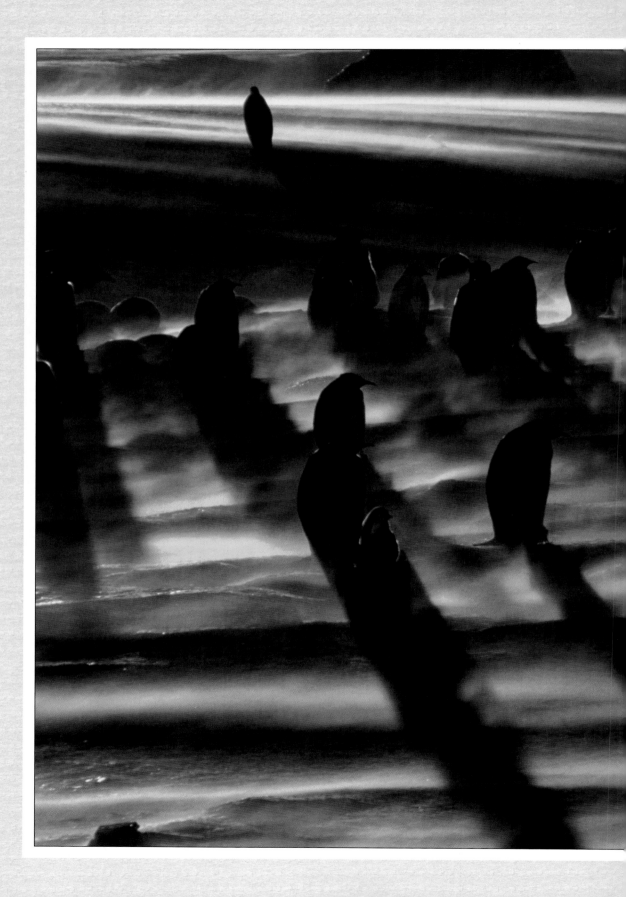

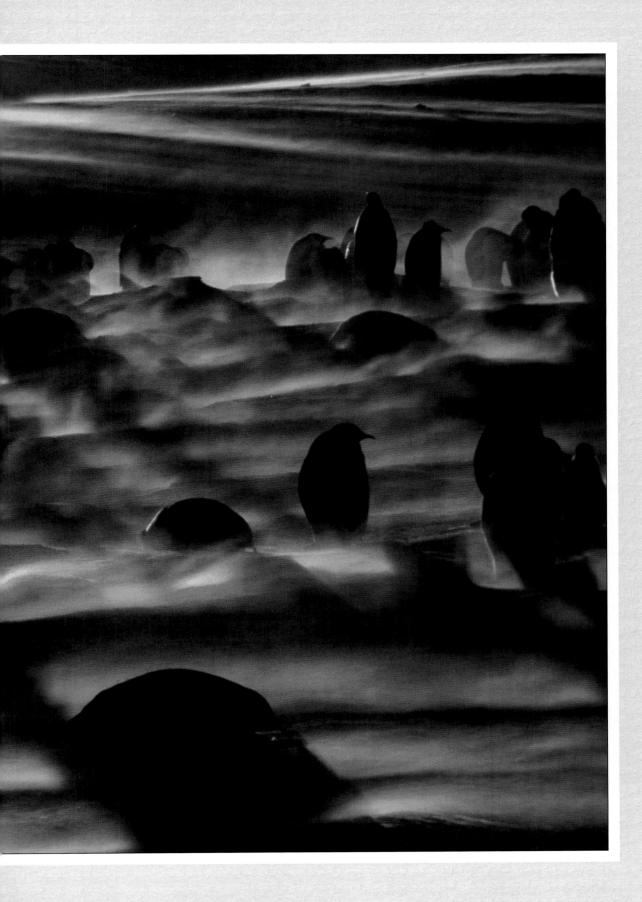

Frans Lanting
The Netherlands
WINNER

Emperor penguin colony

*"With a small party of companions,
I spent a month among 7,000 emperor
penguins on the frozen edge of the
Weddell Sea, Antarctica. Processions of
adult penguins marched back and forth
between the colony and the nearest open
sea, which was many miles away.
During our stay, we experienced the
transition from late winter to early
summer. There were gales that flattened
our tents and times of calm with the
emperors travelling through a landscape
of otherworldly light."*

Nikon N90 with 300mm lens; Fujichrome

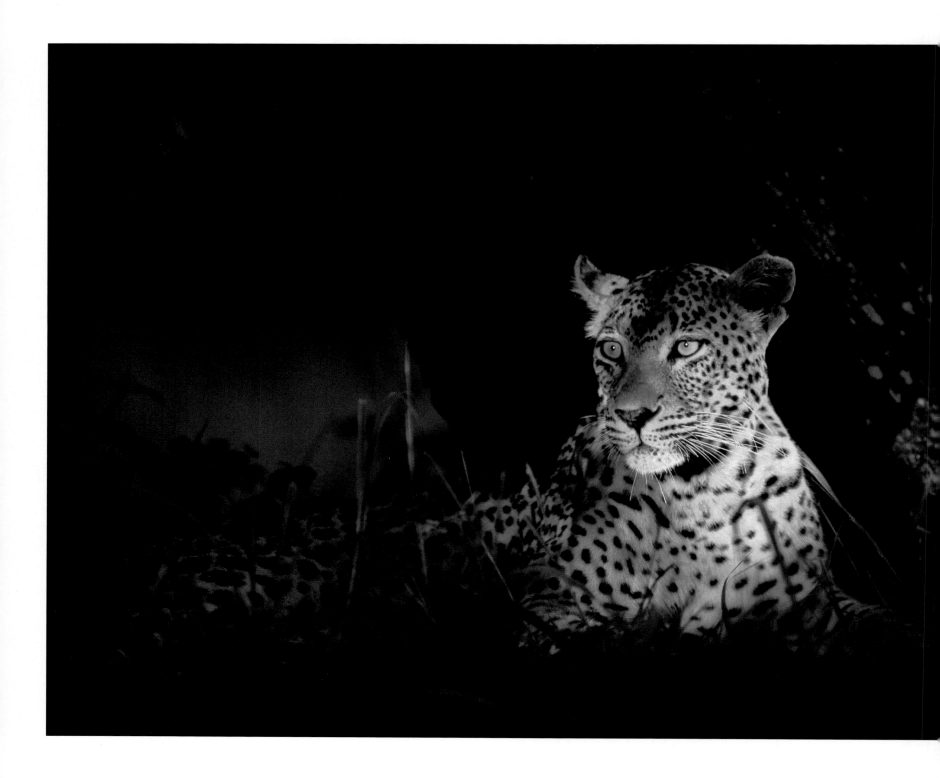

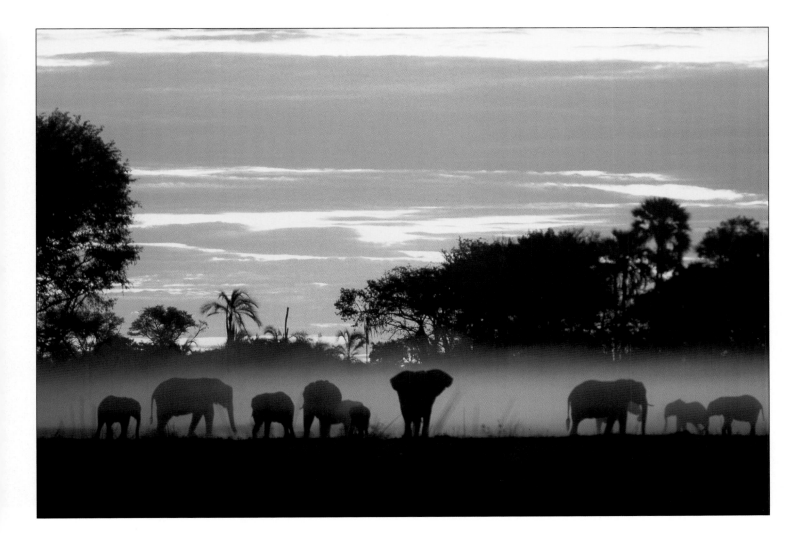

Chris Daphne
South Africa
RUNNER-UP

Leopard

"*Working as a ranger on the Mala Mala
Game Reserve in South Africa, I came across
this female leopard early one evening.
Mala Mala is a private reserve that borders
the Kruger National Park.*"

Minolta Dynax 7xi with 80-200mm lens; 1/60 sec at f2.8;
Fujichrome Sensia 100 rated at 200

David Hamman
Botswana
HIGHLY COMMENDED

Elephant dust

"*The sun began to edge closer to the horizon,
as we watched a small herd of elephants
create dust while feeding on devil's thorns in
the Okavango Delta. The lower the sun, the
more tantalizing the colours became.
The colour combined with the dust gave us
the atmospheric effect for a beautiful image.*"

Canon T90 with 300mm lens; beanbag;
1/60 second at f2.8; Fujichrome 100

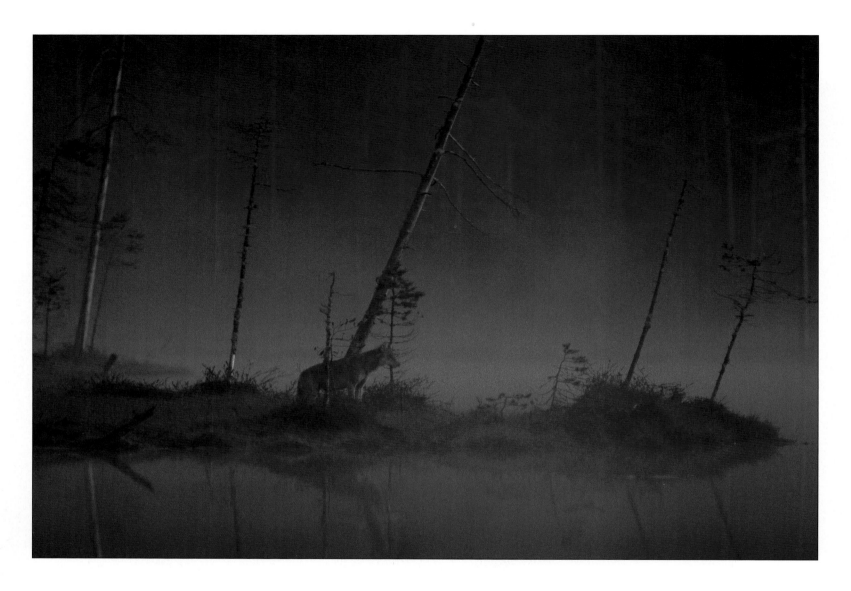

Seppo Ronkainen
Finland
HIGHLY COMMENDED

Wolf in the mist

*"This was the female of a pair of wolves
that I had been watching near the
Russian border. The day before I took this
photograph I left a piece of meat on the
promontory for the wolves. I swam across
so that they would not pick up my scent."*

Nikon F3 with 300 mm lens; hide; Fujichrome 400

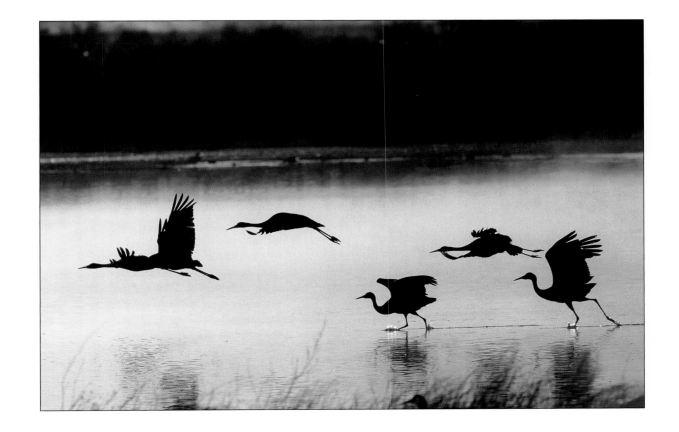

Uwe Walz
Germany
HIGHLY COMMENDED

Greater sandhill cranes at sunrise

"From this lake in New Mexico, many greater sandhill cranes fly off at sunrise to feed. It was difficult to take this picture because the mist soon disappeared."

Canon EOS 1 with 600mm lens; tripod; 1/250 sec at f4.0; Fujichrome Sensia 100

Gil Lopez-Espina
United States of America
HIGHLY COMMENDED

Blue wildebeest raising dust

"Early one morning in the Kalahari Gemsbok National Park, a large group of wildebeest moved towards their feeding ground. A magnificent rim of golden light surrounded each animal. I drove ahead of the herd and stopped in a clearing with an unobstructed view. To get a shot of just one wildebeest I had to wait until the last member of the herd passed by."

Nikon F4s with 600mm lens; car cambrac; 1/250 sec at f4; Fujichrome 100

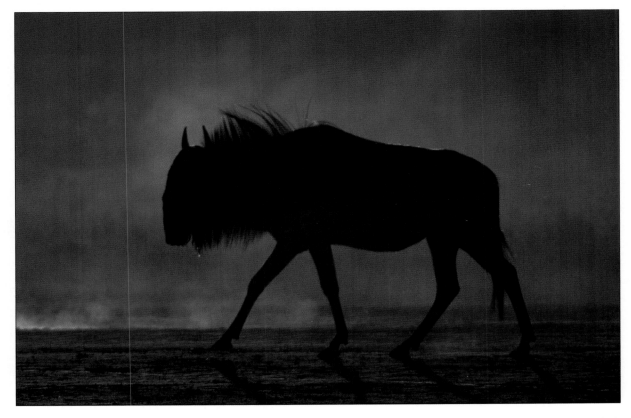

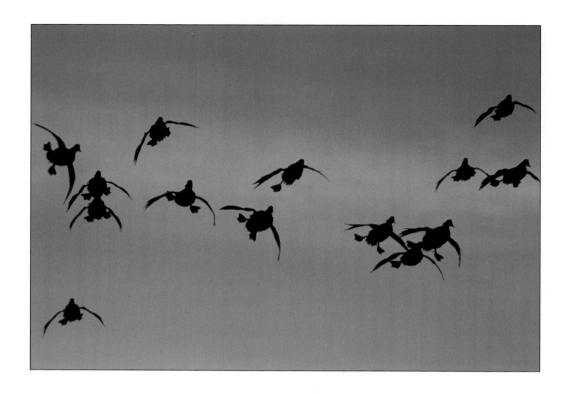

Tom Vezo
United States of America
HIGHLY COMMENDED

Canvasbacks flying in to feed

"On Long Island, New York, it was an especially cold winter and the pond where the canvasbacks usually feed was frozen over except for one small area close to shore. One morning I watched them fly in at dawn and realized what a great photograph it would make. I returned the next morning to a soft peach sunrise and the ducks flew in right on schedule."

Canon EOS A2 with 400mm lens; 1/250 sec at f5.6; Kodak Elite 100 rated at 200

Richard Packwood
United Kingdom
HIGHLY COMMENDED

Wood ibis

"Travelling in the Pantanal, Brazil, we tried to make the most of every dawn and dusk. Only once did all the necessary elements, including photogenic tree, roosting birds, and colourful sunset, coincide with our timely arrival at a place to get a good shot."

Nikon F4 with 300mm lens and x1.4 teleconverter; tripod; Fujichrome Velvia

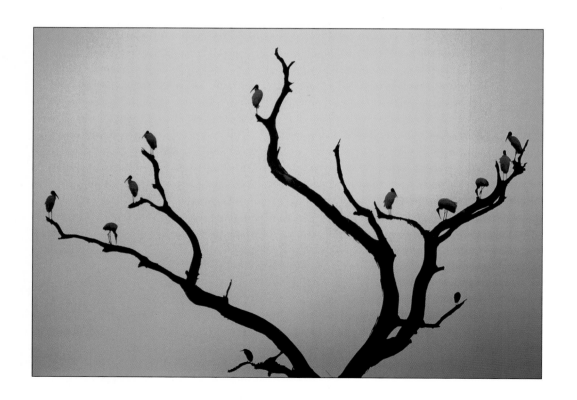

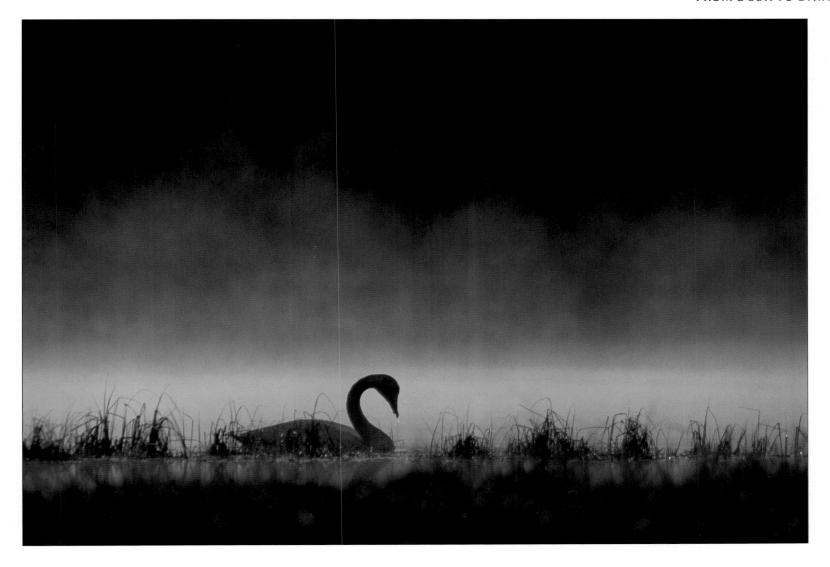

Pekka Kokko
Finland
HIGHLY COMMENDED

Whooper swan in the mist

"At the beginning of April, I returned once again to Lake Kuijarvi for my fifth year of photographing swans. I tried to capture the dramatic atmosphere of this solitary swan with the emphasis on composition instead of a close-up. The classic contrast between a snowy white swan and a dark background is also reversed."

Nikon F90 with 600mm lens; tripod;
1/125 sec at f8; Fujichrome 100

Young Wildlife Photographer of the Year

This section of the competition was open to photographers aged 17 and under. It was divided into three age categories: 10 years and under, 11 to 14 years and 15 to 17 years. Photographers were able to enter up to six images of any wildlife subject. The winner and runners-up in each age-group received cash prizes. The overall winner of the competition, 14-year-old Nicky Wilton from South Africa, received the British Gas award - a bronze sculpture of a scarlet ibis - a cheque for £500 and the opportunity to spend a day on location with wildlife photographer Heather Angel.

Nicky Wilton, this year's young overall winner, first started taking pictures when he was 8 years old. As well as his interest in photography, Nicky is also a keen sportsman and plays soccer, cricket and rugby. He is the first South African to become the 'Young Wildlife Photographer of the Year'.

Nicky Wilton
South Africa
YOUNG WILDLIFE PHOTOGRAPHER OF THE YEAR 1996

Zebras fighting

"These two zebra stallions were fighting next to a road in Kruger National Park when we drove by. Rival stallions fight over mares during the mating season. They do bite each other but serious injuries are rare."

Nikon N90 with 150-500mm lens; 1/250 sec at f8; Fujichrome 100

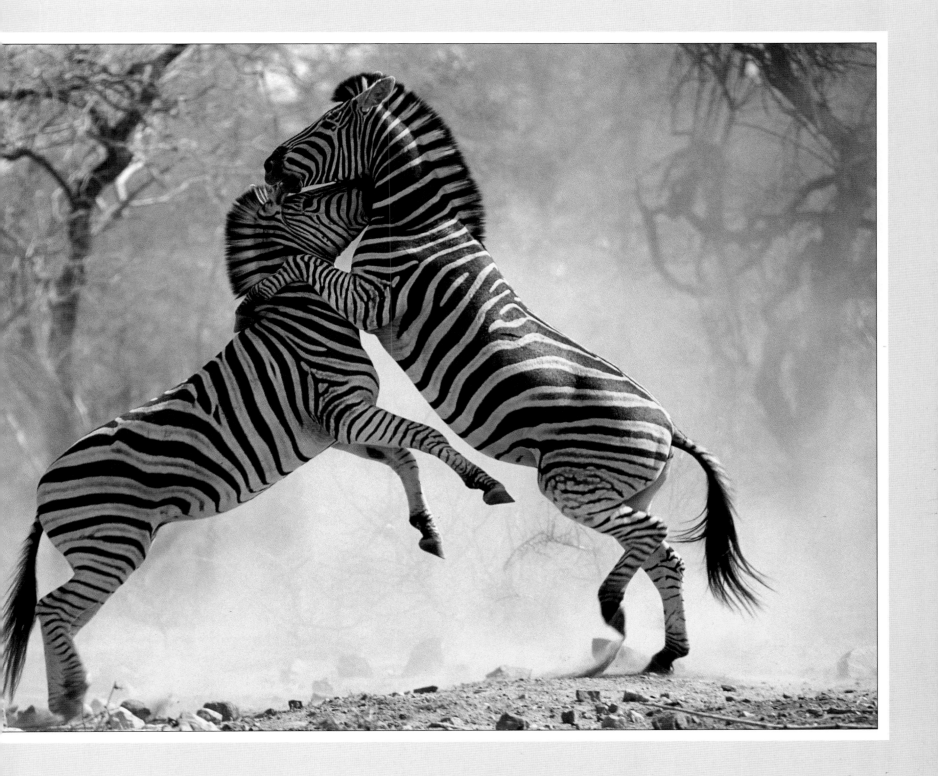

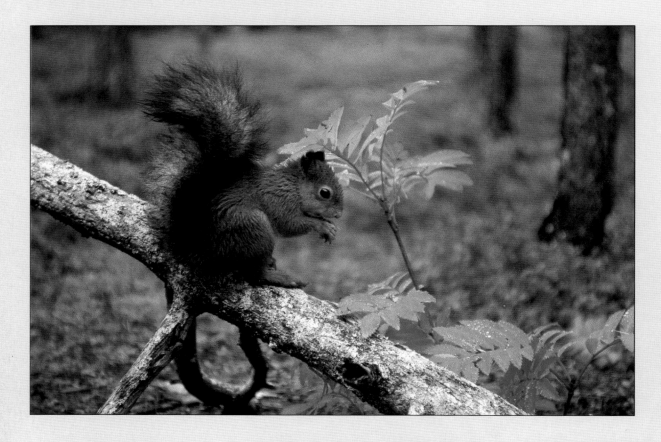

Janina Salo
Finland
WINNER: 10 YEARS & UNDER

Red squirrel

"Deep in the forest near our cottage, I hid food for the squirrels to help them through the winter. A week later the squirrels found the food. Every time a squirrel left with the food to hide it elsewhere, I crawled a little closer with my camera ready. When the right moment came, it had begun to rain."

Nikon F-801s with 80-200mm lens; Kodak Panther 200

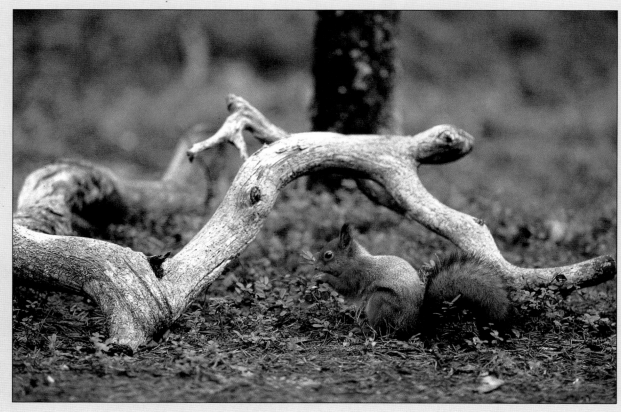

Janina Salo
Finland
RUNNER-UP: 10 YEARS & UNDER

Squirrel thief

"Squirrels make a cache of food to last them through the winter. This squirrel is taking a short-cut by stealing another squirrel's secret food store. I hid with my camera near one of the stores and waited to capture a picture when the thief came along."

Nikon F-801s with 80-200mm lens; Kodachrome 200

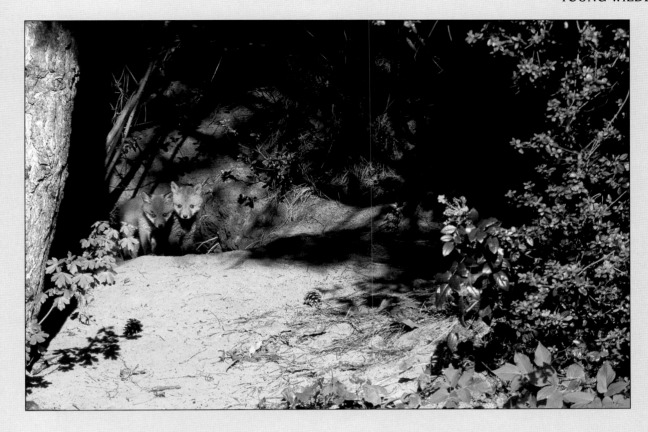

Verena Hahl
Germany
WINNER: 11-14 YEARS

Fox cubs

"For the last three years, a vixen has reared her cubs in a graveyard near my home. She is used to many peaceful visitors, and one year was seen with her cubs during the day. This year she did not come out during the day but I managed to get a photograph of the cubs at the entrance to their den."

Nikon FE with 50-300mm lens; tripod; Fujichrome 100

Nicky Wilton
South Africa
RUNNER-UP: 11-14 YEARS

Suricate family

"The two adults and five baby suricates are all alert because a bateleur eagle is soaring above. I photographed these suricates in the Kalahari Gemsbok National Park. In the ten days we spent there, we never saw this family or any other suricates again."

Nikon F90 with 150-500mm lens; 1/250 sec at f8; Fujichrome Velvia

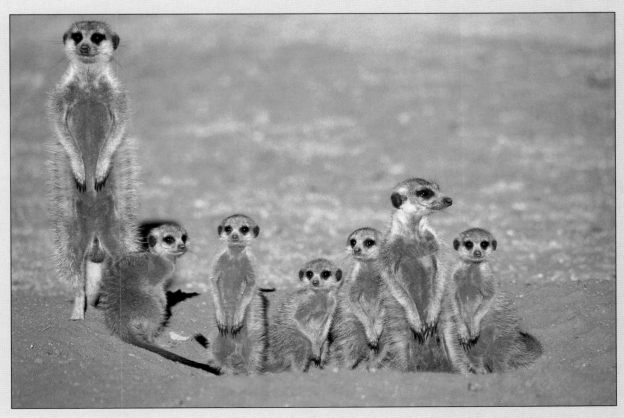

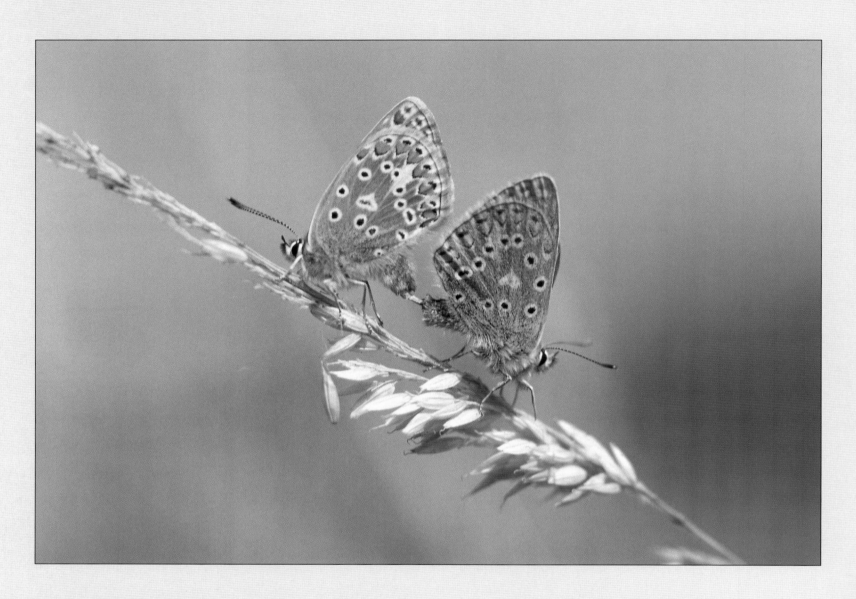

Iwan T Fletcher
United Kingdom
HIGHLY COMMENDED: 11-14 YEARS

Common blue butterflies mating

*"These mating butterflies proved a good
subject for close-up photography.
The butterflies were most active at
midday and fortunately the lighting was
acceptable. The photograph was
taken on agricultural land."*

Nikkormat FT2 with 105mm lens; 1/125 sec at f5.6;
Kodachrome 64

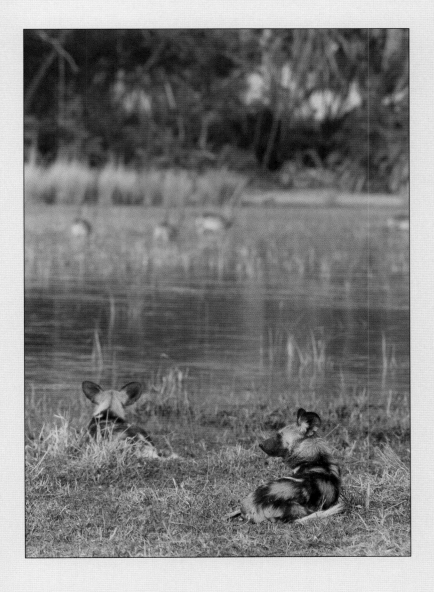

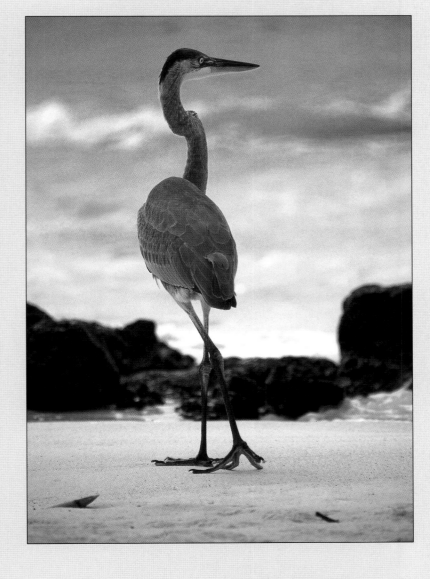

Claire Thomas
United Kingdom
WINNER: 15-17 YEARS

Wild dogs hunting red lechwe

"At dawn in the Okavango Delta, we came across a pack of wild dogs hunting lechwe. The dogs tried to follow the lechwe into a swamp but retreated when the water reached chest height. A few hunt leaders continued to look for a shallow pathway, while the rest played or kept an eye on the lechwe."

Canon EOS 5 with 400mm lens; beanbag; 1/30 sec at f11; Fujichrome Velvia

Barnaby Hall
United Kingdom
RUNNER-UP: 15-17 YEARS

Great blue heron

"My particular interest is bird photography, so on a visit to the Galapagos Islands I was keen to photograph as many species as possible. On my last day I took this picture of a juvenile great blue heron on Santa Cruz island."

Canon EOS 500 with 300mm lens; tripod; Fujichrome 200

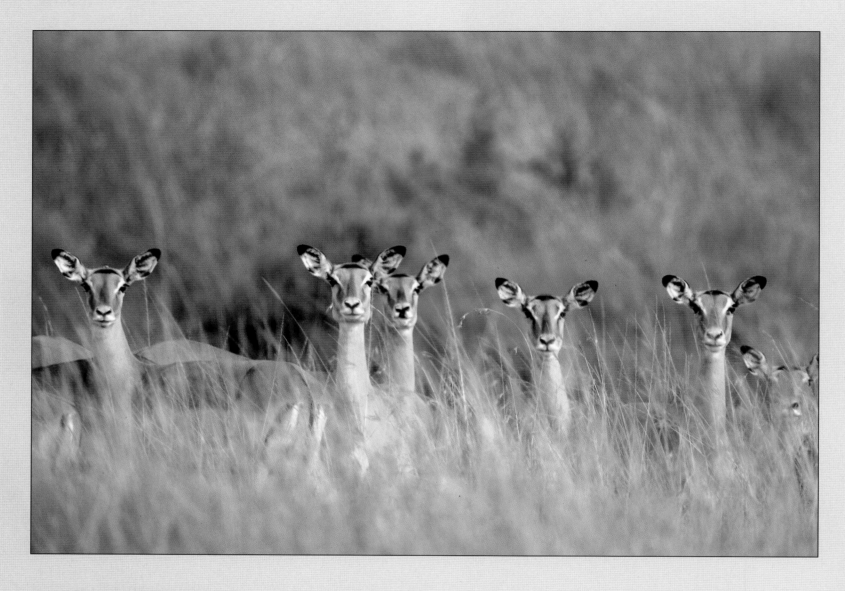

Michael Hill
United Kingdom

HIGHLY COMMENDED: 15-17 YEARS

Alert impalas

"This photograph was taken in the Maasai Mara in Kenya. Impalas always appear difficult to photograph because they never seem to form a tidy group. In this case, they were all alert to the presence of a leopard in a nearby tree."

Nikon F90 with 300mm lens; beanbag from vehicle window; 1/250 sec f5.6; Fujichrome Velvia

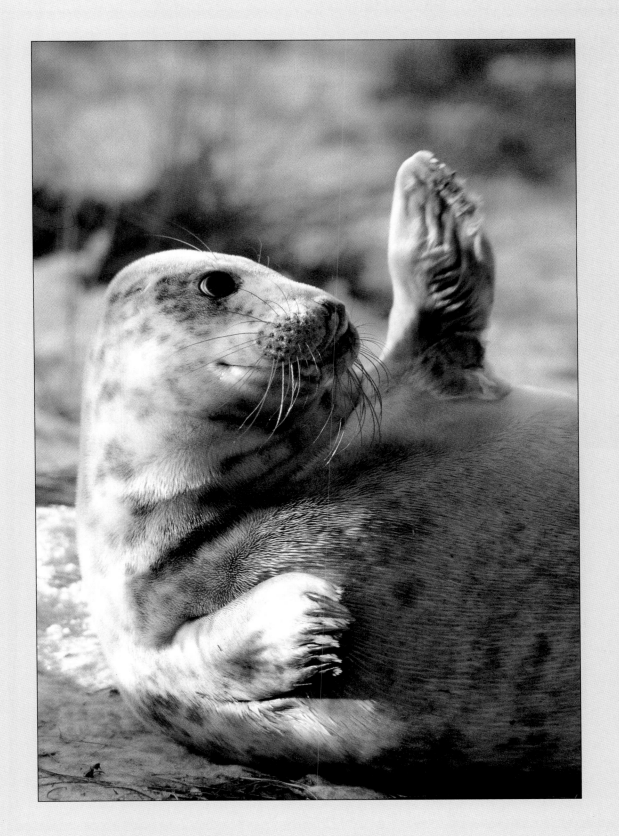

Claire Thomas
United Kingdom
HIGHLY COMMENDED: 15-17 YEARS

Grey seal pup

"On a cold bright morning on the Lincolnshire coast, I crouched near this seal pup for some time, watching as it rolled on the snow-covered sand dunes. Nearby people were enjoying a Sunday walk along the sand. Because the seal pups accepted the presence of humans, I was able to get quite close to take photographs."

Canon EOS 5 with 100-300mm lens;
Fujichrome Sensia 200

THE NATURAL HISTORY MUSEUM

SOUTH KENSINGTON LONDON

The Natural History Museum is known throughout the world for its beautiful galleries, exciting events and education programmes and innovative exhibitions about the natural world. The striking terracotta building was designed by Alfred Waterhouse, to house the nation's natural history collections, and opened to the public in 1881.

The Museum is dedicated to using its collections to promote the discovery, understanding, responsible use and enjoyment of the natural world through scientific research and world class exhibitions. Opened in July 1996, the stunning Earth Galleries are the newest exhibitions to be explored. Designed to inspire visitors about the earth sciences and the world in which we live, visitors can explore earthquakes, volcanic eruptions, landslides, meteorites, glaciers, gemstones and ancient fossils. An annual highlight of the exhibition programme is the Wildlife Photographer of the Year Exhibition.

With around 1.5 million visitors each year, The Natural History Museum is the seventh most popular paying visitor attraction in the UK. The membership scheme allows members on tours behind the scenes and to exclusive events and exhibition previews.

THE NATURAL HISTORY MUSEUM

A MEMBER OF
THE NATURAL HISTORY MUSEUM
Supported By Glaxo

The Museum's collections now number 68 million plants, animals, fossils, rocks and minerals from all regions of the world, providing an unrivalled taxonomic database. The Museum is the UK's premier institution for research on the patterns and processes of diversity on Earth and more than 300 scientists work - both in South Kensington and around the world - on research activities ranging from Systematics and Evolution to Environmental Quality.

Glossy on the outside, gritty on the inside

We take pride in publishing the world's best wildlife images with the world's most important stories. We're Britain's best-selling, award-winning monthly magazine on wildlife, conservation and the environment.

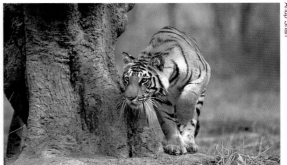

Anup Shah

Behaviour special: Nobody takes you closer to the action.

M Watson/Still Pictures (Three Gorges Dam, China)

News of the Earth: Get a clearer picture of what's really going on.

BBC Wildlife
MAGAZINE

Mark Carwardine

Portfolio choice: We showcase the best photographers' best photos – from sperm whales to slime moulds.

Index of Photographers

The numbers after the photographers' names indicate the pages on which their work can be found.

Telephone numbers are listed with international dialling codes from the UK in brackets - these should be replaced when dialling from other countries.

Jean-Jacques Alcalay
58, 72

26120 Montmeyran
FRANCE

Tel: (0033) 4 75 59 37 69

Agent:
BIOS
18/20 rue Claude Tillier
75012 Paris
FRANCE

Tel: (0033) 1 43 56 63 63
Fax: (0033) 1 43 56 65 17

Cherry Alexander
7, (Overall Winner 1995)

Higher Cottage
Manston
Sturminster Newton
Dorset DT10 1EZ
UK

Tel: 01258 473006
Fax: 01258 473333

Doug Allan
94/95

Long Mynd
The Street
Farmborough
Bath
BA3 1AL
UK

Tel: 01761 470662

Theo Allofs
68/69, 108

PO Box 5473
Haines Junctions, YT
Y0B 1L0
CANADA

Tel & Fax: (001) 403 634 2207
Tel & Fax: (0049) 2831 88504
(Germany)

Agent:
Tony Stone Images
222 Dexter Avenue North
Seattle
WA 98109
USA

Tel: (001) 206 622 6262
Fax: (001) 206 622 6662

Karl Ammann
130, 134

Box 437
Nanyuki
KENYA

Tel: (00254) 176 22448
Fax: (00254) 176 32407
E-mail: kamman@ATTMail.com

Kurt Amsler
102

PO Box 350
8810 Horgen
SWITZERLAND

Tel: (0041) 1 725 8314
Fax: (0041) 1 725 8314

Ian Andrews
66

190 Longdon Road
Knowle
Solihull
West Midlands
B93 9HU
UK

Tel: 01564 774556
Fax: 01564 774556

Pete Atkinson
79, 103

Windy Ridge
Hyams Lane
Holbrook
Ipswich
Suffolk IP9 2QF
UK

Tel: 01473 328349

Steve Austin
112

17 Burn Brae
Westhill
Inverness
IV1 2RH
UK

Tel: 01463 790533

Agent:
Papilio
Natural History & Travel Library
44 Palestine Grove
Merton
London
SW19 2QN
UK

Tel & Fax: 0181 687 2202

Adrian Bailey
10/11, 41

PO Box 1846
Houghton
2041
SOUTH AFRICA

Tel: (0027) 11 486 1473/4
Fax: (0027) 11 486 1394
E-mail: aebailey@global.co.za

Patrick Baker
42/43

Western Australian Maritime Museum
Cliff Street
Fremantle
WA 6160
AUSTRALIA

Tel: (0061) 9 431 8443
Fax: (0061) 9 335 7224
E-mail: PatB@mm.wa.gov.au

André Bärtschi
7, (Overall Winner 1992)

Bannholzstrasse 10
FL-9490 Vaduz
LIECHTENSTEIN

Tel: (004175) 232 0338
Fax: (004175) 232 0339

Agent:
Planet Earth Pictures
The Innovation Centre
225 Marsh Wall
London
E14 9FX
UK

Tel: 0171 293 2999
Fax: 0171 293 2998

Ingo Bartussek
92

Ziegeleistr 12
D-37170
Uslar
GERMANY

Tel: (0049) 5571 5959

Fred Bavendam
78, 97, 106, 107

18 Woodside Lane
Wenham
MA 01984
USA

Tel: (001) 508 468 2354
Fax: (001) 508 468 2365

Rajesh Bedi
6, (Overall Winner 1986)

Bedi Films
E-19 Rajouri Gardens
New Delhi
INDIA 110 027

Steve Bloom
53

PO Box 11733
London
N2 9NZ
UK

Tel & Fax: 0181 883 4831
E-mail: 101357.300@compuserve.com

Jim Brandenburg
6, (Overall Winner 1988)

c/o Minden Pictures
24 Seascape Village
Aptos
CA 95003
USA

Tel: (001) 408 685 1911
Fax: (001) 408 685 1913

Aldo Brando
132

PO Box 53665
Bogot
COLOMBIA

Tel: (0057) 1 249 3240
Fax: (0057) 1 249 3240

Dr Hermann Brehm
70

Speilbach 90
74575 Schrozberg
GERMANY

Tel: (0049) 7939 389
Fax: (0049) 7939 1346

Rupert Büchele
24

Waldstr 12
88486 Kirchberg
GERMANY

Tel: (0049) 7354 699
Fax: (0049) 7354 8411

Rosemary Calvert
124

Distellaan 8
2244 AX Wassenaar
THE NETHERLANDS

Tel: (0031) 70 511 2378
E-mail:
101546,2221@compuserve.com

Tom Campbell
133

238 Las Alturas Road
Santa Barbara
CA 93103
USA

Tel: (001) 805 965 4951
Fax: (001) 805 965 7449

Bernard Castelein
57, 84

Verhoevenlei 100
B-2930 Brasschaat
BELGIUM

Tel: (0032) 3 653 08 82

Marc C Chamberlain
99

1350 Las Flores Drive
Carlsbad
CA 92008
USA

Tel: (001) 619 543 3906
Fax: (001) 619 543 7876

Henri Ciechowski
54

8 rue de Bollwiller
F-68200 Mulhouse
FRANCE

Tel: (0033) 89 52 70 70
Fax: (0033) 89 50 33 66

Norman Cobley
31

1 Hilltop
Cley, Holt
Norfolk
NR25 7SE
UK

Tel: 01223 251611

Martyn Colbeck
7, 17, 51, (Overall Winner 1993)

Julian Villa
West Hill
Wincanton
Somerset BA9 9BY
UK

Tel & Fax: 01963 32443

Agent:
Oxford Scientific Films Ltd
Lower Road
Long Hanborough
Witney
Oxfordshire
OX8 8LL
UK

Tel: 01993 881881
Fax: 01993 882808

Bill Coster
72

17 Elm Road
South Woodham Ferrers
Chelmsford
Essex
CM3 5QB
UK

Tel: 01245 320066

Daniel J Cox
21

16595 Brackett Cree Road
Bozeman
Montana 59715
USA

Tel: (001) 406 686 4448
Fax: (001) 406 686 4448
E-mail: 104253,2036@compuserve.com

Mike Cruise
60/61

Kildonan
9 Clearmount Avenue
Newmilns
Ayrshire
KA16 9ER
UK

Tel: 01560 320713

Chris Daphne
138/139

PO Mala Mala Game Reserve
Via Skukuza 1353
SOUTH AFRICA

Tel: (0027) 13 735 5661
Fax: (0027) 13 735 5686

Tui De Roy
82, 126

The Roving Tortoise Photography
Patons Rock Beach
Takaka
Golden Bay
NEW ZEALAND

Tel: (0064) 3 525 8370
Fax: (0064) 3 525 8370

Stephen de Vere
104/105

New Ridge
Church Street
Beckley
Oxford
OX3 9UT
UK

Tel: 01865 351714
Fax: 01865 351714

Ulrich Döring
13

PO Box 9550
Moshi
TANZANIA

Tel: (00255) 55 50363
Fax: (00255) 55 50391 (Attn: HIMO)

Georgette Douwma
101

139 Bedford Court Mansions
Adeline Place
London
WC1B 3AH
UK

Tel: 0171 636 6477
Fax: 0171 636 6477

Richard du Toit
24/25, 56

PO Box 547
Witkoppen 2068
SOUTH AFRICA

Tel & Fax: (0027) 11 465 9919

Iwan T Fletcher
148

Pen Lon
Maes Y Llan
Llandwrog
Gwynedd
LL54 5TT
UK

Tel: 01286 830378
Fax: 01286 830378

Jeff Foott
83, 111

PO Box 2167
545 S Willow
Jackson
Wyoming 83001
USA

Tel: (001) 307 739 9383
Fax: (001) 307 739 9383

Nick Garbutt
88

c/o 30 School Road
Wales
Sheffield
S31 8QJ
UK

Tel: 01909 770954

Agent:
Planet Earth Pictures

Tel: 0171 293 2999
Fax: 0171 293 2998

John Giustina
85

2440 Olive Street
Eugene
OR 97405
USA

Tel: (001) 541 484 4328
Fax: (001) 541 485 2050
E-mail: GIUSTfoto@aol.com

Bob Glover
40

Hedge Hills
Etheldor Avenue
Hockley
Essex
SS5 5PA
UK

Tel: 01702 201959

José Luis Gomez de Francisco
45

Oviedo 22-3 A
26003 Logroño
SPAIN

Tel: (0034) 41 262398

Axel Gomille
38

Sandweg 8
D-60316 Frankfurt
GERMANY

Tel: (0049) 69 442523

Verena Hahl
147

Goethestr 13a
D-68623 Lampertheim
GERMANY

Tel: (0049) 6206 56421
Fax: (0049) 6206 56421

Barnaby Hall
149

19 Kensington Gate
London
W8 5NA
UK

Tel: 0171 589 1756
Fax: 0171 589 3200

David Hamman
139

Private Bag 159
Maun
BOTSWANA

Tel: (00267) 660 778
Fax: (00267) 661 649

Derrick Hamrick
30

3119 Tarheel Clubhouse Road
Raleigh
NC 27604-9675
USA

Tel: (001) 919 266 5611
Fax: (001) 919 266 5611

Martin Harvey
23, 58/59, 134

PO Box 8945
Hennopsmeer
0046 Pretoria
SOUTH AFRICA

Tel: (0027) 12 664 2241
Fax: (0027) 12 664 2241

Agent:
WILDLIFE
Bahrenfelder Strafle 242
D-22765 Hamburg
GERMANY

Tel: (0049) 40 39 11 93
Fax: (0049) 40 390 58 34

Hannu Hautala
33

Kiestingintie 12
SF-93600 Kuusamo
FINLAND

Tel: (00358) 89 8511 056
Fax: (00358) 89 8523 031

Brent Hedges
100

71 Arabella Street
Longueville
NSW 2066
AUSTRALIA

Tel: (0061) 2 9231 4166
Fax: (0061) 2 9418 6949

Philippe Henry
28

2656 rue Cuvillier
Montreal
Quebec
H1W 3B1
CANADA

Tel: (001) 514 528 8275
Fax: (001) 514 528 8386

Agent:
Oxford Scientific Films Ltd

Tel: 01993 881881
Fax: 01993 882808

Malcolm Hey
52

54 The Thicket
Romsey
Hampshire
SO51 5SZ
UK

Tel: 01794 513248
Fax: 01794 513248

Michael Hill
150

Benson House
Wellington College
Crowthorne
Berkshire
RG11 7PU
UK

Tel: 01344 780650

Mike Hill
34

PO Box 25005
Awali
BAHRAIN

Tel: (00973) 756292
Fax: (00973) 753624
E-mail: hillm@batelco.com.bh

Peter Ittak
123

PO Box 5016
Clayton
Vic 3168
AUSTRALIA

Tel: (0061) 3 9544 7162

Ernie Janes
67

Park House Studio
Northchurch Common
Berkhamsted
Hertfordshire
HP4 1LR
UK

Tel: 01442 871342
Fax: 01442 871342

Adam Jones
81

3415 Rems Road
Louisville
KY 40241
USA

Tel: (001) 502 327 0416
Fax: (001) 502 327 8032

Rob Jordan
64

Stonechats
Espley Hall
Morpeth
Northumberland
NE61 3DJ
UK

Tel: 01670 512761
Fax: 01670 510277

Beverly Joubert
49

PO Box 55
Kasane
BOTSWANA

Tel: (00267) 650 384
Fax: (00267) 650 223

Tony Karacsonyi
96

PO Box 407
Ulladulla
NSW 2539
AUSTRALIA

Tel: (0061) 44 554552
Fax: (0061) 44 554552

Paul Kay
131

2 Fron Pant
Pool Street
Llanfairfechan
County Conwy
LL33 0TW
UK

Tel: 01248 681361
Fax: 01248 681361

Richard & Julia Kemp
6, (Overall Winners 1984)

Valley Farmhouse
Whitwell
Norwich
Norfolk
NR10 4SQ
UK

Tel: 01603 872498

Stephen Kirkpatrick
113

764 Lake Cavalier Road
Jackson
MS 39213
USA

Tel: (001) 601 362 7100
Fax: (001) 601 981 0055

Manfred Klindwort
40

Köhlerstrasse 30
31848 Bad Münder
GERMANY

Tel: (0049) 5042 81654
Fax: (0049) 5042 81654

Pekka Kokko
143

Myllyniementie 14
FIN-53400 Lappeenranta
FINLAND

Tel: (00358) 53 458 7166

Johannes Lahti
77

Luostarinkatu 8B 51
20700 Turku
FINLAND

Tel: (00358) 21 251 9862

Frans Lanting
7, 136/137, (Overall Winner 1991)

1985 Smith Grade
Santa Cruz
California 95060
USA

Tel: (001) 408 429 1331
Fax: (001) 408 423 8324

George D Lepp
27

PO Box 6240/308 Lilac Drive
Los Osos
CA 93402
USA

Tel: (001) 805 528 7385
Fax: (001) 805 528 7387

Brian Lightfoot
66

Parkhead Croft
Balandro
Johnshaven
Montrose
DD10 0PU
UK

Tel: 01561 362017
Fax: 01561 362017

Doug Locke
122

1415 Oakbrook East
Rochester Hills
Michigan 48307-1127
USA

Tel: (001) 810 656 1625

Gil Lopez-Espina
128, 141

104 Division Avenue
Belleville
NJ 07109-2683
USA

Tel: (001) 201 751 5641
Fax: (001) 201 751 5641

Thomas D Mangelsen
7, (Overall Winner 1994)

Images of Nature, PO Box 2935
2nd Level, Gaslight Alley
Jackson, Wyoming 83001
USA

Tel: (001) 307 733 6179
Fax: (001) 307 733 6184

Luiz Claudio Marigo
15, 135

Rua General Glicério 364/604-
Laranjeiras
22245-120-Rio de Janeiro
BRAZIL

Tel: (0055) 21 285 4606
Fax: (0055) 21 556 1832
E-mail: marigo@muiraquita.com.br

Scott McKinley
80

PO Box 1358
Jackson
WY 83001
USA

Tel: (001) 307 733 3818
Fax: (001) 307 733 1805

Rita Meyer
47

28 Carletta Street
Paarl 7646
SOUTH AFRICA

Tel: (0027) 21 872 1143

William E Middleton
132

Ledaig
16 Anderson Road
Selkirk
Scotland
TD7 4EB
UK

Tel: 01750 21829

**John Eastcott
& Yva Momatiuk**
12, 71

151 Eagles Nest Road
Hurley
NY 12443
USA

Tel: (001) 914 338 4260
Fax: (001) 914 331 3204

Bruce Montagne
74

857 Union Street
Milford
Michigan 48381
USA

Tel: (001) 810 685 7240
Fax: (001) 810 685 1643

Francesc Muntada
90

Sant Pau 33
E-08221 Terrassa
Catalonia
SPAIN

Tel: (0034) 3 731 7001
Fax: (0034) 3 731 7001

Hiroshi Ogawa
86

628 Kuwata
Iwase-town
Nishiibaraki-country
Ibaraki-Pref 309 12
JAPAN

Tel: (0081) 296 76 0652
Fax: (0081) 296 76 0652

Pete Oxford
63

1414 Dexter Avenue North #327
Seattle
WA 98109
USA

Fax: (001) 206 285 5037

Richard Packwood
142

22 The Gardens
Kerry
Newtown
Powys
SY16 4NX
UK

Tel: 01686 670700

Agent:
Oxford Scientific Films Ltd

Tel: 01993 881881
Fax: 01993 882808

Monika Paulat
74/75

Feigenberg 74
76770 Hatzenbühl
GERMANY

Tel: (0049) 7275 5466
Fax: (0049) 7275 1235

Constantinos Petrinos
98

Ex-Libris Co
Solomou 4-6 & Stratigi Str
N Psychico 15451
GREECE

Tel: (0030) 1 6779 616
Fax: (0030) 1 6722 812

Greg Pierson
26

1414 S Dairy Ashford #1209
Houston
Texas 77077
USA

Tel: (001) 713 263 2301

Fritz Pölking
55, 90

Münsterstrasse 71
D-48268 Greven
GERMANY

Tel: (0049) 2571 52115
Fax: (0049) 2571 97098

Richard Price
93

16 Dryden Mansions
Queens Club Gardens
London
W14 9RG
UK

Tel: 0171 730 9633

Roman Radaci
110

Haskova 2
638 00 Brno
CZECH REPUBLIC

Tel: (0042) 5 79 34 74

Werner Reuteler
121

18 Rose Street
Newlands 7700
Cape Town
SOUTH AFRICA

Tel: (0027) 21 683 4536
Fax: (0027) 21 683 5128
E-mail: werner@igubu.saix.net

Seppo Ronkainen
140

Juortintie 5
74200 Vieremä
FINLAND

Tel: (00358) 77 714504

Norbert Rosing
35, 109

Amselweg 15
D-82284 Grafrath
GERMANY

Tel: (0049) 8144 7813
Fax: (0049) 8144 98469

Galen Rowell
125

1466 66th Street
Emeryville
CA 94608
USA

Tel: (001) 510 601 9000
Fax: (001) 510 601 9029
E-mail: galen@mountainlight.com

Jouni Ruuskanen
6, (Overall Winner 1989)

Ratakatu 31 As 14
87100 Kajaani
FINLAND

Tel: (00358) 86 133026

Janina Salo
146

Metsakaari 16c 32
05460 Hyvinkaa
FINLAND

Tom Schandy
32

Elgfaret 35
N-3320 Vestfossen
NORWAY

Tel: (0047) 32 70 05 85
Fax: (0047) 32 70 05 85

Wolfgang Schweden
14

Elsternweg 11
D-40882 Ratingen
GERMANY

Tel: (0049) 2102 870915
Fax: (0049) 2102 870955

Angela Scott
127

PO Box 24499
Nairobi
KENYA

Tel: (00254) 2 890738
Fax: (00254) 2 891162

Agent:
Planet Earth Pictures
Tel: 0171 293 2999
Fax: 0171 293 2998

Jonathan Scott
6, (Overall Winner 1987)

PO Box 24499
Nairobi
KENYA

Tel: (00254) 2 890738
Fax: (00254) 2 891162

Agent:
Planet Earth Pictures
Tel: 0171 293 2999
Fax: 0171 293 2998

Anup Shah
16/17

29 Cornfield Road
Bushey
Herts
WD2 3TB
UK

Tel: 0181 950 8705
Fax: 0181 950 8705

Agent:
Planet Earth Pictures
Tel: 0171 293 2999
Fax: 0171 293 2998

**Wendy Shattil
& Bob Rozinski**
6, 18, 48, 78, (Overall Winner 1990)

PO Box 37422
8325 E Princeton Avenue
Denver
Colorado 80237
USA

Tel: (001) 303 721 1991
Fax: (001) 303 721 1116
E-mail: 75447.215@compuserve.com

**Jill Sneesby
& Barrie Wilkins**
38/39

PO Box 5060
Walmer 6065
Port Elizabeth
SOUTH AFRICA

Tel: (0027) 41 511214
Fax: (0027) 41 511217

Gabriela Staebler
22, 87

Am Eichet 2
86938 Schondorf a Ammersee
GERMANY

Tel: (0049) 8192 1095
Fax: (0049) 8192 1095

Mirko Stelzner
46

Ossielzkystr 54
01662 Meiflen
GERMANY

Tel: (0049) 3521 457622

Charles G Summers Jnr
6, (Overall Winner 1985)

Wild Images
6392 South Yellowstone Way
Aurora
Colorado 80016
USA

Tel: (001) 303 690 6664
Fax: (001) 303 693 4750

Larry P Tackett
44

#10-06 International Plaza
10 Anson Road
SINGAPORE 079903

Fax: (0065) 227 5402

Claire Thomas
149, 151

18 Berwick Chase
Peterlee
Co Durham
SR8 1NQ
UK

Tel: 0191 587 1008
Fax: 0191 518 1804

Shaun Tierney
106

10 Netherby Road
Honor Oak
London
SE23 3AN
UK

Tel: 0181 699 8894
Fax: 0181 699 8894

Darryl Torckler
87

PO Box 33-693
Takapuna
Auckland 1309
NEW ZEALAND

Tel: (0064) 9 366 4175
Fax: (0064) 9 480 0832
E-mail:
med_gwhalley@mednov1.auckland.ac.nz

Jan Töve Johansson
129

Prastgården
Härna
S-52399 Hökerum
SWEDEN

Tel: (0046) 33 274028

Agent:
Planet Earth Pictures
Tel: 0171 293 2999
Fax: 0171 293 2998

Duncan Usher
91

Gut Wissmannshof 3
34355 Staufenberg
GERMANY

Tel: (0049) 5543 3450
Fax: (0049) 5543 4545

Heinrich van den Berg
114/119

HPH Photography
PO Box 13244
Cascades
Pietermaritzburg 3202
SOUTH AFRICA

Tel: (0027) 331 472728
Fax: (0027) 331 472728

Ingrid van den Berg
29, 86

HPH Photography
PO Box 13244
Cascades
Pietermaritzburg 3202
SOUTH AFRICA

Tel: (0027) 331 472728
Fax: (0027) 331 472728

Colin Varndell
73

The Happy Return
Whitecross
Netherbury
Bridport
Dorset DT6 5NH
UK

Tel: 01308 488341

Jason Venus
9, (Overall Winner 1996)

24 Central Acre
Yeovil
Somerset
BA20 1NU
UK

Tel: 01935 706834
Fax: 01935 706834

Tom Vezo
142

16 Raeburn Court
Babylon
NY 11702
USA

Tel: (001) 516 422 9679
Fax: (001) 519 893 7818

Uwe Walz
141

Pommernweg 11
D-21521 Wohltorf
GERMANY

Tel: (0049) 4104 3122
Fax: (0049) 4104 80412

Kennan Ward
19

WildLight Press Inc.
PO Box 42
Santa Cruz
California 95063
USA

Tel: (001) 408 459 8800
Fax: (001) 408 459 8869
E-mail: KENNANWARD.aol.com

Mark Webster
65

Photec
42 Trelawney Road
Falmouth
Cornwall
TR11 3LX
UK

Tel: 01326 318307
Fax: 01326 318307

Dave White
36

20 Campbell Avenue
Leek
Staffordshire
ST13 5RR
UK

Tel: 01538 371526

Staffan Widstrand
89

Smedvägen 21
17671 Järfälla
SWEDEN

Tel: (0046) 8 583 51831
Fax: (0046) 8 583 51831

Alan Williams
62

30 Fairfield
Ingatestone
Essex
CM4 9ER
UK

Tel: 01277 354981

Nicky Wilton
Front jacket, 144/145, 147

51 4th Street
Houghton 2198
Johannesburg
SOUTH AFRICA

Tel: (0027) 11 728 5591
Fax: (0027) 11 477 1069

Lawson Wood
99

Ocean Eye Films
1 The Clouds
Duns
Berwickshire
TD11 3BB
UK

Tel: 01361 882628
Fax: 01361 882975
E-mail: oceaneye.demon.co.uk

Konrad Wothe
20/21, 76

Maenherstr 27A
D-81375 München
GERMANY

Tel: (0049) 89 717 453
Fax: (0049) 89 714 7141

Agent:
LOOK GMBH
Fraunhofer Str.5
80469 München
GERMANY

Tel: (0049) 89 260 6320
Fax: (0049) 89 2606322

Dr Mamoru Yoshida
37

4485 St Andrews Drive
Pine Tree Golf Estates
Boynton Beach
FL 33436
USA

Tel: (001) 561 734 5559
Fax: (001) 561 734 5559

NAVVYMAN
DICK SULLIVAN

CORACLE BOOKS

Sullivan, Dick
Navvyman.
 1. Labor and laboring classes—History—
Great Britain
I. Title
331.7'98'0941 HD4851

ISBN 0 906280 05 2 (hardback)
ISBN 0 906280 10 9 (paperback)

First published in 1983 by
Coracle Books, 1 Prince of Wales Passage, London NW1
Copyright © 1983 Dick Sullivan
Cover design by Peter Gladwin
Printed in Great Britain by Expression Printers Ltd,
39 North Road, London N7